The Order

Expectations, Restoration, and the Beauty of Chaos

who I used to be

daughter

Be bold
but do it quietly

Smile!

not enough

nobody
told me

shame

were we really friends?

I do NOT regret to inform you

mother

too. much.

A Moms Who Write Anthology

ISBN: 979-8-9851333-2-5

Cover art by Abby Harding, Allie Gravitt, and S. R. Logan for Moms Who Write LLC.

Edited by Casandra Chesser and Our Galaxy Publishing.

Layout by Allie Gravitt.

Individual authors maintain all rights to their own work.

Published by Moms Who Write LLC.

For permissions email contact@momswhowrite.org

momswhowrite.org

Table of Contents

Inception

Breakdown

Reclamation

Acknowledgements

This book is not ours. It is yours.

Thank you to everyone who submitted. For every truth you told and every risk you took.

To Moms Who Write: You are all a part of something beautiful. Thank you for listening and for serving each other. Thank you for learning and growing and telling your stories. They are important and we are so grateful for this community.

Thank you to the Moms Who Write admin team for your countless hours and for your devotion to this book. You read hundreds of submissions and poured your heart into this project from its inception and you are why it exists. In absolutely no order, our Moms Who Write anthology team includes: Abby Harding, Shell Sherwood, Emmy Seal, Rose Jay Rigby, Sarah Logan, Jill Robinson, and Casandra Chesser. You are not only my partners and colleagues, you are my friends and I am so proud of what we are building together.

Thank you to Our Galaxy Publishing and Christine Weimer. Thank you for saying "yes" and for being supportive at every single turn. Sometimes we just need someone else to ask "Why the hell not?" Thank you for being that person.

Thank you to Casandra Chesser and Christine Weimer for editing

this project. It is not easy to keep people's hearts intact while making their words stronger. You are a gift.

Thank you, Megan Hanlon, for coming in and helping us clean up after the edits. We are so grateful.

From our Anthology team: Thank you to Atticus, Iris, Jude, Evie, Chloe, Kara, Alexa, Xavier, Quinn, Parker, Addyson, Nathanael, Dinah, Clara, Abram, Jackson, Gus, Patrick, Benjamin, Ivy, Felicity, Clara, Wyatt, and Lilly for making our team into the humans that we are. We love you.

Thank you to caffeine, the lifeblood of our operation. Without you there would be no words.

All my love,
Allie Gravitt
Founder, Moms Who Write

The Order of Things

Allie Gravitt

We spend our childhood developing our plans. The people around us don't even know they're doing it, but they teach us what is possible. They ask us what we want to be when we grow up, and we say things like ballerinas and firefighters and baseball players and actors. They fill us with ideas and insecurities, and, if we're lucky, dreams and goals and hopes. Our dreams are born from the world that we know.

At some point — and this happens differently for everyone — we realize that there is a lot more to life than what we know. The boxes that we put ourselves in suddenly feel too small, and the Order of Things feels a lot more negotiable.

When I was a kid I wanted to be a rock star, but I would never tell anybody I wanted to be a rock star. By the age of seven, life had stuffed me into a box. I remember telling my second-grade teacher that I wanted to work at a grocery store, because that was the most normal, acceptable grown-up job I could think of at the time.

My dad told me he was disappointed. I didn't know why. I was sure I'd done something wrong, though.

I went into too much debt to go to college. I got a business degree, because that was the "responsible" thing to do, even though I hated taking finance and accounting classes. Everyone was proud of me, but I'm not even sure they knew why. I was the first one to graduate

college. I had a job. I was doing things correctly. It seemed like it was worth congratulating, I suppose.

I wanted to be married and start having kids so badly that I couldn't figure out what else I was supposed to do. Some of that desire was honest — I always knew I'd be a mom. Some of that came from imposed expectations that I internalized and etched into my psyche as the way things are done. Either way, my window for being a young mom had closed. In the absence of that option, I worked. I moved every few years, bouncing around Nashville, Raleigh, Washington, D.C., and Atlanta without ever bothering to anchor myself in a community or a relationship or a job. I felt like I was failing, but I wasn't sure how to make my made-up timeline work. To compound my insecurities, I went to a Baptist college in Tennessee, where most of my friends were marrying young and having children.

I mostly pretended I was fine with deviating from my Plan, but I was not okay. I hated that things were not happening in the order I was told they were supposed to happen, because it left me feeling inadequate. I was still the girl that disappointed her parents in second grade because she didn't know how to tell anyone what she wanted to be. The thing is, when you're good at what you're doing, people assume that is what you're meant to be doing. That isn't always true, though, is it?

Sometimes, things that you're good at weigh on you. They distract you and steal joy. They become false idols for you to hide behind. I was good at my work. For a while, I considered the travel and the salary and benefits to be success. It was a terrible, empty version of success, though, which involved a lot of insecurity, self-flagellation, and defeat. The plan that I had been trying desperately to execute had failed me.

Something happened around the time I turned 30. I had moved to Georgia and taken a less visible job, and, for the first time, I was living alone in a new city. There was no reason left to pretend. I was in my own house, making my own money. There was nobody for me

to answer to, and that realization was liberating. I shed my pen name, picked up a guitar, and started over.

I let myself revisit the life that I dreamed about when I was a kid. I started to remember who I imagined being before I crafted a new and utterly boring human out of expectations and guilt. I got more tattoos and colored my hair. I wrote songs and sang them on stage. I took thousands of photos and I bought beautiful vintage clothes that I wore for no reason. I dated and I traveled alone and I got a hedgehog. She was small and white, and I named her Talula.

My adorable 150-year-old bungalow was perfect for creating art, and drinking wine, and playing music, and writing things nobody would ever read. I hung tapestries and twinkle lights and burned Nag Champa and rested. I talked to God again. I made friends again. I stopped quitting jobs and leaving the state every time I got bored or frustrated or felt trapped. For three years, I allowed myself to exist.

It turns out that when you nurture life, it grows. Sunlight heals, and I slowly exited the dark, flat night of soul dormancy that I thought was life, and emerged into the day. I was finally able to grow. By the time I turned 31, I began to bloom. I made a decision to embrace who I am and honor the things that I am not, giving myself permission to deviate from The Plan. It was at precisely that point that I met my husband. In a whirlwind of a year, we met, got engaged, got married and moved to Australia. By that summer, we had a baby on the way.

I still wish I had figured some of this out earlier. I feel like I missed out on years with my family that I can't get back. I wish I had the energy I did at 25 and the freedom that comes with a lack of baggage and responsibility. We always wish we had more time, don't we? I know, though, that I'm a better mom. I'm a better wife. I have more to offer my family because I am a more whole human.

As I stare down the barrel of my 40th year, I am in a place where I've embraced having goals and dreams instead of a plan. Most of the time, a plan goes wrong. Some part of the execution will inevitably disintegrate, and it will leave me feeling that because The Plan has

failed, I have also failed. The Order of Things has broken down, so I break down and lose track of where I'm going.

A goal or a dream lets me focus more on the outcome. It lets me make more room for failure and change and growth. It's okay that I didn't write my first book in my 20s. I've published two, and I'm not finished. It's okay that I didn't have kids until my mid-30s. I have a family that is my world. I got there, and I'm still going.

Plan be damned.

Inception

every dark chance

LA Roquemore

I was taught to pray everyday

on earth as it is in heaven

"this earth is not our home"
the elders would say with pomp and a shirk

i began to imagine that my home
was somewhere in the dancing stars

and i still remember the chills that slid up the back of my arms
the first time i heard carl sagan's line
how every human being who ever was
lived out their lives

here

on this pale blue dot
that i came to know
will forever be my home

i look for the moon and stars

every
dark
chance
i get

sometimes
i want to be reminded that i am tiny
and something else is constant

the elders always made me feel small
they were meant to be the wise ones
but not so, after all

the moon
and the sea
are mothers
to me
the wisest ones
i look to them
when i need to be held

The Littlest Things

K. L. Mielke

Certain things from my childhood still bring me joy, some twenty-plus years later. I had a happy childhood, filled with many fun memories, but two small details bring me happiness: high heels on the linoleum floor and chocolate milk.

Like many other little girls, I often tried on my mom's shoes whenever I could. High heels on the linoleum floor meant dressing up, pretend play, and imagining a time that I would wear them all the time. If I wasn't wearing them, the sound meant Mom was, and that meant date night. Date night meant a fun babysitter was coming over, and also almost guaranteed pizza night and a movie from Family Video.

And then there was chocolate milk. Well, sometimes it was chocolate milk. Other times, it was a donut preferably a Persian, but the backup was always a Long John with vanilla frosting and sprinkles. Rarer still, it was a Little Hug barrel of juice (the green ones are where it's at). My siblings and I earned them *only* when we accompanied my dad to the grocery store. The catch? He went – and still does – religiously at 7:00 a.m. when the store opened. *Every* Saturday.

Have I mentioned I'm not a morning person? I'm not.

Somehow, he managed to convince us to come along, and we would wander up and down every aisle with him, with bedhead and rumpled clothing, dragging our feet. I might have even navigated an aisle or two with my eyes closed. However, as we neared the final aisles, a pep returned to our step. As an unspoken thanks for accompanying him, Dad would buy us a little something for the ride home, a little snack for our "troubles." As petty kids, it also provided bragging rights, joyously announcing our winnings to the siblings who did not come along. As an adult, I recognize it as a special time with just him.

There was always something small I remembered about the best things in my life. A grandpa who snuck jelly beans from the nearest bowl when he thought no one was looking. A grandma who believed that when you saw rays of sunlight between the clouds, it meant that people were going up to heaven. Wearing Bugle chips on my fingers while drinking kiddie cocktails with another grandpa. The smell of my grandma's perfume, and having to find the lipstick marks somewhere on your cheek or neck because I was too tall and she couldn't always reach. The feeling of colorful bingo chips snapping across the table at my siblings after the church picnics.

As a mom, I can't help wondering what my boys will remember. What will spark those happy memories down the road? What will remind them of me?

If I'm being honest with myself, a tiny piece of me hopes it might be the COVID era.

The pandemic roared through our lives when our kids were three and one. The school where I worked closed down in March of 2020, and my job duties as a paraprofessional were limited in virtual schooling. So from March to September, I was blessed with an extended period of being able to watch my kids learn and develop. It was an extra taste of stay-at-home motherhood I would not have had otherwise. I spent each day molding my boys into people of whom I was immensely proud. They learned to play together, to share, to be kind. They knew only that there were "icky germs" which had closed

the park across the street, and that didn't allow them to come to stores with Mom or visit older family members. However, the "icky germs" provided them with more time to experiment, where nature walks led to endless I Spy games, or with snow dumped into the bathtub for sensory play when our Wisconsin winter storms were too harsh. Cardboard boxes I decorated and colored provided hours of imaginary play. We had daily dance parties, painting, and crafting sessions, even bowling *inside* the house! Routines kept our lives slow and simple. Slow and simple and perfect.

For that time, I was able to make my boys' world revolve around us. Did we miss our extended family? Of course we did. Was every day perfect? Pardon me while I laugh, before giving you a resounding *no*. But did we have fun? Absolutely.

I do not know what they will take away from this pandemic era. They are young enough that we were able to shield them from the uglier parts of it. Maybe someday, a large cardboard box will remind them of that time they dressed up like astronauts and took a trip to the moon. Perhaps the smell of Play-Doh will bring them back to the rainy or snowy days when whole worlds were created, destroyed, and rebuilt. Maybe "Sweet Caroline" will bring them back to dancing around the living room, belting botched lyrics with not a care in the world.

For me, it was, and always has been, the little things that bring the most joy.

The Force Between Us

Allison Prine

I watched my entry into motherhood from a vantage point floating
just over my right shoulder, numbly aware of the surgeon reaching
through the seven layers of tissue, prying my daughter and that little
arm wedged next to her face back up through my vagina, and into the
alien white shine of the operating room lights. I was jolted back into
my shaking body as the blue mass of nurses surrounded her quiet
form, begging for them to tell me she was alive as black spots
bloomed at the corners of my eyes. I awoke to her face held up to
mine, momentarily grounded as my lips brushed hers, and I felt life
flow, warm and serene, between us. I vaguely wondered why I was
not crying – I had always imagined crying when I first met my
daughter – before drifting into unconsciousness.

The birth of my daughter was the first of many moments in
motherhood that unfolded entirely antithetical to what I had
expected and hoped for. That first year of motherhood, I lost myself
in a blur of sleep deprivation, sore leaky breasts, sundown anxiety,
and the softness of her. My camera roll documents every inch of her,
from the downy hairs on her newborn ears to her gentle coos in
conversation with mine, as if capturing these moments could slow
down the inevitable forward momentum of time. Deep existential
angst, the stuff of first loves and teenage heartbreak, gave rise to
these little anchors, moments frozen in time. I knew I would need to
come back to these reminders to find the depth and light in this
overwhelming, amorphous fog. Becoming a mother was not a

singular event in my life. I have found myself again and again in the slow awakenings, the tender aftermath of trauma, the depths of loss, and the purest love. It has been a story of tentative healing, of raw growth, a place of becoming where surviving was enough and thriving took time.

I held the pain of my daughter's birth deep within my pelvis, not touching or looking at the violet scar slashed across my belly, unable to connect to the place where she emerged into the world. The hands of healing women taught me to breathe back into this sacred place within me. I felt the sobs rise through my chest as I felt into my own new body as a woman transformed by motherhood. I learned what it was to touch, to trust, and to unconditionally love my body for the first time. As I healed, realization dawned that my flinching away from my husband was beyond feeling touched out; it was a trauma response that read like repulsion, a scar that served as a wall between us. That first time we had sex nearly a year later, we found each other and fell for each other all over again. We tapped into a primal connection full of shaking legs, of racing hearts, of losing ourselves in each other. This healing was a slow unfolding, where we accepted the loss of the shape of us that had existed before and became excited for what our love might become. Through the delicate dance of finding myself in motherhood, I felt some semblance of personhood returning to me.

As I settled deeper into a felt sense of identity, both as a mother and as a woman, we discovered that our fledgling intimacy had led to another pregnancy. I reeled from the bathroom counter where the test lay, nauseous from a visceral fear of how this accidental life would ripple through our family. I held my daughter to my chest, grieving the impending change in our relationship. I searched the internet for stories of breastfeeding through pregnancy, I weighed the pros and cons of having an abortion. Despite being nowhere near ready to embark on this journey again, after a few days, we felt connected to this possibility. We needed to see where this plot line took us. The whole future seemed to shift into this alternate reality where everything from this point on would be forever defined by this moment. This was the start of a life-altering cascade of events... just

not in the way we had imagined. We sat in the doctor's office, my daughter balanced on my husband's lap, hearing words like fetal pole and late implantation thrown around. We stared at a black chasm on the ultrasound screen and stumbled into weeks of uncertainty that culminated in being prescribed the abortion pill to assist our miscarriage.

I was startlingly underprepared for the waves of contractions that intensified as I found myself in labor in the backseat of our minivan, purchased too soon and now so cavernous, on our drive down to Southern California for Thanksgiving. I left the debris of our pregnancy at various rest stops along the I-5 corridor. Somewhere around Kettleman City, I stood up from the car to an avalanche of blood and tissue pouring out of me, deep red blood falling in drops around my feet. In the bathroom, the world bustled around me, and I dissociated as I held the gestational sac dispassionately in my hands. I bled waterfalls into the toilets in gas stations and Targets, stuffed towels into my pants, called the advice nurse pleading with her to tell me I could bleed this much without dying. I stood in the packed emergency room, blood dripping down my legs, holding my daughter's body across my own so she could nurse, feeling myself tethered to life by the pinch of her latch on my breast. Nursing her through the contractions and the blood, the fears and the hormone crashes, kept me anchored and moving forward.

This little life sprung from my own called me back from any darkness that threatened to consume me again and again. This force between us is a magic that has grounded me and brought me strength in the face of death. In the aftermath of crisis, I finally began to feel that damp fog of early motherhood begin to lift. I was brutally shaken out of all of the false expectations, the well-meaning advice, the implicit messaging, and found a deep sense of knowing that all that mattered was that light glowing between me and this little human. In the aftermath, I learned to linger longer, memorizing her every feature, letting myself love so deeply it hurts. In the curve of my hand around her cheek, the weight of her head on my chest, the way she throws her head back when she giggles, I found meaning and myself anew.

The tragic beauty of being a mother is holding the darkness and the light all in the same breath. It's fading into unconsciousness as she uttered her first cry, feeling the blood of loss drain from my body as life-giving milk flows into my daughter, grieving her growth while in awe of the person she is becoming. My entry into motherhood has been a jarring series of dashed expectations, of false starts, of little deaths. The awe, the joy, the deepest love all walk hand in hand with grief. Disentangling the light and the dark would be a fool's errand; it would only serve to deny my story and deprive me of profound meaning. We have since added another several pregnancy losses to our story, and some days I cannot help but feel the waves of grief swell up. I feel them in quiet moments, where I wonder if our daughter will be our only child, and in loud ones, where Brandi Carlile is blasting in the car and I know she won't hear my stifled wail in the backseat. Those moments of grief are fleeting these days, as the trauma of motherhood has ultimately brought me rich meaning and deep gratitude. There is something about the presence of death that makes the colors next to it more vibrant, the feelings more moving, and the moments more impactful in an unparalleled way. I have birthed complex beauty in the peaks and the valleys of my motherhood, discovering a deep strength, an undeniable truth, and my purest self in the space where day melts into night.

Breaking Free

Laura Babyn

A chair scrapes on the floor beside me as yet another one of my peers raises themselves from their seat. The room is only half full now, when it was once at capacity, but it still suffocates. My stomach is so knotted it would take hours to untangle. I force myself not to look up, knowing I need every minute with my test paper, but no matter my efforts, my thoughts keep wandering. I am acutely aware of my peers. Every tap of a pencil, every cough, every whispered question draws my attention like a beacon.

My eyes flit back to my paper and I re-read the question I have been studying for the past two minutes. *Is that the explanatory variable? Or is it the confounding variable?* I knew this an hour ago... I know I did. I sigh, leaning back in my chair as I randomly pick one. *That's the beauty of multiple choice*, I think. *You have a 25% chance at getting it right even if you don't have a clue.*

"Time's up!"

The head T.A. begins to make the rounds to collect our papers. I reluctantly hand mine over, hoping for a miracle. The last remnants of adrenaline and anxiety fade from my body as the numbness settles over me. I've cried so much over the past several months that *not* feeling is a welcome relief.

"Laura! Over here!"

Sarah, a friend from first year, calls me over as I exit the room. She's standing with another student I don't know, the familiar excitement and post-exam exhaustion evident on their faces. She looks surprised as she pulls me in for a hug. "I didn't know you were in this class!"

You wouldn't, I think. *I've only gone to maybe two of them.*

"How did you do?" Sarah asks nervously. "There were some really tough ones! What did you get for question 17?"

"I have no idea," I say honestly. "I'm just hoping to pass at this point. Everything else is gravy."

She nods, a smile creeping onto her face. "I guess that's true. That's a healthy way to look at it."

Sarah is a bona fide genius. I know there's no way she needs to worry about passing, but I appreciate her transitioning away from exam talk.

"Thank you," I say, and force myself to be bright and warm like her, carving my lips to match her smile, even though I feel like a walking zombie. Can she see that I'm hollow and broken inside? I hope not.

I don't tell her I've already flunked the course... that even if I got 100% on the final, I would fail. And yet, I still came to take the test. I need to pass this exam. If I don't pass the final, I go on academic probation and I can't take a year off. I *need* to take a year off. I need to break free of the darkness that has settled over me the past few months. Leaving is supposed to fix me. *Oh God, I hope it fixes me.*

"What are you going to do for the summer?"

"Not sure," I shrug. "Get a job somewhere."

She laughs, her perfect blonde ringlets bouncing along with her, emphasizing her brilliant spirit. "Of course! That's always the goal, isn't it? I've got an internship with one of my profs. I'll be cataloguing cells all summer." She says this like it's tedious, but her eyes sparkle — I can see the excitement oozing off of her.

"That's amazing." I say, genuinely happy for her.

"Are you sticking around for the summer, or leaving?" she asks, hopeful. Sarah has always been a good friend to me, even though I haven't seen her as much these past few months.

"I'm leaving. Actually, I'm taking a year off, so I won't be back in the fall either."

My throat tightens a little, despite myself. I wish I could be the carefree student excited to take on the world. I know I need to leave for my health, my sanity — I feel it in my bones. But I'm also terrified. School is all I know. School is safe, school will set me up for a good job, career... life.

And I hate it. I hate every minute of it. I'm terrified that I will never come back. That I will never break free of this dark cloud, slowly suffocating me, drowning me. That I will never excel at anything.

I'm self-aware enough to know that I'm severely depressed, but I don't completely know why. I just know I need out. I need to breathe. I need to know that my struggle is worth it, that I'm enduring school for a career I will love in the end.

She raises her eyebrows, surprised. "What are you going to do?"

I bite my lip. "I don't know yet... travel, I think?"

Her eyes light up. "How wonderful!"

I force another smile. "I hope so."

ONE YEAR LATER

Pffftttt. A thin bamboo reed flips back upright and slaps me on the shoulder – hard. I brush it aside quickly, ignoring the pain. My eyes lock on the tall, thin man in front of me: Olivier, our guide. He's dressed to match the scenery in monotone dark green apparel. Olivier moves fast, despite the unyielding jungle surrounding us. I rush to catch up, my foot slipping on the thick, soft mud created from weeks of rain. I'm grateful for the long poles they gave each of us and stab mine into the ground to prevent face-planting. It slips at least six inches down into the mud.

"This way," Olivier says, taking a sharp turn down the hill.

I don't bother trying to walk down the hill anymore – the thin bamboo shoots that surround us don't have wide roots to provide grip. Instead, I sit down, and let my body slide down the steep hill, haphazardly grabbing the reeds to slow myself down when I near the guide. I'm not efficient enough though, sliding several feet too far.

I can hear John, another member of our group, groan from behind me as he slips and falls. He's still adamant he can walk the hills.

"This is harder than Kilimanjaro."

I've never hiked up Kilimanjaro, but I can't help agreeing with him. This is definitely the most challenging hike I have ever been on. We've been going for over three hours now, and the entire trek has been like this – blindly rushing through the thick jungle brush after our guides as they track our quarry. Up the hill, then back down. Up in another section, then back down... then back up. I have absolutely no idea where we are, nor could I find the way back to the headquarters if my life depended on it. And I love it.

My legs quiver with exhaustion and I'm thoroughly soaked from the rain mixed with sweat, but I'm excited. I worked two full-time jobs for months, sleeping on my brother's apartment floor so that I could

afford to be here. I paid $500 for this once-in-a-lifetime opportunity — I will not squander it with a bad mood.

Olivier stops and motions for us all to be quiet and join him. He stands at an opening in the forest brush, and I creep quietly over to stand beside him, alongside the other eight members of our party. A large, mature, male mountain gorilla has its signature silver back to us, about 10m away. I feel my breath catch at the sight of him. Even at this distance, he's much bigger than I expected. A white sheet of mist covers the area, casting him in an ethereal light. He's so beautiful.

More gorillas lumber into the valley. Mothers with babies, juveniles, and other males fill the space.

"There are 36 gorillas in the Susa family," our guide whispers to us as the animals settle in. "It's the biggest group we have here in the Volcanoes National Park."

I nod my head. They told us all this back at headquarters. It's one reason I agreed to join this particular trek. That, and I liked that the Susa family was farther away than the others. It felt like it would add to the experience somehow.

"You get one hour," Olivier reminds us. "No food, no sudden movements, no loud noises, and we must stay 6 meters away from the gorillas at all times, unless they approach us."

"What do we do if they approach us?" Kelly, an older woman in our group, asks. She looks worried.

"Remain calm and stay still," Olivier tells her. "Then *walk* away when it is safe to do so." He pauses after the word "walk" to emphasize that running is not an option.

My cheeks are starting to hurt, I'm smiling so much. This is SO cool... a life goal. It's one reason I wanted to go to school to become a vet – to study majestic wild animals like these. As my 5-and-a-half-

month trip through south-central Africa nears its end, I find myself thinking about school more and more.

I know I don't have the grades to become a vet, but I've learned a lot about field biology in my time here. I've studied the flora and fauna of the region extensively while volunteering in South Africa for ten weeks, and I actually helped create a scientific paper on the ecology of big game predators. Guiding is also an option, something I'm seriously considering in South Africa or Botswana if school doesn't work out for me. Maybe even diving. I learned how to dive in Malawi, and loved how calm and close to nature I felt.

I'm also keen to head back to my family and friends in Canada. It no longer feels like a black cloud follows me everywhere I go. I am lighter, happier, and stronger. I feel capable now, when a year ago I was anything but.

My thoughts are interrupted as the guide informs us it's time to go. We start to make our way out of the area – I'm one of the last in the line. A large female gorilla charges in front of me, passing only one meter away. I stop to let her through. She's taller and probably has several hundred pounds on me. My heart races from her proximity, but she barely gives me a passing glance. I realize I've been holding my breath and slowly release it, awe replacing my fear.

When the gorilla is a safe distance away, I make my way back to the rest of the group. The collective high between us is palpable. On the way here, we mostly hiked in silence, but we can't contain the chatter now.

"That was so cool!" Peter, another tour member, exclaims to me. His smile radiates pure joy.

My smile matches his effortlessly. It's hard to believe smiling was so much work not too long ago. "I know! I can't believe we just did that."

"I can cross it off my bucket list now," John says. "First Kilimanjaro, now the gorillas. Making waves this month!"

I raise my eyebrows. "I'll say! What's next?"

"Not sure," he laughs, conspiratorially. "Maybe Everest?"

I laugh too. "That's the natural step up."

John turns to me. "How about you? What will you do next?"

I take a deep breath, finding the words I have longed to say for a while. "Back to school, I think." I'm ready.

Wishes Don't Wash Dishes

Liz Tiethoff

I wish you had seen me,
Instead of the fiction you carried
Close to your heart like a talisman
Shielding you from the truth.

"I did my best."

I wish you had asked why,
Instead of telling me my sins
That you knew by heart
Because you wrote them.

"I meant no harm."

I wish you had sung my successes
Instead of reciting my failures
Like our favorite song,
Spinning me on my heels.

"I loved you more."

I wish you had believed my words,
Instead of cocking your head
And pulling me into the light
Like a stain to be removed.

"I did my best."

Matrescence Stage One: Baby Fever

Amelia Orr

It seems that at age 30, I've recently recovered from my first bout of Baby Fever. *Recovered* doesn't quite seem like the exact term I'm looking to describe this feeling; this shock of hearing your own biological clock tick, the mild disappointment that evolution hadn't yet advanced my femininity beyond the biological clock.

So far in my life, I had never imagined that someday I would try to become pregnant, that I would ever plan for it, try to schedule it, or make it happen on purpose. The idea of giving birth, especially in my young 20s, would make me feel slightly physically nauseous. How cruel that the physical feelings of an upcoming menses should be so easily confused with the physical feelings of a newly growing fetus.

For two weeks, I had been feeling an inner certainty that I was pregnant. The feeling began after realizing the little pink flower on my period-tracking app also happened to be the day we had knee-bruising, unprotected sex. The feeling grew after an instant heartburn I experienced from drinking that nice dark stout, when I had never felt heartburn in my life. And the horoscopes! So suggestive of a certain pregnancy! It intensified more when my chest grew even heavier than when I was on birth control. Then, when my

period was a day late, I think, is when the Baby Fever officially hit, a culmination of spiritual and physical evidence.

The spiritual evidence was highly subjective, but this objective now physical evidence provided solid backing for one possibility: pregnancy. This possibility didn't make me feel nauseous (yet), weirdly, surprisingly. I reminded myself that I had voiced all my precautions with my partner, and we had equality in our decisions and actions regarding this, among many other potential outcomes. The next day, the second day late, the fever intensifies when a close friend calls to say that she was newly pregnant. How quickly I imagine her and I sharing this experience together. I start to think that while this may not have been planned, it would certainly have been welcomed, loved. And honestly, would I ever try to have a baby of my own, on purpose? An unplanned pregnancy may be the only kind I have in my life. The heartburn is increasing, and now I'm feeling lightheaded, too. Early on the third late day, the cramps come on. The blood, unusually thick, I imagine could be a little 3-day old fetus. My first (and hopefully, hopefully, hopefully) only miscarriage, I think. One side of me fears that this might be the first in a string of karmic miscarriages; atonement. The silver-lining-seeking side thinks maybe this is my body's way of being sure it's ready, cleaning out any built-up residue, like a chimney sweep to a chimney, grateful that this explanation bolsters the trustworthiness of my intuition. Both sides unearth the existence of a biological clock within me, an acceptance of future womb occupation.

I feel a little physically nauseous, feverish; I think it'll be a long time before I'll ever purposely plan on becoming pregnant, if ever, and what if it's not easy then? What if, what if, each what if heating the fever. Did I mention how cruel I think it is that the physical feelings of an upcoming menses should be so easily confused with the physical feelings of a newly growing fetus?

My Universe

Eve Croskery

In the beginning,
it was just us.
He orbited me
day and night.
Or perhaps I was the one
who orbited him?
As my stomach stretched and swelled
I began to worry
how my heart would stretch as well
when one became two.
How would I share my
time, my love, my self?
A shift.
Our universe,
rearranged.
I didn't consider
the gravitational pull
drawing the two of you
towards each other.
There are two suns now.
Radiant golden rays,
lighting each other up.
While my heart
expands, stretches,
explodes.

Aphrodite's Son

Lisa Masé

Every part of me is filled with you,
my body a water jug ready to spill
in celebration of your coming, child of light,
Aphrodite's son, miracle who swims in my womb.
You listen, breathe through liquid as though your soul
knew the song of the sirens who guard the seas
with their spectral cries.

You will journey as Aeneas did, know new lands
and meet others with the kindness of one who remembers
the mother who sacrificed everything to carry him
in the safety of her ocean, surrendered everything
to release him into turbulent waters.

Missing Person

Crystal Rowe

He was a missing person away from home.
Staying out late ev'ry night, seeking freedom
from the emotions he's been taught to silence.
Insecurity deprives him of the peace
that could fill his heart if he's willing to love
his fam'ly with every fiber of his being.

No one told him being a dad meant being
vulnerable with the people in his home.
No one told him that enthusiastic love
could be the one thing that finally set him free.
No one told him the way to find inward peace
doesn't come from everyone being silent.

Instead, his rage taught her to hide silently
in her room if she wanted the house to be
without caterwauling; a calm place of peace.
She could never truly be present at home
when he was there. She was never fully free
to speak her mind or embrace the things she loved.

She grew up thinking it was hard work to love;
that loving someone meant a life of silence.
Her dad taught her the only way to be free
from his wrath was her pretending not to be.
He was hardly there, but when he was at home,
she thought her silence would help him be at peace.

Always wondering if she would have a piece
of his heart, she often longed to feel his love.
One day when she was ten, her mom brought her home
to her dad sitting on the couch in silence,
waiting for his chance to tell her that being
her dad was something he wanted to be free

to try once again. Would she grant him freedom?
Could she forgive him and move forward in peace?
She nodded slowly; fear kept her from being
honest with him. He never expressed his love
for her before; why would he stop his silence
now? Nothing changed; he still stayed away from home.

Only when he left home for good was she free.
No longer silent, but still yearning for peace,
she would screw up love before she learned to be.

Unexpecting

Jenna Wilson

Uterine Septum

People keep asking me
"When does she get a sibling?
Come on, Mama,
Keep them close in age!"

And they smile and I
Smile
And I try not to scream

I return the call to the
Specialist
Who's going to carve the right-sized space in me
To make room for a sibling
But I can't schedule my procedure
Until my husband signs up, too,
Because why would I be trusted
With my own insides?

And I feel so blessed to have her,
To see my smile on her face,
But I'm still not quite complete
Carrying a uterus stuffed with cartilage
And no heartbeat.

Smile

I will never forget
The thick blanket
Of saw-toothed rage
That coated my throat
When I left the ultrasound office
Clutching a photo of gray blobs they told me was a baby
Having seen no fluttery heartbeat on the screen
And stood in front of the elevator
Begging myself to stay together
Until I could collapse in private
And some
Fucking
Man
Told me
To smile.

Bleed

You ask me how it's going
And I'm bleeding
But I shrug and say
"Just Living the dream"
And you nod.

You ask me about my week off
And I'm bleeding
But I shrug and say
"Family emergency"
And you nod.

You ask me about my daughter,
If she'll ever be a sister,
And I'm

Bleeding
But I shrug and say
"One day,
I hope"
And you lightly punch my shoulder and
Encourage me to
Get
Started.

As the date approaches
And passes
When I could have told you-
As the date approaches
And passes
When I could have held him-
As the months pass
And my daughter ages
And you never know
Because I never said -
I'm bleeding.
Every ounce
Every drop
Is leaving me
And you smile
And I shrug
And I bleed
Trying to fill the empty space I'd set aside
For the child I'll never get to meet.

Unexpecting

Dear social media advertising algorithm:
You got it wrong.
When you saw me typing the words
Uterus, fertility, and pregnant
You missed the words
Broken, clinic, and can't.

So now you're showing me maternity clothes
And nursing bras
When this belly is only rounded
By stress eating
And these breasts won't
Nourish
Anyone.

You're linking me to baby names
But I already imagine every little
Somebody
Who cannot grow inside of me.
Aiden and Asher and Addison -
I'm sure they would have loved me -

But instead,
I scroll past your ads
And try to unsee them
And write this poem
Hoping maybe the words can fill the void
Left by lack of little fingers
And toes.

Dear Yuy: A Letter to My Childhood

Yuy Ren

Dear Yuy,

I see you, with your expectant eyes looking up at the adults around you, trying to make sense of your reality. You're ten years old, and growing up across cultures is hard. Coming to terms with the disparity of expectation and reality will continue to be a challenge, but you'll get there.

Now I am you, twenty-five years later. I am often still navigating the same problems, and desperately trying to do better for my children. Yes, children. You will become a mom of two beautiful, kind, and gentle kids.

As a mom, your lived experiences hold new meaning to me. I wish I could have been there for you, little one, to help you understand and navigate your confusing world as you experienced it. A little guidance would have helped you discover your path sooner and with less pain.

As a writer, I hope to reach you with this letter. It's a bit late, but I know it will still help you heal.

ONE

Systemic racism exists. It's not your fault.

It was the summer of 1994, in Germany. On your way home from school, you always had an option. You could hop onto a public transit bus for a stop or two with your bus pass, or you could walk the thirty or so minutes home. On some days, you chose to walk, and on others, you would take the bus.

On this wet and rainy day, you thought it was a good idea to hop onto the bus. You waited at the bus shelter, and soon, the transit vehicle came to a full stop.

The door opened, and you proceeded to get on, as you have done many times before.

"No," the bus driver said in German. "I'm not giving you a ride."

He was a middle-aged man, and he looked at you with a hatred you couldn't place. You tried to remember if you had ever seen him before. Were you perhaps unnecessarily disruptive on one of the previous bus trips that now had you banned from public transit? You came up with a blank.

"You people just come to our country to take our jobs. We should never have let you guys into our country." With that, he closed the door and drove off.

You stood at the bus stop, looking puzzled at the retreating vehicle going off into the distance. You didn't understand what was going on. You've never had a job, and you've never really wanted to be a bus driver. Were there many 9-year-olds taking over bus driving jobs? It was all very confusing. Maybe you really did something unruly on your last bus ride. You'll have to be on better behavior going forward.

Unable to place this interaction anywhere in your schema, you just shrugged it off and walked home.

After all, you walked home half the time anyway.

* * *

It was spring of 1996. You arrived at school and saw your friend. You had been playing together all year in the playground and during free play, and you were quite fond of her. You approached her, eager to talk about last night's episode of the show you both had been obsessed about.

You noticed that she was playing with another girl from your class and they both stood up as you approached. It didn't matter to you; the more the merrier.

"Sorry, Yuy," she said, before you even had a chance to open your mouth. "My mom found out yesterday that you weren't white. I'm not allowed to play with you anymore. My mom said that you are a bad influence, and I have to do what my mom tells me."

Her eyes showed no malice, but no kindness either. She had the look of someone who was simply doing what she was asked, believing it was the right thing, the same expression one had when crossing the street when the light was green, or paying at the cash register... a bored, matter-of-fact look.

She grabbed her other friend's hand and dragged her to another part of the playground. The other girl shrugged and happily went along.

You looked at them both and stood there bewildered. It didn't feel right, but you couldn't put your finger on it.

Her mom told her not to do something, and she was listening to her mom. There was absolutely nothing wrong with that. After all, listening to parents was a good thing. She was being a good kid. You

conclude that there must have been something wrong with playing with you, if an adult had said that it wasn't allowed.

You weren't sure what to do with that information.

Maybe you can try being less you.

* * *

Little one, these experiences have happened to you in the past, and they will continue to happen to you in the future. You don't know the word for it yet, but it's called racism. You're being singled out because you are Chinese, living in a very white neighborhood in a very white country.

Germany does become much more multicultural in the next couple decades, coming to the aid of many refugees, but they weren't so nice to you in the '90s. That's just your lived experience.

As you get older, you will realize that when it comes to racism, your experience is not unique. In fact, racism is such a problem that there are many other races who have it much worse. That, little one, is still a truly sad state of affairs.

Systemic racism is a very large problem affecting so many people, and, 25 years later, you'll still be trying to find your voice around it.

But the biggest lesson, little one, I want you to take away now is this:

It's not your fault.

I see you trying to internalize these interactions as something you did.

It's nothing you did. It's not your fault.

Continue to be you.

Don't change for racism. It doesn't work anyway.

TWO

Everyone eventually finds out Santa isn't real. I'm sorry about the way you did.

You were seven years old, and Christmas was just around the corner. You've been living in Germany with Mom and Dad for about two years now, and have fully adopted the traditions of a German Christmas. You knew all the carols from school, and you were very excited about getting presents. Last week, Mom and Dad took you to a shopping mall where there was a Christmas tree in the lobby. Pens and little paper ornaments were available for kids to write down their St. Nicholas wish list. You wrote down what you wanted from St. Nicholas, Mom filled in our address on the back, and you hung it up on the tree. You were confident that you would get picked to get a new Barbie. You were already dreaming about finally owning your very own Barbie doll. It was going to be amazing.

You also knew the tradition of the boots very well by now. Children had to clean their winter boots and keep them outside their door. At nighttime, St. Nicholas would come and put all sorts of treats in your boots.

Last year, you had been skeptical, but you had done it just the same. You washed a pair of rain boots, which were the only pair of boots you owned. Then, come Christmas morning, you had been so incredibly surprised by the chocolate and toys overflowing from your boots.

You had quizzed Mom and Dad for days, and they swore up and down that they did not put the toys and candy there. They genuinely looked as puzzled as you did. Mom had said that it was probably one of the other residents in the student housing that you were living in, but you doubted that. Why would another college student bother to

put toys in your boots? If it wasn't Mom or Dad, it was definitely St. Nicholas.

This year, you were extremely excited, because you knew that you were good all year, and St. Nicholas would definitely fill your boots with toys again. You scrubbed the rain boots in the bathtub and placed them outside your bedroom door.

It was Christmas day. The boots were empty. There was nothing inside them. That was odd. You picked up the boots and examined them. Did you not do a good job cleaning them? After careful examination, you did notice some dirt still stuck to one of the heels. It was probably your fault then, you surmised. The boots weren't clean enough for St. Nicholas, and you missed your chance this year.

That afternoon, you were out for a walk down main street with your parents, and they stopped in front of a kiosk that was trying to promote something that didn't interest you. The kind lady at the booth asked you if you had a good Christmas, and if St. Nicholas came to your house.

That was when the waterworks started.

You couldn't hold back your tears when you told the lady about what a terrible job you did cleaning those boots, how you had been good all year, and were so much looking forward to it. The lady at the kiosk looked at you, and then looked at your parents. She then gave you a pen and some paper and told you to go draw on the side. She wanted to talk with Mom and Dad. They spoke in hushed voices, and you weren't really listening, but you caught some comments from Mom and Dad, in their broken German, about Christmas traditions.

"What's the point?" you thought at the time. Mom and Dad don't understand Christmas. They don't know who St. Nicholas is. They don't really understand the whole boot thing. They are Chinese. It's not a Chinese tradition.

The lady at the kiosk came back to you.

"Yuy," she said as she knelt down to meet you at eye level. "Did you know that St. Nicholas sometimes makes two trips?"

Your eyes went wide, and hope bubbled in your chest. "Really?"

"Yes." She sounded very confident. She must know what she was talking about. "Sometimes, it just takes too long, and he has to do another round. Maybe he just missed your home yesterday. Why don't you go home tonight, make sure those boots are squeaky clean, and try again."

"Yuy, you've been cleaning those boots for two hours," Mom said from the bathroom doorway. "I think they're clean enough."

"I just want to make sure," you said, still scrubbing. "This is my last chance."

The next morning, you got out of bed and stood by the door. You didn't want to open it. You didn't want to be disappointed again. Taking a deep breath, you opened the door and looked down. Your boots were overflowing with stuff. Your eyebrows shot up and your heart was full. You brought the boots into your room and dumped out the contents.

It was filled with chestnuts, walnuts, and oranges. No candy.

But that didn't matter to you at all. St. Nicholas came and brought you some goodies. You ran downstairs to the communal kitchen that was shared by all the residents of the student housing.

"Mom, mom!" you screamed in excitement. "Look at what St. Nicholas left me!"

"That's nice!" Mom said, but she didn't look excited. In fact, she didn't even look up from making breakfast.

Beside the stove, you spot the bag of mixed nuts that were recently opened. Next to it, a fruit basket was missing oranges.

* * *

Oh, little one. I remember how disappointed we were.

For the next few weeks, you had wondered if perhaps you were just a bad kid, undeserving of a visit from St. Nicholas. You tried to be extra good, and you tried to hide your disappointment, but it was really hard.

I know by now you have come to realize that St. Nicholas, or Santa Claus as they call it here, wasn't real. That year prior, it was indeed a well-meaning college student who was living one floor below you who had filled your boots. He had realized that the cultural gap would make it difficult for our parents to understand and carry out this tradition, and took it upon himself to not disappoint a child. That was awfully nice of him. It was too bad that he graduated and wasn't around the year after.

Here's the thing, little one: this is just one example of the many cultural gaps that you'll have to live through. It'll be tough at times. Real tough.

This is the advice I can give you:

Your parents love you and they are immensely proud of you. However, they were raised during a time and in a country where food was scarce and running water didn't exist, so something as luxurious as toys and candy in boots was just beyond their comprehension. Mom thought she had indeed carried out the instructions by the kiosk lady really well. To her, nuts and oranges were a treat. As you get older, you'll learn to appreciate these differences, and you'll learn to appreciate their sacrifices. For the most part, you'll laugh at the mishaps of cultural discrepancies.

For those tough moments that continue to sit with you... well...
maybe write about them.

THREE

You will find your tribe. It will be life changing.

In 2008, you'll be living in the big city of Toronto, Canada, working
your first internship, and you'll find a group of theater-loving, board
game-playing, and writing-obsessed misfits who will accept you for
who you are. They will see the authentic you.

From then on, you will continue to meet creatives from all walks of
life in multiple cities, across multiple continents. They will see the
authentic you.

You'll meet your future husband, who will love you unconditionally,
and will patiently tolerate all your emotional baggage. He will
somehow also make it his life mission to always make you laugh. And
you'll laugh. A lot. He will see the authentic you.

You'll also have two wonderful kids who will bring more joy to you
than you ever thought possible. They will see the authentic you.

Through it all, you'll realize the following:

No one will understand you. They really won't.

This is because your lived experience is very unique. But, you will
realize, so is everyone else's lived experience. You will also not be
able to fully understand their internal struggles and all their hang-
ups and baggage.

And that's okay.

They don't have to understand you. They just have to accept you.
They'll accept exactly the person you want to put out to the world.

You can be present in front of them with all your scars, your bruises, your insecurities, and your doubts.

They will accept you for who you are.

They will.

And they do.

It will be life changing, little one, so wait for it.

With all my love,
Yuy

Exploding Into Parenthood

Megan Hanlon

To bring a child into the world, you must explode.

Doctors and midwives claim you bear down, pushing with all your might until the baby slides from your body in a glistening and screaming triumph.

This is a lie.

In reality, you will explode, suddenly and shockingly.

You can attempt to be ready – attend classes, read bestsellers, pepper friends with questions – but you cannot prepare for how thoroughly becoming a mother will destroy you. A building can't comprehend what it's like to be razed.

I knew being a parent would be challenging in ways I had little concept of. The sleeplessness, the inexperience of holding another person's survival entirely in my small hands, the million decisions I would have to make every single day – I expected those unexpecteds. But I did not imagine that motherhood would take so much of *me*.

Before, I moved about the world with independence. Before, I had important views on politics and stray dogs, cable TV programs, and popular restaurants. I enjoyed a vivid life outside of my home, a job

and hobbies and friends. I was a formidable woman, a steel skyscraper with ornate details and glittering glass.

But in the months after becoming a mother, everything in the before was obliterated, pieces hurled for miles. Dust and confusion clouded every blink. The air took on a texture that was difficult to swallow. And somehow, I stood last in all the relief lines. The children's needs must be met first, and then sometimes the husband's, and then sometimes the dog's. I learned to exist in the leftover, occasionally catching glimpses of my tired face in what shards of the old life I could find.

They call this love.

Once the skies cleared, once it got a bit easier, I began trying to put myself back together in new and different ways. I ached to be me again, not just a laundress and cook and slave to the call of mama. But my pieces no longer looked the same. The fasteners didn't hold. All my shines had dulled, and I couldn't find anything of me that wasn't smeared with mother.

There are parts of me I swore kids would never overrun – *this is mine and only mine* – but that's proved futile. My ability to devour a book, my need for time alone to re-center and decompress – both reluctantly squandered. Even my relationships, which I naively insisted would not revolve around my ever-shifting children, are no longer mine. Conversations with other women inevitably drift toward kids and housework, rooms we can't stay out of even if the floors are dirty.

Parenting takes from me more than it gives. Each morning, I am forced to rebuild my own legs and move forward, even while I am no carpenter, even while my children pick at the glue.

Sharing these struggles is often challenged with, *"you chose this. Being a mother is what you wanted."* But who can truly know for sure until it is too late to change your mind?

I promised I would remain myself, a complete person, with children an addition rather than a total renovation. I couldn't have known how far away my pieces would fly in that explosion. I couldn't have seen I'd be too tired and too lost in monotony or noise to know where I should start rebuilding. And I didn't know I'd be continually interrupted once I began.

Nearly nine years after blowing wide open in a hospital bed, my sticky blood pooling on the floor, I foolishly expected to have more of myself back together by now.

I am wrong but still trying.

Some facets of my identity in the before I still work to reclaim; others are permanently lost to memory and longing. Perhaps I can rebuild a majority of who I was, but this life will never be just mine. In all of my spaces are reminders that I belong to others, first and forever.

I stand amid repurposed women — structures suggesting all of us can rise again after demolition if we try hard enough — but I can't see through the windows.

God bless the women who can become whole again after giving birth. I'm not sure I can.

Balance

Lane Patten

Balance is the first glow of sunrise seen far away through the predawn darkness as I drive my car towards the bright lights of the hospital. A tear escapes as I think of the child I won't be hugging before he goes off to school. Does he know I love him? Does he know home is a safe place to land, even if I'm not always physically present? Does he know he will never be alone, even though no one will be there to greet him as he gets off of the bus? He is still so young, only ten years old.

Does my daughter, who is now forging her own path, away at college, see what I've sacrificed to show her what it means to be a working mom? To lead my team as an Emergency Physician? Did I focus too much on my career and not enough on her? The most brutal of all of my training was done when she was a preschooler, with missed soccer games, dance recitals, and Halloweens, with weekends spent with grandparents. Does she see me as strong? Or does she see me as absent? I park my car in the still-empty lot and head for the door.

I shrug on my smile and head for the chaos, diving straight in, no time to waste as I attend to the sickest of the sick. I head first for the stabilization room, where the nurses are already waiting for me to don my mask and gown and join them under the bright lights. I glance at the monitors overhead, muted but waiting for their next patient. The equipment I need for placing the breathing tube has

already been set out on the metal table, ensuring it is in reach if I need it. I can hear the sirens in the distance. The day has started. Thoughts of my kids drift away as I attempt to clear my mind to focus on the task ahead. Broken bones and heart attacks. COVID pneumonia and abdominal pain. Trauma, trauma, trauma... so much trauma.

Balance is moonlight's filmy haze seen through the window as I eat the dinner my husband left for me. It was a long shift, made longer by the absolute lack of resources as we've reached a crisis in health care. We're out of staff, out of room, out of places we can transfer the sicker patients, the ones who need more than my hospital can provide. I am exhausted. My son is enthusiastically trying to discuss the events of his day. My face is listening, but my brain is struggling to stop thinking about the family of the cancer patient, and how my words devastated them. I keep seeing the face of the mother whose child had a near-life-ending asthma exacerbation. I think again of that patient early in the shift. I did have to put a breathing tube into him as COVID ravaged his lungs, making it impossible to breathe. I still haven't found an ICU in the state that has any beds available for him. I left him in the capable hands of my partner, who will now keep calling across state lines as the distances grow further and further, hoping something opens up somewhere. I struggle to listen to the elementary school gripes about math homework and a fellow classmate's inability to sit still. It's bedtime, but who am I to tell my animated son to head to bed when I've only been present for the last ten minutes? Thoughts of the emergency department and its insane challenges drift away as I attempt to clear my mind to focus on my child's words.

My phone dings with an incoming text. It is my daughter, jubilant about an A she got on her first college essay. She is learning to manage her own time, doling it out carefully to the assignment that needs her the most. Did she learn that from me? Did I teach her how to prioritize? She is now texting photos of her new boyfriend. They look so young. Distractedly, I notice his wide smile, how he shines it on her as they smile for the camera, arms around each other. Did I teach her how to be a part of a healthy relationship? When did I last

spend time alone with my husband? I leave myself a quick note: date night is way past due.

I trudge to my bed and lie down, quickly rolling towards my husband, who has been so patiently waiting. I feel terrible that he gets the last five minutes of me before I fall into a deep slumber. We discuss the day briefly. Evidently, it's also time to schedule the annual vet appointment for the dog, and my husband also wants my opinion on the new health insurance options available to us. These are the little things that mark a 23-year marriage. Have the kids been to the dentist this year? Do they fit into their winter clothes? The snow is coming. The daily grind stops for no one.

I would love to do some writing tonight, but if I don't sleep now, I'll have a headache in the morning, and I can't afford to have any less to give. I again attempt to clear my mind as I enter a dreamless sleep.

I'm up again in the middle of the night. Anxiety nips at my consciousness. I must compartmentalize to be good at any of these jobs: mother, wife, Emergency Physician. But can I compartmentalize enough to be good at all of them? Honestly, I don't know. Balance is a paradox. We talk about it, we write books about it, we hold it up as the ideal, yet no one ever achieves it. I'm fairly certain I'm not doing any better or any worse than any other busy mama with a full-time job and never-ending obligations. Really, we're all holding on by a thread around here.

And as always, I wonder, does making everything so important automatically demote its true importance? I will never be able to choose between these roles; they all make up the essence of me. I was told from the time I was small that I could do everything I wanted to do. I could be whatever I wanted to be. There was no ceiling that couldn't be shattered, if only I wanted it badly enough and was willing to work hard enough. It's only in my later years, after having achieved my goals, that I see the parts of that statement that were left out in the original telling.

You can have it all, but there is a price.

The more you achieve, the higher the tightrope that you walk. Balance is the goal, but it is also wickedly elusive – the short-lived flicker of a firefly on a balmy summer night, the flash of lightning across the storm-darkened sky, the fiery glow of a dream you can barely remember upon awakening. What I do know is that I will get up tomorrow before the sun rises, and I will do it all over again – the important, the heart-wrenching, the exciting, and the mundane. I will give it my all. And it will have to be enough.

Postpartum Google Searches

Tristan Tuttle

- How much hair loss is too much hair loss?
- How much do plumbers charge to unclog drains?
- Spicy foods affect/effect breast milk?
- When to use affect or effect?
- How to hand express breast milk?
- Best formula to supplement with?
- Formula recall?!?
- Gentle parenting vs. spanking
- How to keep toddler from accidentally smothering infant sibling?
- Safe co-sleeping practices
- SIDS
- When will I stop accidentally peeing?
- Local pelvic floor rehab center
- Cost of professional pelvic floor rehab?
- At home pelvic floor exercises
- Why am I so angry postpartum?
- Postpartum depression
- Postpartum anxiety
- Postpartum rage
- How long can a person go without sleep?
- Is it safe to drive on no sleep?
- When do babies sleep through the night?
- Cry-it-out method
- Sleep training
- Momcations
- Best beaches in USA
- Airline tickets
- How to lose the baby weight?
- How to calm a crying baby?
- How to calm a crying mom?

Breakdown

Where the Wildflowers Grow

Tristan Tuttle

My former gynecologist's office offers a procedure called Labia Beautification, as if a woman's body is an official government project.

Just a sad stretch of highway in need of litter pickup and wildflowers planted.

As if my children are not wildflowers enough.

Prepare Me Not

Shell Sherwood

No one prepares you for the sacrifices
A fathomless echo among my tribe
These futile words remain trapped in my mind
Barbaric twisters that rarely cease
A spitfire phrase igniting rage
Bursting aspirations in friendly fires
No one prepared you
No one prepared me
But I've realized – whoever could?

Who would volunteer to be the reaping knight
Racing to rescue the mothers of the world
To deliver a menu of sacrifices
A tradesman of prospects and umbilical cords
Allowed to grant miracles or dreams, but not both
Sometimes persuaded to leave nothing at all
A demented carnival game of feminine way
So skillfully constructed
Our mothers never saw the chains.

I lost the game again today
Another career slipped through the cracks
One positioned at pedestal height
I'd built the ladder grain by grain
To finally grasp this romantic idea

Of having it all in the snow globe of life
Congratulations, you have been chosen
A place to thrive, to age, to flourish
The wax seal on my future.

But the wax soon chilled
And the stamp lay shattered
By the almighty fluttering
Of unexpected life
Unphased by any seeded plan
I left the notice stained with tears
Next to the stick with too many lines
Another dove compelled to prosper
My feigned heart, beating in rhythm.

It's not your time
Your place is here
These blessings need you
There will be others
It clearly wasn't meant to be
Your path will show itself in time
Motherhood is like that, as you know
I didn't
I did not.

What choice could I have made
With a carnival menu of sacrificial tricks
Which ones would I have locked away
Which ones would I have left to the wind
The humor in it all is hope
I would have thought the choices lies
Paraded away to live out my dreams
After all
No one prepares you not to.

No one prepared me not to.

Mother's Day

Kristin Yates

Mother's Day is standing at a podium in front of a room full of my esteemed peers, five minutes into a speech that could redefine my career trajectory, and feeling a sudden unhooking, deep in my belly, and a warm gush of blood crest the top of my thighs, and instead of falling apart, I just start thinking tactically. I am wearing black pants and dark shoes. The lights are low so that people can read the slides behind me, and my dark trench coat is slung over a chair next to the podium. I can get it on before the lights are fully up. Nobody will notice. I've lost other pregnancies, and I know how to cover this up. How to retain a little dignity. Nobody in this room knows I am pregnant. I can keep this a secret. I can do this, I think, get out of here without anyone the wiser, and so I do.

Mother's Day is the first pregnancy I lost, several years previously, curled up on the cold tile floor of my bathroom, my husband asleep just twenty feet away and blissfully unaware of what was happening while I cried into a towel to muffle my sobs. When I had the strength to move, I used that towel to mop up the blood, then stuffed it into a garbage bag, along with the pajamas I had been wearing and the bathroom rug, and took it all out to the trash in the alley. I told him, eventually, a decade later.

Mother's Day is all the people who asked me when I was going to have a baby, at least twice while I was in the process of miscarrying a

pregnancy – two separate pregnancies actually, and two different askers – because the universe has a real sense of humor about sending someone along to say the worst thing possible at the worst possible time. Twice. Mother's Day is about how it turns out that miscarriage isn't an act with the kind of discrete boundaries you might expect, and so I have to go to work and bleed, get groceries and bleed, walk around in the world and see a million other women pushing baby strollers to remind me of my own failure, while I bleed out every tender little dream and wish.

Mother's Day is no more fucking around here, and it's time to roll up my sleeves and really throw science at this problem, and five injections a day – I do them myself because my husband is squeamish – trying to trick my body into thinking it is strong enough to sustain a pregnancy. It's also my cardiologist yelling at me about pushing my limits, and my reproductive endocrinologist encouraging me to keep trying, loss after loss after loss. It's walking around with giant rings of bruising around both thighs and my belly from the needles, and welcoming the morning sickness, because it's a good sign, the best really, that this time this pregnancy will take. Then it's also lying on a gurney in the emergency room a week later, while a nurse yells at me to keep my eyes open and focus, but really it seems like a much better idea to ignore her and just drift around in my own head for a bit; kick off from the shore and float for a while and let all the yelling people and bright lights float away, too.

Mother's Day is the nurse who insists on telling me her guess about the sex of the baby, and watching the oddly smug expression on her face as her words rip my heart out.

Mother's Day is about how badly I needed a mother while I tried to become one; how desperately I needed a woman to put her arms around me and lend me her strength and let me cry after each failed pregnancy. Mother's Day is about how I finally did become a mother, but only because a merciless God ripped another family apart, sending their children helpless into the world in a whirlwind of pain and suffering. Mother's Day is how I spend the day comforting my

children on the loss of their birth mother while I stay silent on the loss of my own.

Mother's Day is a slip of paper hidden in my jewelry box, the ink faded and the folds gone soft with age. Some entries have names, though most are just scribbled dates, all of them wanted and cherished and wished for and dreamed about. Mother's Day is that secret record. You mattered, every one of you. You were loved. You are loved.

Sacrifice

Cara Howard

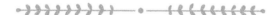

1. a decision to suffer inconvenience in order to achieve a higher purpose

I woke up filled to the brim with adrenaline, ready for battle. My 5-year-old, Becca, had been less than cooperative at her dental appointment six months prior. This time, 2-year-old Ben would also get an exam, so I invited my mom, the kids' beloved GaGa, along for moral support.

Betting on his easygoing spirit, I had Ben go first, and hoped his sister would fall in line. He threw one leg up and hoisted his body into the dental chair, slid across the vinyl, and relaxed into its reclined position. Opening his mouth into a wide "O," he stared up at the ceiling and waited.

"That's right, honey," I told Ben. "You'll open up just like that so the dentist can check your teeth." He turned his head toward me, mouth agape. "But you can close it until she's ready."

My mom and I tried to suppress our laughter. Becca sat on GaGa's lap, happily swiping through photos on her iPad, grateful not to be in the hot seat.

Ben held this position until his exam began. He didn't complain when the dentist stuck her gloved finger into his mouth, pointed at

each tooth, and sang her own version of the A-B-C song that identified and counted them all. In no time, his turn was over.

"Great job, buddy!" I told him, hoping my praise would inspire his sister. He hopped down and climbed up into my lap. Becca took his place in the big chair.

I held my breath while she got settled. Her serious expression made me nervous, but to my surprise and relief, she cooperated: no fussing, tears, or tantrums. My strategy had worked!

"I am so proud of you guys," I said, as the four of us rode the elevator down to street level. "You were so good for the dentist."

"We even got prizes!" Becca said, beaming. She held out her wrist to admire the pink plastic bracelet she'd scored in the vending machine with her token. Ben clutched his own new treasure, an orange rubber bouncy ball.

GaGa spoke up. "I think we should go out to lunch to celebrate. What do you guys think?"

"Yeah!" they cheered, skipping ahead of us toward the building's automatic front doors.

The crisp March air drew the day into sharp focus as we walked outside together. I took a deep breath and soaked in the changing season's first strong rays of sunlight. "Put your prizes in your pockets," I told the kids.

Happy chatter floated up to my ears from both sides. I stood sandwiched between my little ones, with my mom at the end of the line, connected via the tiny fingers of my daughter. Linking hands, we formed a chain - big, little, big, little - and stepped off the sidewalk.

Glancing to my left and right, I acknowledged the lonely purple Chrysler, a PT Cruiser, idling a hundred feet away in the space

between the medical office building and the rows of parked cars. The flat backside of its distinct old-timey design faced us. No vehicles were approaching, so I called out, "All clear! Let's go."

When I think back, it's the sound I remember. The background crescendo of the engine was otherworldly, distant and haunting. Like a growling beast's roar, it rumbled louder and louder. My subconscious blamed an overloaded semi speeding past on the nearby highway. Until the eerie sound was silenced by a thud.

2. the surrender of something valuable for the sake of something else, considered as having a higher or more pressing claim

Interlocked fingers released on impact. My mom and Becca disappeared from my peripheral vision and laid at my feet, sprawled on the pavement. I sensed a looming presence behind my right shoulder and reflexively knocked on the back of the vehicle with my fist. My empty right hand reached down to pull Becca back to standing.

When my eyes registered the contrast of my mom's clean white hair against the gritty black tire, I realized: *My mother has been hit by a car.* Less than one more revolution of that wheel would crush her.

I screamed, "Mom, get up!" and stuck out my hand for her to grab.

She stared up at me. In a small voice, she said, "I can't."

I took another look and figured out why. Sticking out of her pant leg where her flesh-enclosed ankle should have been was an ivory rod. Stripped of its skin, the stark white bone exposed to the air embarrassed me with its lack of modesty. *Where was her foot?* Left behind, it stayed firmly planted in the leather clog she abandoned in mid-stride. Dark red drops fell, forming a circle on the hard ground. I marveled that so little leaked from what appeared to be a severed limb.

Time paused and flipped a switch, jolting us onto a new set of tracks headed in an unexpected direction. My mind lagged behind, stuck in our previous reality, the one that made sense just seconds before. I struggled to connect the dots and assess the current threat level.

My mom's injury was obvious to me, but not to her. Shock had done its job, shutting down signals from severed nerves at the onset of the emergency. From her vantage point, she could only compile clues to determine the severity of the problem: the scream escaping from my lips, the shuffling shoes of strangers, the wailing high-pitched sirens. Lying still on her right side, she was conscious, coherent, calm... and confused.

The graphic sight imprinted in my brain. I feared it would become the wallpaper of my mind, the image that would appear every time I closed my eyes to try and sleep. My reckless imagination rushed ahead toward possible outcomes: surgery, amputation, wheelchairs, prosthetics, loss of independence, internal injuries, even... the beginning of the end. The disconnect between what I saw and what I heard coming from her lips added to my sense of dread.

Becca whimpered softly and snapped me back to the present. Tugging on my hand, she pointed out the new hole in her pink knit pants that exposed her skinned knee. "Mommy, my knee! It's bleeding," she said. "It *hurts*. And my hand hurts too. I fell down." She held up the scratched palm that had saved her from hitting her head on the pavement. Ben stared at his sister with concern.

"Let me see, honey," I said, bending down to check her knee and examine her hand. "Ouch! I'm sure that hurts, but I think you're okay."

Suddenly, it dawned on me: my little ones hadn't yet seen my mother's gaping wound. This knowledge burdened me with an overwhelming sense of responsibility. I couldn't predict the level of loss they'd experience from this collision, but there was still time to protect them from this sight they might never unsee. I possessed the power to limit the collateral damage.

In my unstable mind, the blacktop quaked and separated under my feet. I straddled the growing divide, struggling to maintain my balance. Most marks on our timelines are faint at first, best identified in hindsight. This one slammed into me and stared me in the face, threatening to divide my life into *before* and *after*. I'd stumbled upon a milestone of motherhood. I would have to choose who to comfort and protect: my mother or my children. Slowly, I turned toward my children so that my body blocked their view.

3. an act of kindness that comes at a significant personal cost

I was standing there, frozen, when a stocky, middle-aged man in a navy blue coat rushed over. He knelt on the ground beside my mom and started asking her a series of questions. After a moment, he noticed my puzzled face and informed me that he was an off-duty paramedic.

"I had just gotten out of my car and was about to walk toward the building when I saw the accident happen," he told me. "I can wait here with her until help arrives."

Just then, I felt a hand on my shoulder. I turned and saw a woman wearing lavender scrubs. She introduced herself to me as Lesley, and explained she was a nurse who worked in one of the offices in the building.

"Let's get you and the kids out of the street," she offered. I nodded. Together, we ushered my kids toward the strip of grass next to the building, and left my mom in the care of the helpful stranger.

I felt torn, unsure whether I should have left my mother's side. But my guilt evaporated when I realized I'd done exactly what she would want me to do. "The kids come first" had been her motto throughout my childhood. She embodied and modeled this self-giving love while raising me and my brother, and now it extended to my children, too. Even though it broke my heart to walk away from her pain, I knew she'd agree that my babies needed me more.

Huddled together with our backs to the wind, Lesley and I formed a protective human wall around my kids. Ben peeked out of our circle and saw the red and blue flashing lights. "Eese car!" he exclaimed, pointing to the police car behind us, parked in front of where my mom was still lying on the pavement.

The rest of us turned to look just as an officer opened his door and stepped out. He exchanged some words we couldn't hear with the paramedic, then caught my eye and started heading toward us.

"I think the policeman needs to talk to Mommy for a few minutes," I told the kids. "Can you guys wait right here?" They looked up at me and responded with almost imperceptible nods. Leaving them with Lesley, I went to meet the officer and gave him my statement.

When I returned, Lesley suggested that we get the kids out of the wind so they could warm up. She walked with us to my minivan, and I drove us all closer to the scene. Once there, I parked, opened the sliding back door, and stood there trying to distract the kids with conversation while they stayed buckled into their car seats.

Ben chattered on and on about the firefighters, but I couldn't focus on his words. I was busy offering up silent, pleading prayers. Finally, I interrupted him. "Hey guys, let's say a prayer for GaGa." I squeezed my eyes tight and led them in a short prayer, hoping my voice didn't betray the terror I felt. Afterward, I opened my eyes and noticed the kids staring at someone behind me.

I turned around to see an older woman in a white, puffy coat. Her face was drawn, and her cheeks were wet with tears. She locked eyes with me and asked, "Are you her daughter?"

"Yes," I said slowly, "that's my mom." My throat caught as the words left my lips. I realized in that moment who this woman was: the driver of the car.

She grabbed and hugged me before I knew what was happening. With my ear pressed against her shoulder, I strained to understand her words through her muffled sobs. "I'm so sorry," she cried. "I didn't see her. I just didn't see her."

She finally let me go and explained that she had been late to drop off her 90-year-old mother at the building for chemotherapy. While backing up to snag the handicapped parking spot she'd driven past, a horrible noise made her hit the brake. "I knew I'd hit something," she told me, "but I couldn't believe I'd hit some*one*."

Her earnest apology completely disarmed me. On any given day, I could have been her: distracted, running late, guilty of an impulsive act that had irrevocable consequences. I felt my kids watching me closely, waiting to see what I would do. I knew that this was a moment I would never get back. I knew I might never see this woman again, so I said the words I wanted to mean – "I forgive you" – and a weight lifted off my chest.

The paramedics loaded my mom onto a stretcher and wheeled her into the ambulance. The police officer came over to tell me the name of the hospital where they would take her. "You'll want to get her checked out, too," he said, nodding in Becca's direction. "Just to make sure."

"Yes, of course," I told him. As he walked away, a wave of exhaustion swept over me. I blinked back tears and let out a sigh, steeling myself for a long day ahead.

"I know we just met," Lesley began, "but I'm worried about you driving right now. You're still in shock."

A tear slipped out and ran down my cheek. "I'm worried too," I admitted.

She put her hand on my shoulder. "I was about to go out for lunch with my co-worker, but I'd be happy to drive you and the kids to the

hospital in your van if that would help. I can ask her to follow us, and she can drive me back."

This is crazy, I thought, *I don't even know this woman. But me trying to drive right now might be crazier.*

"That would be wonderful," I told her. "Thank you."

When we checked into the emergency department, the woman at the desk led us to a private room in the pediatric wing. There, we waited for an x-ray to confirm that there were no broken bones in Becca's hand. Someone wheeled in a cart full of new children's books and invited each of my kids to choose one. Becca and Ben flipped through the pages and snacked on some pretzels I'd discovered in our diaper bag as I texted family members. My husband left work, and brought lunch for me and the kids. A half hour later, my mom's cousin Jane showed up to wait with us.

While we were eating, a nurse knocked on the door of our room and asked me to step into the hall. She informed me that my mom was being prepped for surgery to repair the compound fracture. I must have looked confused because she went on to explain, "That's the medical term for her injury. The impact fractured her leg bone at the ankle and broke the skin, causing the wound to open."

I shuddered at the memory of what I'd seen. "I couldn't even see where her foot was still connected," I said. "Will they be able to reattach it?"

"That's what the surgeon will do today," she said. "We won't know the extent of the injury until after she's out of surgery, but she's right where she needs to be. Don't worry. She's in good hands."

A lump rose in my throat. I swallowed hard, then asked, "Can I see her?"

"Of course," she said. "Once she's all ready, I'll come and get you."

I went back into the room to find Ben in his stroller, munching on some french fries. Becca had finished her nuggets and was writing a note for her preschool teachers. I told Jane and Bill what the nurse had said. While they helped Becca spell the words she wanted to write, I looked up the term *compound fracture* on my phone.

A medical website I found listed the most common scenario resulting in this type of injury to be a pedestrian struck by the bumper of a moving car. I read on to discover that the risk of complications was high, infections were probable, and recovery would be long and painful. My heart sank.

As I absorbed the reality of my mom's condition, Becca patted my arm and handed me a piece of paper. "Look at the note I wrote, Mommy."

With a pencil, in all capital letters, she'd carefully written: "TO MISS SHAY AND MISS LEAH, REBECCA IS OK. I GOT BUMPED BY A CAR. MY GAGA IS OK. I LOVE MY WHOLE CLASS. I LOVE YOU."

"Do you like it, Mommy?" she asked in a hopeful voice.

I wrapped my arms around her and squeezed tightly, trying to suppress my impulse to sob. I closed my eyes and took deep breaths until I managed to collect myself. When I released her, I took her little hands in mine.

"I *love* it," I said, looking into her eyes and mustering a small, tight-lipped smile. She smiled back, pleased, then picked up her new book. My heart throbbed as I watched her peacefully absorbed in the story, her little feet dangling off the edge of the chair.

4. a painful offering made out of love for another person

A little while later, the surgical nurse led us down the long hallway to spend a few moments with my mother before her surgery. Lying in the pre-op waiting room, her face was as white as the sheet that

covered her. Her panicked eyes relaxed when they came to rest on the children I carried on each hip. She couldn't talk, but her relieved sigh told me: We were there. We were whole. This was all that she needed to know.

Bending over her bed, I found a space between the tubes and kissed her cheek. I lowered my kids to the mattress, one at a time, so she could squeeze their tiny fingers. Then I navigated our way back to the waiting room through blurry eyes while they wheeled her away.

Our pedestrian lives were interrupted, my kids' sense of security, threatened; my own, lost. Never before had my roles collided in a single instant. But our unexpected tragedy revealed to me that I had been well prepared. My maternal instincts aligned with my own mother's heart. Love was a knee-jerk reaction, and sacrifice, a reflex, part of the job description. Even when it meant letting go of one another's hands.

Bereft

R.H.G.

If this were a perfect world, we would still be there. I wish so deeply to go back to those mornings, *our* mornings, the mornings we had before you became ill. I would wake up to the sound of your little footsteps approaching my bed, and we would cuddle for a moment, your head resting on my chest and my nose burrowed in your hair. Your little fingers and toes were always so cold in the mornings. Then we would go to the kitchen, where I would make pancakes like I always did, and you would exclaim, "Pancakes! That is my favourite. Thank you Mommy!"

We would laugh as the sweet aroma of my morning coffee filled the air, and the warmth of the sunshine saturated the kitchen. Somehow, in my memories there was always sunshine, even on the cloudiest day. Maybe it's just because we were together. But this is not a perfect world.

I wake up alone with no sounds of footsteps, no morning cuddles, and no cold fingers or toes to warm up. I go alone into the dark and gloomy kitchen, where no laughter awaits me. The bitter smell of my morning coffee fills my heart with dread and sorrow. I make the same pancakes just as I made them for you, but I eat them alone, while I look at the empty chair where you should be. Somehow, these days it's always cloudy outside, even on the sunniest day. Maybe it's just because you are not here anymore.

The Empty Cup

Emmy Seal

"You can't pour from an empty cup." Well-meaning people say it all the time. While that makes sense, I had no idea how to solve the problem.

"You can't pour from an empty cup." So we count running an errand without kids as self-care, as if just because a tiny human isn't hanging off her leg, it's equivalent to silence on the beach.

"You can't pour from an empty cup." It's bullshit.

"You can't pour from an empty cup." I can't even remember a time my cup was half-filled. I think it was the hour or so before I got the initial positive pregnancy test eight years ago.

"You can't pour from an empty cup," they say without lifting a finger to help.

"You can't pour from an empty cup," as they pat my back and say I'm doing great.

"You can't pour from an empty cup," as they console the tears when I feel like I've failed for the hundredth time today.

"You can't pour from an empty cup," but no one offers suggestions on how to fill it up.

"You can't pour from an empty cup," so I guess I'll refill with coffee again.

When My Dad Died

Allie Gravitt

Saying our relationship was strained is much too kind and palpably cliché. Our story was hard and broken and unfinished, riddled with addiction and abuse and absence. I don't remember spending any time alone with my dad in the last two decades of his life. The only real connection he'd been able to forge with me over the years was through music. He leaned into that when he didn't know what else to do – I suppose because it was one of the few things that he understood about me.

When I was 8, he took me to see Bob Dylan at the Warner Theater in Erie. It was my first concert – on a school night – and I thought it was the coolest thing I had ever done. I wore a harmonica pin on my denim jacket for weeks. In the following years, he took me to see most of his favorites. Phish. The Grateful Dead. Jeff Beck. Santana. When I was old enough to have favorites, he would brave those shows too. Sorry for inflicting my lesbian rock phase on you, Dad.

When I was 14, he brought me to D.C. to see Fleetwood Mac on the last stop of The Dance tour. I remember almost everything about that night. I remember Stevie Nicks' voice sounding hoarse. I remember not being able to afford a hotel, and driving four hours back in the middle of the night. I knew it wasn't easy for them to do it. I rode that high for weeks.

I know he tried to love us. I don't think he had any idea how to do that, and his life was spent trying to avoid his own demons. My memories include bongs on the coffee table, dugouts in the cupholders of the truck, and the ice hitting the glass for mixed drinks every night – vodka, cranberry and orange juice when I was little, and then Jack and Coke later on. We mixed cranberry and orange juice in our glasses as kids to be like him.

When I was 17, he said he would quit for the first time in my memory. For the rest of his life, every time we talked he was "quitting."

I wanted to believe him. I did my best over the years to forgive affairs and abuse – to ignore his absence. To pretend I didn't understand what it meant when we got a Christmas card from Celine. I asked who she was, and my mom tensed up. "Ask your father." I was twelve. I understood.

I believed grace meant refraining from judgement, even when my parents' marriage fell apart, even when he didn't show up for my college graduation… especially when he invited me to his "wedding" in the Outer Banks less than a year after my mom had thrown him out. That wedding, incidentally, never took place. My parents' divorce wasn't final yet.

There's something unique about the absence of someone who is always around. I didn't know him and he didn't know me, but the proximity to his demons had broken me. I believed the things he said to me, even when I knew I shouldn't. That's what children do. The toxic dynamic had to be broken. The week I moved to Washington, D.C. for a job was the week I cut ties completely.

At some point, he remarried. Messages came from his wife on holidays, always an attempt to manipulate me into a visit. I would feel pangs of guilt. *Maybe it was me. Maybe he's different. I have to show grace.* I never responded, though. I told myself that I'd know when I was capable of showing grace. I still didn't think I could.

A decade of brokenness passed. Holidays spent with friends. Holidays spent alone. The lingering notion that I would get a call that he was dead was always there. What would I do with that? I didn't know.

The year after I got married, I got a message that I chose to respond to. My dad had been diagnosed with late-stage liver and lung cancer, and they gave him six to 12 months. Maybe.

Everything else aside, I wanted him to meet my husband and my son.

So, a week after I got the message, we brought our kids up to North Carolina. I had no idea what to expect. How do you navigate a reunion when you know that it will end in death? I sat on a plane – my head and teeth throbbing with a massive sinus infection, a tired toddler flailing across my lap – and laughed at the absurdity of what I was doing. I was bringing my husband and son to meet my estranged, dying father for the first time, and I wasn't even sure I wanted to see him.

As we approached the house, I realized I had no idea what we were heading in to. I had no idea what his house was like or how he lived. I relaxed slightly when we were greeted by his wife in the driveway. She was sweet and upbeat in a way that was either superhuman or naïve; I wasn't sure which. I'm sure she wanted us to have the best visit we could possibly have under the circumstances. I'm not sure how it would have gone without her.

My dad, however, was a smaller, tired, weak version of the person I remembered. He looked much older than his 58 years, and was obviously in a ton of pain, trying not to show it. We visited for a few hours, and I found that I was able to separate the past from the present, if only for the few hours we were there. I could separate the years that I spent fatherless – wishing that I had a "normal" family that spent holidays together, and didn't miss college graduations and weddings and the birth of their grandchildren.

It's a different kind of loss when you've already grieved the death of the relationship. I'm not going to miss weekly phone calls — we never had those. I won't miss holidays — the last Christmas I remember with him was when I was 17, and I spent it locked in my bedroom. He missed every critical event in my adult life. I spent 10 years releasing that, and didn't expect an apology.

What I did want was context for my husband. I wanted a picture of my son with his only grandfather. I wanted his wife to know that her love for him was appreciated, and that she had support. Most importantly, I wanted to show grace to a man who rarely received it or deserved it. He could be forgiven. He was loved, despite everything.

So, I let my son play with my dad's dog, and he learned how to spin circles in his kitchen. I pretended not to notice the pipes on the coffee table. I brought my dad his favorite white pie from J&S Pizza, and we ate ice cream while he sat on the couch in his Grateful Dead shirt.

He didn't say much, but I did smile when he finally asked me what music I'd been listening to.

I guess, in this situation, that counts as closure.

Honest

Hannah Godfrey

I had this friend once,
Bonded over an insatiable desire for
The truth.

>> I tell the truth
>>> Whether you like it or not,
>>>> She said.

We were babies then.
> Eighteen,
Nineteen.

She was my person.
> She had people.

She walked with me through fire.
My personal hell.
And when we came out on the other side,
I thought
I'd take the flames for her
Any day.
If she needed me.

We grew up.
> Twenty-five,
Twenty-six.

I said,
I'm pregnant!
Getting married!
 Congratulations.

Be my bridesmaid?
 Okay.
 Weeks pass.
 I can't, followed by an excuse which
 I accept.

What's wrong?
 I'm fine.
See you at the wedding?
 Okay.
 But on the eve,
 Can't make it, followed by an excuse which
 I accept.

Come to my baby shower?
 I'm unavailable.
 I accept.

Are you okay?
 I'm fine.
Come meet my son.
I carried him without you,
Brought him into the world without you.
The least you can do...
 Fine.

Tell me the truth.
What happened to us?
When did the truth become less desirable?

 She was going through something
 And didn't feel she could be honest with me.

Some friendships are worth holding onto
When you travel through fire.

 She has people.
I have this pen,
This paper,
Crippling self-doubt,
And burns.

Am I a bad friend?
Eight years too many?
Tired of my shit?

Maybe our friendship was never as
Honest
As I thought.

A Neighbor's Gift

Frances Lu-Pai Ippolito

"My neighbor gave me a gift today." My 65-year-old mother told me over the phone.

It was late May 2021, and the weather where I was in Portland, Oregon, was hot but beautiful. With the phone pressed by my shoulder to my ear, I looked out my home office window to the front yard, where a mature oak tree stood tall with a canopy of starry-lobed leaves. Beside the great oak crouched the little fig, with the beginnings of fruit budding between its leaved gloves. Around them, the strawberry vines weaved a carpet of pink and white flowers that drew bumble bees to perch on pale yellow pistils to gather their nectar.

I tried to imagine what my mother's garden was like in Los Angeles, where she lived in the vibrant Chinese-American community of San Gabriel Valley. I hadn't seen her garden on the backyard hill in nearly two years, because we hadn't seen each other in-person, had a meal together, or hugged in that same amount of time. Even though she had just received her second vaccine dose, neither one of us wanted to chance transmitting COVID to her before I and the rest of the family was fully vaccinated.

Back on the phone, I was curious about the gift. "The neighbor with cancer? Who never comes out of her house? Did you wear a mask?" I asked, concerned for both of them. By age, my mother was already in a high-risk bracket, and had high blood pressure and diabetes

added to that mix. Even so, it seemed even more dangerous for the immune-compromised woman next door — who was fighting cancer and mothering a toddler — to interact with non-household members.

"Yes. She and I wore two masks and gloves. We stayed outside."

Some of the tightness that I didn't know was wound up in my chest released. "That's nice of her. Maybe I should get her something too and have it delivered to her door?"

"No need. I gave her pomegranates from my garden."

"Good idea." My mother's juicy pomegranates were always the size of grapefruits. "What did she give you?"

"Pepper spray. A lot of bottles," my mother answered.

"Pepper spray?" *What a strange thing to give.*

"She told me another Asian woman was attacked in the store. She gave me the pepper spray for when I take Bee-Bee on walks. She wants me to be careful."

"Yeah..." I trailed off.

My neighbor was right. There had been attacks — beatings, thefts, and lots of the usual name-calling. And months earlier, eight people were gunned downed at a spa in Atlanta, Georgia. Six of them were Asian-American women with faces like my mother's.

"She gave me too much; I'll send some to you. You have kids, you have to be careful. Don't go out. Your husband can go to the store. You should stay home. It's safer for him," my mother suggested, and then added, "You never listen to me."

I bristled. The rebellious teenager roused, ready to argue that I was plenty capable of taking care of myself. After all, I was in my 40s, and

a mother of two children myself. Didn't I need to teach my son and daughter that women shouldn't be scared to be women?

But I bit my tongue. As much as I hated to admit it, my mother knows parts of me better than I do. Maybe it's because she recognizes those parts in herself.

The truth was: after Atlanta, I *was* scared, afraid to go out alone to the playground with my mixed-race children if my white husband wasn't with us. Because if he was there, then by sheer physical adjacency, we might be protected by the gloss of his whiteness, that by being near our children, they could wear his skin like a protective cloak to make themselves invisible if someone full of hate walked by.

I was angry and ashamed at these secret thoughts and feelings I struggled with, mad at having to be even more vigilant about how people saw and treated me and my children based on how they viewed our bodies. Ashamed to always feel this burdensome weakness. Yet the fear of having my children attacked took all the space in my chest. Fear does that. It stuns you, pushes you down, and tries to smother the life out of you – pinning you to the pavement with a knee kneeling on your neck until you finally forget how to breath.

Naively, I assumed my mother would be immune from any real danger in the concentrated Asian-American community of Southern California. The reality is that it's not about "real" danger (though the danger is always real). It's about the Fear that is always there, both collecting and collective.

And on that phone call, my fear only expanded to blanket my mother's home, her garden of ripe oranges and sugar canes, her neighborhood, her stores, and a kind neighbor who gave her gifts.

I thought all these things, but kept them to myself. I didn't want to upset my mother. She was particularly anxious after Atlanta. And this far away in Portland, I felt helpless, unable to physically be with her or to emotionally reassure her that the danger was minimal.

So instead of saying what I felt, I told her, "I can get pepper spray here. Do you need more? Do you have enough? Make sure to bring extra if you go out."

See what I did? I lectured her, rather than letting her lecture me, and switched the roles as mothers and daughters do when they argue easily, but have a hard time saying "I love you."

"I have enough. I am worried about you." There it was again, the flipping back of the roles. I stared out of the window once more, trying to find peace and delight in the same garden view. But I'd lost the moment. The sweetness of birdsong was there, but muted by the growing thunder in my chest.

"Are you afraid?" I asked. Flip.

"Of course not!" she retorted. "If something happens, something happens. I'm not afraid. But you... your children are still young. You have to be careful." Another flip.

Suddenly, I felt very tired. The kind of fatigue that worms into the bones. "I'll be careful. Talk to you later. Be careful too."

I didn't wait for her to answer before I ended the call, and set the phone down on the desk. Then I stood up — restless and unable to concentrate on the work I had planned to finish. Instead, I pulled the blinds closed, and shut out the garden, the hopping birds, dancing bees, pink flowers, and the silent sentinel oak tree.

Is this what it took to be safe? Another layer of hiding on top of hiding? An avalanche of burying until no one sees you, but you're left without air?

After the Atlanta shooting, friends called to check on how I was doing. Many apologized. Some said they assumed that Asian-Americans didn't count as a marginalized community because of perceived academic, financial, and professional success. Others

were surprised that they'd never heard about any incidents against Asian-Americans.

Though I appreciated the concern, love, and care that my friends sent my way, the experience was a revelation. Violence against Asians was not a surprise to me. I had my fair share of experience pre-pandemic. But what was different this time was the level of increased reporting and the acknowledgment that, perhaps, Asian-Americans had it bad too. Certainly, reporting is up. According to a new study from the Center for the Study of Hate and Extremism at Cal State University San Bernardino, in 2020, anti-Asian hate crime increased 146% across 26 of America's largest jurisdictions, that comprise over 10% of the nation's population. In New York City, reports of anti-Asian hate crimes increased 223% in early 2021. However, these are *reported* crimes. From my own experiences, I knew that most incidents aren't reported. Most of the time, there is a cultural tendency, at least in my family, to stoically bear suffering because of the pain passed generation to generation from diasporic colonialism and displacement. And, at the root of it all, there is a self-flagellating belief that there is a price to pay for being American.

Soaking in a well of Fear is consuming. I let myself indulge for a moment or so before the Anger (and if I'm honest, Rage) took over. Why did I have to hide? Was my role in all this flipping to become unreported and unseen? And so I picked up a pen (metaphorically, because I mainly type), and began to write during the pandemic – not to become famous, wealthy, or sell a million copies, but only to be. To exist. To be visible. To throw one pebble-sized story at a time into the chasm of disparity between which voices are loudest and heard and those that are historically silenced. The pebbles I write are little gestures, like a neighbor's gift of pepper spray. But what they represent is much more: A flipping of roles from being afraid (which I always am) to pushing back. Because if we throw enough pebbles, we can start mending and filling in the holes.

Carving Up My Love

Kate Loveday

Carving up my love for you three ways
Tracing the blade close around my apple heart
Peeling it in one long despairing coil
Unraveling
Everything I knew to be true
Delicately decanting our love
So that not a drop of its purity, its boundlessness,
its blind faith, is ever spilled
I will pour it into our beautiful children
My world
While you are gone

The Blades

Heather Carter

The brightest sunlight, golden and glittering
Shines from above upon my dark bittering
Knives like teeth that cut my bone
Protrude from my back, finding their home
The veins of silver within the crag
Beneath me and my travelworn rags
Tells the tale of beauty in darkness
Of precious things that live in starkness

I lift my chin and cry to the sky
Why have I been left here to die?
We danced, we smiled, they once called me fair
But sharpest of words have rendered despair
So, to this spot, I've crawled, and I've staggered
Dripping with blood from a spine full of daggers
Clutching the ground, summoning strength
My tongue utters mercies of uncommon length

I draw in the air; I draw in the light
I draw in an impossible volley of might
One by one, I pluck out the blades
They clatter on stone and slide into shade
The pain is consuming but so is relief
As agony of bitterness gives way to grief
The light is a blanket, tending my wounds
Today I am weary, but strength will come soon

I Don't Want to Drown

Hannah Godfrey

Recently, I was rear-ended for the second time in three weeks with my toddler in the car.

I, a woman of 30, burst into tears just like I, a girl of 16, had the first time I'd had a collision. There'd been tearless collisions in between. So why did this minor bump cause a disproportionate response?

My first thought after making sure my son was unharmed was, *There must be something wrong with me. I am either a terrible driver or terribly unlucky.* I'd been waiting for an opening to pull out onto the main road, not even moving either time I'd been hit... just waiting, like a sitting duck emitting some sort of unfortunate magnetic pulse to draw other bumpers to mine.

The driver who hit me said he thought I'd gone. Should I have? I couldn't remember what exactly I'd been thinking about when it happened. My mind had been cycling through 182 different thoughts so quickly. *Maybe I should have gone.*

We had been running late for school. I couldn't get my toddler dressed and sun-screened and tooth-brushed. When we were hit, my second thought was, *If he'd just let me get him dressed, we wouldn't have been late. We wouldn't have been here at this exact wrong time.*

I already felt guilty, because my husband had to help me get through the morning routine (effectively making him late to work – another thing to feel guilty about, and somehow, his boundless patience with me only makes it worse). But I needed him; I couldn't manage our son's temper tantrum. I couldn't parent.

And now I was going to blame my toddler for this car accident? Guilty. My third thought: *No, no. It was me. If I'd handled the situation better, we might have left on time. If I were a better mom, we wouldn't be here right now.*

After flip-flopping between blaming my son and blaming myself for the bad morning, I thought about how this minor accident was just one more thing on my list. I hadn't even had the time to send our insurance company pictures of the bumper from the accident three weeks prior.

Well, that's not true. I had had time. I just hadn't used it for that. I cried harder, alarming the man who'd hit my car, as I felt the weight of this piling on. *I'm already behind and it's only Monday*, I thought. *You have no one to blame but yourself.*

When it rains.

My son asked, "Are you sad, Mommy?"

I am, I thought, but smiled and said, "Mommy is okay, Bub. I'm just a little overwhelmed."

Drowning.

He held my fingers in his little hand, and we watched the blue lights of the police car whirl in the rear-view mirror. My flashers ticked, ticked, ticked. I counted them.

I felt guilty that I'd let my son see me cry. I felt guilty that I dropped an f-bomb in his presence. I felt guilty about the whole damn day. It was only 8:24 a.m.

My husband came to rescue us (now super late to work — again, that pang of guilt for needing him), and took our son to his grandparent's house for the morning. I took time to eat my feelings in sushi and cookie dough bites. I felt guilty about the eating. I felt guilty about the time taken. I felt guilty about writing the first draft of this when I should have been working or editing my novel or cleaning something.

I think I spend a lot of time here with guilt, like when I need to clean the kitchen and my toddler has asked me to play. I can clean the kitchen and feel bad about not spending these precious moments with my son... or I can play with my son and try to suppress the anxiety that stacks as high as the dishes as the minutes until I must start dinner draw shorter. I feel like I'm wrong either way.

I think a lot of mothers do this to themselves; women in general, maybe. But I can't remember. I haven't been able to separate being a woman and being a mother for some time now.

We accept blame even when there's none to be passed. We walk around taking up the rocks of "I'm sorry," "That was my fault," and "I'm just the worst," putting them in our backpack so that no one else has to feel their weight — at least, not until we're ready to chuck them at each other, projecting our own stuff at another woman, when we can't even imagine how heavy her own pack must be already.

"You're not at fault, ma'am," the police officer said.

Then why do I feel like I am? Why is my backpack so heavy, sir? How do you do it, sir? Leave your rocks behind to grow moss and crumble and reduce to sediment? Tell me the secret to letting go, man. *Caring this much is dangerous.* Even now I feel it. When it rains, it pours.

"You doing okay?" my husband asked later.

"I guess so. I wrote something. That helped. But I don't think I can publish it. Just a waste of time." *Backspace, backspace, backspace.*

It helped. Was it a waste of time? Why do I feel guilty for taking time to process?

You're not at fault.

Sometimes I am. When I storm out of the room in frustration when my son has flung himself on the floor instead of putting his socks on, that's on me. That's my inability to cope with my feelings at that moment.

You're not at fault.

Sometimes I am not. When I need an hour to breathe and replenish before I can face my day, that's not something I should feel guilty about. I cannot pour from an empty cup. I should not pour from a cup full of rocks.

I don't think I'll pick up any more rocks — not any of the ones that don't have my name on them, anyway. Mom guilt runs deep. I don't want to drown, pulled under by the weight of a full pack.

If just one other mom reads this and empties her backpack today, I'll be solidly convinced it wasn't a waste of time to write it.

Going Through the Motions

Abby Harding

Muddling through never felt so good.
Reading the same book again and again,
making routine love with your socks on,
letting the laundry molder cheerfully in
cornered baskets, reeking of mediocrity.

Being self-aware only leads to hurt
– stubbing your toes on overflowing ashtrays
of bad habits and double-standards –
but in inevitable moments of crystallization
you know with frozen lungs
the only thing holding you together
is a tenuous attraction of atoms
your own personal Hiroshima waiting to happen:
 no way to know
 who you are
 at any given time.

I know the feeling – the collapsing sensation
in the center of your body
an accordion wheezing shut,
the instant you are living someone else's life,
when you almost lean over to kiss the wrong lips –
 the inhale where you learn we are all
 fish in a splintered mirror, countless refractions
 of a thousand broken scales,
 drowning in glass, choking on air.

Are We Still Friends?

Rose Jay Rigby

Are we still friends?
That's what he asked me.
Why do you care?
Is it that you hoped people wouldn't find out?
That your dirty secret was safe?

But your secret wasn't safe.
Someone saw.
Someone protected me from more.
From worse.

She saved me from what she had gone through.
From what you had done to others.

You took my childhood.
You took my family.

You stole from me.
And now, I have to live with this.
I carry this burden.
I won't forget.

Miscarriage

Emilee Moore

I'm 29 years old, having my first period.

It's not my first period ever, but it is my first period since the miscarriage, and no one told me that I needed to brace myself for this. It seems presumptuous to call what is happening PTSD because goodness knows I am not a veteran, and I have never been abused, but that's the best description I can find. Because when I see that toilet bowl full of blood – scarlet, some clots, and just so much of it – I am right back to September 13th, in labor over the toilet, flushing my baby away because its body was too tiny for me to discern flesh from clot.

I had named her, you know? Stupid, because I was only nine weeks into my pregnancy, and stupid, because it could have just as easily been a boy. And that hurts, not knowing if I lost a daughter or a son. But I am pretty sure it was a third daughter: Eleanor Julia Moore. Her room would have lavender walls, and she would dress in hand-me-downs, but only the good, stain-free ones. Her sisters would adore her, and just like that, our house would be filled with an inseparable three rather than the two best friends I have now.

Gosh, I love those two. I hope you know that my grief for this baby, lost, doesn't diminish my love and gratitude for babies kept. My gratitude is magnified. Two healthy girls. Two successful pregnancies. 18 months of hell, but I would have gladly endured the

seven more this fetus needed to have her here. Well, maybe not gladly. I feel guilty about that now, about ever complaining about the burden of pregnancy.

And, speaking of guilt, I feel so guilty because I didn't want this baby. Or, I didn't want this baby *yet*. In a few years, I would have felt more prepared. My other children are three and one, and it's all I can do to make it through each day. Still, I wanted her. Or him. A boy is not what I'd imagined, but I would have been thrilled with him. Baby, I love you so fiercely, and even now, I feel the need to protect you, your memory, to honor you, and never forget. I was scared to be pregnant again so quickly. I didn't know I needed to be afraid of *not* being pregnant.

It's my first period since I lost my baby, and every time I use the bathroom, I want to die. I want my girls to disappear, temporarily, so I can curl up in the fetal position and weep. I want my girls clutched tightly in my arms, so I know these two miracles are real and are thriving. I want my husband to hold me and tell me we will be okay, which he does. I want my husband to leave me alone because, yes, I know he is sad too, but it's not his body that failed us. I want to move in with my mom, to be small again, someone who is taken care of rather than taking care of. I want to tell my best friends, every day, that I am still so sad, but I don't want to burden them or bore them, and time marches on, so instead, I don't talk to them at all.

Because miscarriage, especially early miscarriage, is grieved quickly in public, if at all. I have not been pregnant now for longer than I was pregnant. How can I still be so broken? But I lost my baby, and I miss my baby, and I want my baby. So, I start sobbing to a Taylor Swift song. I have an anxiety attack and vomit for hours. I keep the TV on because too much Mickey Mouse is better than a mom who can't seem to stop yelling at toddlers who are just being toddlers. Mickey Mouse gives me a chance to breathe, re-center, and be the wonderful mom I know I can be, for them. I am so grateful for Mickey Mouse.

And I am a great mom. I love my daughters. I love being at home with them, teaching them, exploring with them, making art and music, and laughter. I get up and go every day for them. But it's hard to be a great mom when you are drowning in your own depression.

And they say it will get better, easier. They say a lot of stupid things. Still, I do believe it will get better. It already is, at least a little bit. I am healing as the months pass. But I will never forget my baby, or the blood that covered my bathroom floor. I will never forget whispering "oh, shit" to myself, over and over and over again, as I sat on the toilet because I knew my baby had died and there wasn't anything else to say. But it will get easier. And I love my daughters, love the mom life, love my husband who works so hard so that I can be home with our little girls each day. But right now, I am sad. I'm OK, but sad. Still, later I won't be. Not like this, anyway.

Unwanted Conversations With My Mom

Jeni Conrad

Note from the author: These are personal narratives from my childhood until now. Names have been changed, but the stories and conversations all happened.

12 years old:

"The men in the chimney are listening. We can't talk about anything important, or they'll hear us and tell your dad."

I looked behind my mom towards the empty fireplace we'd never used. It seemed like it would be difficult for one man to fit inside, let alone several men, but I let it go, knowing it was pointless to argue with her.

"Oh, and we'll need to make sure to secure the basement door at night so the men hiding in the crawl space won't come out and attack us. You girls can sleep in the upper corner of my bedroom, behind the green armchair, so you'll be as far from the basement as possible and safe."

Over several weeks, she gathered different items around the house, tying the basement door handle to the stair railing every night so that it couldn't be opened from the inside. There were at least two bathrobe belts, several strands of yarn from her crafting box, and a bungee cord that people usually used to tie their car trunks shut.

One day, we were sitting on the couch. She always sat in a certain spot on the end, usually laughing and talking to herself.

She started telling me a story that I've never forgotten.

"You know, your father's gang kidnapped me."

I put down my book and looked at her. "They did?"

"Yes. They tied me to a table and then straightened out a wire hanger." She used her arms to illustrate how one unwinds a wire hanger and straightens it out. "Then they stuck it up inside of me."

There was no doubt about where she meant. I had learned about the third hole in a woman just a few months before when I'd been surprised to see dark spots in my underwear.

I was too speechless to respond, picturing the gruesome scene in my mind, and knowing instinctively that this was something my dad would never allow to happen, had he had a gang at all and certainly would never do himself.

"They swirled and poked that wire around inside of me, just to explore and see what was in there."

She went back to laughing her strange manic laugh, and I was left to go back to my book, the images forever seared in my mind.

As Mom was unable to hold a job, and she had kicked my dad out years ago, we were dependent on the money he could send, along with help from my mom's parents. While Dad did send money, it's unclear where it all went. Thankfully, we at least had electricity all the time, even if we didn't have food.

"Is Grandma coming with food today?" I asked as I took out a bag of frozen peas, the only thing left in the fridge. "Angie needs diapers. We used the last one two days ago."

Mom was sitting in her spot on the couch which had been stained red over the months. Despite having taught me to use a pad during my own cycle, she seemed to forget to change hers, letting the blood seep out from underneath her.

She didn't answer, so I asked her the question again.

"What? Yes." She laughed again. I could tell from the type of laugh that it was for something funny the voices in her head had said.

Even though Grandma always got the cheap brand of marshmallow cereal, and her macaroni and cheese was as watery as thin soup – complete with peas floating around in it – she often brought bologna with bits of cheese inside for sandwiches. I always hid it in the back of the fridge behind old bowls of moldy, nameless leftovers so that my three younger sisters wouldn't eat it all at once.

It was worth it to have her visit, even if that meant we had to see Grandpa. Grandma couldn't drive herself, so she relied on him for transportation, and despite the court order that he wasn't allowed to see us, he came over with her anyway… and because my grandma couldn't carry in all the groceries herself, he'd come inside instead of waiting in the car.

"Good morning!" He called cheerfully as he walked into the house behind Grandma, carrying the few bags of groceries that were supposed to last five of us through the week.

I mumbled something to him as I bounded down the stairs, eager to help put away the groceries before my sisters could eat it all in one day, and so I could get the biggest bowl for cereal.

"What's that? That's no way to greet your grandfather. Are you a grumpy-pants today? I said, 'Good morning!'"

"Good morning," I said a little louder.

"That's my girl." He put the bags on the kitchen counter and then turned around to greet me.

"How about a hug for your grandpa?"

I should have refused, but I didn't know how. I had been taught to respect people of authority, and I certainly didn't want him to stop bringing food.

When I was four and my next youngest sister, Katie, was three, she told my dad that grandpa had touched her in her private parts. I was then questioned about similar behavior and I confirmed the story. He had also touched me there. I admitted it, feeling ashamed that my younger sister had been braver than me, when I should have been the older one protecting her.

He went to jail for a few years, but not forever.

I went in for the hug, cringing inside and focusing on the cereal I was about to eat. He hugged me so tight that the metal buttons on his shirt and the pocket-protector full of sharp pens dug into my budding chest. Whiffs of fruity gum pressed out from the fabric, and I pulled away as soon as he would let me.

"There's a good girl. Ah, and here is Katie. Give me a hug, Katie!"

13 years old:

"This baby is evil!" Mom snarled as she tossed the new Christmas present over the fence and into our neighbor's yard.

Angie was on my hip, already screaming because Mom had taken away her doll. It was one of those babies that told secrets and could whisper – I'll admit, a bit creepily – but Angie had loved it the moment she'd unwrapped it.

I sighed, shifted Angie's 3-year-old underweight on my hip, and walked around to the front of our house so I could go knock on my

neighbor's door and get the doll back. Because I had chased after Mom so quickly, I wasn't wearing a coat or even shoes, though I did have both of those things, only because our cousins had passed them down.

"Hey, Shannon." I sighed again and bounced Angie on my hip, trying to get her to settle down as I stood on the porch of our neighbor's house. "Can I go get a doll my mom threw over the fence? Angie's really sad without it."

Shannon took one look at me, my sister, and my mom, who was now dragging the Christmas tree down the street behind us, and she shook her head. "Go get your other two sisters, your coat, and come back over here to just rest for a minute, okay?"

Relieved, I agreed. I'm not even sure if I told my mom where we were going, but that was the last time I saw her for twelve years.

24 years old:

"I'm not even sure which ones are mine." She stood just inside the room, having walked through the front door of my dad's and stepmom's new house. Her hair was long and wavy, but there were streaks of grey woven into it. Her face was weathered, her skin pink and raw from being a homeless bag lady for several years.

"I'm Jeni, and this is Samantha and Angie." I gestured to myself and the other two girls who had come into the room.

It was mostly understanding that she didn't know who her own kids were since we had added three new girls to the family as stepsisters, but it was still odd to introduce myself to my own mother.

Katie had found Mom on the streets after we'd been notified by the state that they were going to knock down my grandparents' house, several years after they died, and that there was a squatter there. We would need to go through our family's belongings before they took over the property. Somehow, Katie had managed to convince my

mom to get on medication for the first time in Mom's life, and had agreed to let Mom live with her, her husband, and their two kids.

Mom nodded at each of us. "You all look so old." She laughed that manic laugh, and it sent chills through my body as traumatic memories whizzed through my head.

29 years old:

Several years later, Katie got divorced and then remarried, moving out of state. She'd taken care of Mom for five years, but we both agreed it could be my turn. I had just gotten married as well, and was living in a two-bedroom townhouse while I went to graduate school and worked as a general manager at a busy restaurant.

"Can you get next Thursday off?"

She had followed me down the stairs as I rushed to get ready for my nine-hour shift.

"You know I have the schedule done already for next week. I need a lot more notice than that. Why do I need to take it off?"

I paused while grabbing my granola bar to give her my full attention, afraid of what would come out of her mouth.

"Bob and Marie are coming to pick me up and drive me back home."

We were living in a different state than where she'd grown up, and she had expressed a desire to go back home several times, but as she wasn't able to live on her own, we couldn't accommodate her wishes.

"Who are Bob and Marie?"

"They're my friends. They're coming to pick me up."

"I've never heard you mention them before. Who are they? Where will you live when you get there?"

"They're my friends."

I sighed. "Can I talk to your friends? I need to make sure this is all going to work out well."

"No, you can't talk to them. Only I can because I have telepathic powers."

I was twenty minutes late to work that day, staying late to try and convince her that no one was coming to take her home. Finally, she agreed just to calm me down. "I'll pack up my things, just in case."

Her friends never showed.

32 years old:

"Hello," I said with a silent reminder to be nice when I saw who was calling me.

"Hello, Jennifer. This is Nancy Johnson."

"I know, Mom. I have your number in my phone."

"Oh. I was just calling to see how you and your family are. How is Stacy?"

Through several years of hard work and help from one of my stepsisters, we'd found a home for my mom, back in the state where she wanted to be. It was a state-owned facility with a nursing staff that offered housing to people who would otherwise be homeless. It was paid for through government funding, and we'd been more than grateful to find a place where she could have some of her own independence, and we could, too.

"Stacy is fine, but we did have some medical issues a few months ago."

"Oh no. Is she okay?"

"Yes. She is okay, but it turns out she has a chromosome deletion which causes her seizures. We spent half a week in the hospital trying to get her on the proper medication so she could have less seizures. She still has lots of little ones throughout the day, but the big ones are controlled, and she's a lot more responsive."

"Oh. That poor girl. How's Ricky?"

Stacy was my not-quite-two-year-old baby girl, and Ricky was our family's pet dog. Mom had a prescribed list of what to talk about when she called me once every few months, and hospital visits, combined with medication, were off topic.

35 years old:

"Hey, Mom. How's it going? How is your roommate?"

"Oh. She's okay. She's got a gun."

"She does? How do you know? Did you see it?"

"No, I just heard a loud banging. She's going to shoot me in my sleep."

"What? Did she say that? Did you tell the nursing staff?"

"No. I just know."

"Oh. Right. It was probably just a loud thud or furniture. They wouldn't let her have a gun."

And then several months later...

"I just wanted to let you know I'll be going off my medication."

My heart raced as anger coursed through me. "You're doing what? Why would you do that? They'll kick you out and you'll be homeless. You can't move back in with us. We can't handle it. You have to take your medicine!"

I'm sure I sounded quite distressed, but I was. We'd had to police her taking medicine since Katie had pulled her off the streets. It didn't completely cure her, but it certainly helped a lot.

"Well, they can't make me take my medicine if I don't want it. Legally, they can't make me."

"Listen to me, Mom. They will kick you out once your sickness takes over. You can't stop taking your medicine! I don't have the mental strength to keep talking with you if you don't take your medicine. In fact, if you aren't taking your meds, I refuse to talk to you."

It was cruel, but I wanted her to understand how strongly I felt about it. Maybe if she couldn't take it for herself, she could take it for me. I don't know why I had hoped it would work. It hadn't worked when we were young; why would it work now?

"They can't make me take my medicine. They want to hurt me, and my medicine is poison."

I exhaled a puff of frustrated air and hung up on her. My hand trembled as I put down the phone and turned back to change the diaper of my second-born, who was only a year old.

36 years old:

A strange number showed up on my phone, but I was in the habit of answering strange numbers because of my daughter's school or doctors or other places with multiple numbers that I didn't have saved.

"Hello, Jennifer. This is Nancy Johnson."

"Mom? Katie said you were in Missouri?"

Nearly a year after she'd stopped taking her medicine, she'd left her housing. They'd given her several options for rehousing, but she'd refused them all. She left, not even taking any belongings, claiming they'd all been tampered with, and had disappeared onto the streets.

I'd started the process of putting out a missing person's report, but we hadn't heard from her all summer. Then Katie got a call from a hospital in Missouri, nearly 2,000 miles away from where Mom's housing was. She had been there for ninety days, and that was as long as they could keep her. She hadn't done anything drastic enough that they'd be able to commit her, so she would be released to the shelter.

"Yes. I came here because there is going to be a big earthquake back home, and it's safer here. I'm staying at a shelter, but I can't give you a number to call me. They looked up your number from Facebook, so that's why I can call now. I didn't have it until now."

"Mom, they can't get my private number from Facebook, or Katie's number."

"I don't know, but they did. They were so rude at the hospital. Very forceful. I hate their guts." These were strong words coming from my mom who refused to come anywhere close to cursing.

The hospital had tried very hard to convince her to go back on medicine and to agree to get treatments on her own, but she'd refused. She knew exactly where the line was before being committed and she knew how to appear just sane enough to keep her rights.

"Mom, you need to go back home. You've got thirty days to go back before you'll lose your benefits. The card you used to fly there isn't going to work anymore. You won't have food. It's dangerous to stay in the shelter. You had your own place there. You really need to go home."

"Okay, well. It was nice talking to you."

And she hung up because I was talking about things she didn't want to talk about.

I sighed and hugged my daughter, who was having one of her bad days. She drooled and shook and was nearly unresponsive. She couldn't hold a drink or food without flinging it across the room from a seizure. It was all I could do to hold and rock her and try not to cry.

My thoughts reeled from all the memories my mother's voice brought to mind, and I couldn't help but think of recent research that had come out a few months earlier. A study linked my daughter's chromosome deletion to a mental disease called schizophrenia, something I knew too much about, and while she was still non-verbal at 5 years old, the fears for her potential mental problems screamed so loudly in my mind I couldn't hear anything else.

Last Family Vacation

Lisa Holcomb

People say
 "Why are you so ISH about the beach
 This year?
 YOU LOVE THE BEACH."

And it is true. I love the
 Sounds of crashing waves
 Calling gulls
 Flapping flags
 Happy children.

But the beach is also tiring
 To walk across
 All that sand

Blinding sun making
 MY HEAD THROB
Sweat dripping down
 All my limbs

This year is also the last.
 The last as a family
 Of five.
 The last with 3
 Children at my side.

The last whole family vacation before
 College
 Separation
 Longing
I do love the beach, but
 I hate what this trip
 Represents and I hate
 Not having the energy
 To enjoy it and
 I hate having messed it up by forgetting all
 The things
But mostly I hate it
 Because it's the last.

I hate every imperfection
 That he will remember
 And remark on through
 The years. I hate every
 Minute that he steals
 Away from us when he
 Goes out with friends.
 I hate how he covers his
 face and makes me take
 Mind pictures because
 Memories fade and
 I hate that I'm already 2 days in
 To the
 Last family vacation.

Onion Tears

Monica L. Culwell

We're all like onions in a way, with our layers of experiences, emotions, and physiology. Each layer reveals something hidden beneath our protective flesh. People may catch glimpses of pearly white membrane beneath the brown scales, but only a lucky few get to see our whole raw selves. They may even weep with us when our delicate membrane is nicked. However, many of us may never allow anyone to delve deep into our innermost layers... not even to heal ourselves.

I thought I could heal myself just by talking with friends and safe family members. During meditation, I envisioned pushing the most vile memories out through my toes or ripping them from my gut like a cancerous growth, but those experiences never really left. They lay deep within my most tender young center. And although they are deep, tamped down by my strong will to survive, they remain vulnerable to stabbing cuts. Something as simple as a sound, like shuffling slippers in a hallway, or the smell of oil-soaked wood, can pierce through all of my armor. I wince. The phrase "Don't you know I love you?" curdles in my gut. And then I weep milky tears.

Sometimes we like to flirt with vulnerability. We let others chip just enough of the brown scales away to view glimpses of our outermost self, but there is nothing to that layer, is there? There are no major discoveries or deep personal connections. It's just enough for us to

feel like we've given away something personal, without giving away anything at all.

Perhaps that is what I had been doing with myself all along… peeling just enough of the thin brown paper that I felt like I was seeing myself clearly for the first time upon seeing any flesh at all. That is a false sense of personal connection. Until the onion weeps its milky tears, there is nothing exposed: no vulnerability, no sense of depth, and no sense of growth.

Maturity and a desire to be a good mother gave me the courage to seek a therapist, someone skilled at cutting deep to release the tears without destroying the self in the process. I wanted nothing more than to give my best possible self to my son for his best chance at a healthy childhood. I wanted to know myself better. I wanted to steep in the onion tears and break any cycle headed for our small family. The protective layers I had built up around me needed names so I could tell them apart. How can you change your trajectory if you don't understand all the laws at play in your mind and body? For my son, I wanted to be the adult I needed when I was growing up.

I spent the first three months of therapy crying the whole time. After one full year of therapy, my therapist diagnosed depression and Complex-Post Traumatic Stress Disorder (C-PTSD). Once I could name the layers, I was able to begin the process of untangling the distortions that pervaded my thoughts and ideals.

And the onion tears flowed.

Abuse survivors run on fight, flight, or freeze mode all of the time. Can you imagine running your car in the red for every trip to the store or long drives across the country? Our bodies were not designed for that level of intensity at all times. We need to have our safe places.

My only safe place was my imagination. Every night before falling asleep, I imagined myself the protector every child needed. Like a Pied Piper, I led all of the children to a safe place where they could

be children. I savored the thought of remorseful adults pining for their children, knowing they alone were responsible for losing their children by not taking them seriously.

The onion tears flowed and stung my gloating, red cheeks as I thought about justice served.

I wanted to be loved and chosen. I wanted to know someone actually wanted me, and that I was special, put on this earth for more than just being a victim of abuse. But seeking that validation beyond myself brought many bad relationships with people and alcohol. When you just want to be loved, your expectations for a relationship are anything but healthy. Alcohol made me fun. Low self-worth made me prey.

And the onion tears gushed until I thought I had no more tears to cry.

Fear walked beside me for decades and stays in my wing today. I have wanted to make major changes in my life, to move to another state or start writing full time. But fear pokes me and says, "Not for you. You can not afford to take risks. Your safety is the priority." I listen to fear because she has saved me from discomfort in the past, but I remain stirred to act. What if I move and things don't work out? What if the chaos of a change dislodges the balancing act I've had going in my brain, trying to avoid chaos? What if I become those things in a parent i don't want to be, all because I made a life change? I realized I can't tell the difference between a genuine protection and a C-PTSD protection.

And now my tears flow from my heart like a raging river.

My grandmother always said my bad experiences would allow me to help others someday. For years, I tried to figure out how that looked in real life. I volunteered with abused and neglected children at a daycare and a women's shelter – worthwhile efforts, to be sure, but volunteering faded, as it really wasn't the same as my vision of layers I didn't even know I had. As I learned about adverse childhood

experiences for children in foster care and how that impacts their behavior and risk factors for self-destructive behavior, I recognized myself. And this was when I met my son, adopted from foster care almost five years ago. I recognize this calling was what my grandma meant: I could be the safe place for a child in need... the adult I needed.

And the onion tears now flow like a tsunami crashing through my body, tearing away any remaining layers, and exposing the reason I now live and heal. I do this all for myself, and for my son.

Gathering Dust

S. Escobar

Was there always so much dust? Dreary autumn light – almost winter – casts in through grime-smeared windows, emanating a ghostly glow. It seems so long since the windows were last opened to fresh, pure air.

The fruit in the bowl is soft and splotched brown; their smell of sweet-slow decay layers upon the odor of dirty-worn clothes in this stagnant air. Suffocating though these smells are, the air is warm against the cold of outside, and the warmth would be lost if the windows were thrown open in my desperation to breathe. So here I stand in this stillness, this too-quiet; my beloved ones still sleeping in the eerie morning light.

And I am seized with a sudden terror that all time has stopped for me – and has been for so long, for I remember so little of yesterday. I am seized, yet time still devours the world around me.

The dust – has it not grown even thicker than before? My daughter's sleeping face as I look over her, how much it has matured since I had last looked upon her. How much further her legs stretch down the bed. And when was it I last looked upon her?

Outside, the autumn leaves have all but fallen from off the brittle dark trees. There is not a trace of color, not even upon the ground, when earlier, just moments ago it seems, I could have sworn I had seen a blaze of orange upon them. Was that days ago? Weeks?

The fruit in the bowl, more rotten than before. Blackening, pooling with juices.

Dust — the dust is everywhere now. I reach for my coffee cup; the liquid inside having long evaporated but for a spot of green-gray mold growing inside.

And more dust.

I go to my husband, still sleeping. His hair shines in the pale light. Gray hairs I've never seen glisten on his head and in his beard. How much time has passed? Why can I not remember? Why is there no dust on him? Perhaps, if I watch closely, he will move. Perhaps he *is* moving, but just too fast for me to see. Perhaps the days are just coming and going so rapidly, I have stopped discerning them.

Panicked at the suffocation of time, I lunge for the door. The knob is difficult to turn; my hand upon it more roughened and wrinkled than I remember. The door doesn't budge until I throw the side of my body upon it, and at last, it bursts open.

Instantly, I can feel the fresh, cold air upon my cheeks. My lungs gasp for it.

I can hear birds and the skittering of dead leaves in the light wintry breeze. I am dazzled by movement.

How long has it been since I have been aware like this?

The door creaks open behind me. My husband comes to stand on the porch at my side. He lifts his arms as he yawns and stretches, wrapping a great warm limb around my shoulders, unaware that I had just been locked away, trapped, for I don't know how long.

I stare up at him as though he has been missing to me for years.

"Can I make you some coffee?" he asks in his grunting morning

voice, but I cannot focus on anything other than how his voice materializes into steam and rises into the sky, his mustache glittering with those new gray hairs in the yellowing sunlight.

The door opens again as our daughter comes out to join us. I scoop her long body into my arms as she comes to me, still warm from bed. She weighs more than I remember. Her hair so long and fragrant, no longer of her baby shampoo, but of my own. So many details I have missed; so much time lost. And where have I been? Here, among them, all along.

What I'm Worth

Christina Lynn Lambert

Flashlights

Apologize
if your shorts are too short
or too long
Apologize some more
for violating the sacred scale
of just right
Heed the suggestions to fix
every flaw
because
help never comes
and opportunities run dry
if you don't fit the mold
And remember to never
shine the flashlight behind the curtain
otherwise
the illusion of our weakness
will shatter
and the imperfections once vilified
used to keep us in line
will shine
with the beauty
the men behind the curtain
never wanted us to see

Friends I've Never Met

Stop talking to me
I don't want to smile
But the man who has stopped me
wants to be heard
His stupid frat boy grin
a reminder
to tread cautiously
Nothing to worry about yet
while his words are a safe ratio of
innocuous to obnoxious
Soon though
I could be headed into danger
I watch my step
looking for the safe path
that circumvents
further conversation
and obligation
When his hand lands on my shoulder
a friendly face I've never seen
emerges from the crowd
"we have places to be" she grabs my arm
because that's what we do
what we always do
to save each other
from being
acquired

Instructions for the Intern

Quiet
Listen
Follow along
behind
and mind
your instructions to become
the scaffold
a beam of support
Rays of sunshine
to light the way
for those too lazy or greedy
to use their own light
Most importantly
don't forget
to take your daily dose of
compliance
No ego
Just hold up the world
and pretend
someone else is responsible
for your ideas
Play along until
we've all got our sledgehammers
The system
can't survive us

Magic

The commercials tell me
that the importance of my existence
diminishes
with every silver strand of hair
Magic lotions in expensive glass jars
promise to erase
the lines of time
to make me visible again
They've sent us on a hopeless quest
for the fountain of youth
because they want us quiet
afraid to become irrelevant
So let fear walk beside us
We've faced darkness before
The scar tissue blunts the pain
of harsh words and new wounds
The real magic is in our refusal to spend
our existence
desperate to please

Burning the Misogynists' Rule Book

Throughout women's lives, we're exposed to countless messages about how we should act, how we should dress, who we should love, and what products can help us fit the mold that other people have created for us. Those in positions of undeserved power want to make us eager to please while keeping us too busy to realize how toxic their agenda has always been. Over time, I've realized how these messages are designed to keep girls and women in line. Playing by the rules in order to slowly create change was my original strategy.

I grew up in the '80s and '90s, during a time when women's voices were growing in strength and number. Unfortunately, the majority of influential society wasn't quite ready for women to have an equal voice, despite the growing unrest. Most parents wanted their sons to act like gentlemen, but many didn't understand how to, or even understand the need to, teach their sons to treat girls and women with dignity and respect. But change has to start somewhere. The hopeful, wistful message that women could one day have the career of their choice and be more than pretty faces and background scenery sparked enough upheaval to keep the problem of inequality from being completely pushed aside.

I was inspired by seeing women in news articles, magazines, and movies portrayed as powerful, capable members of society. But on the heels of all of those messages of encouragement were the reminders of how women should look, dress, and act if they wanted a chance at their dreams. The misogynists had written an updated, slightly more relaxed rule book for women's success. Change is slow. People with power rarely relinquish it immediately or willingly. I listened to the messages, and even though I knew they were absolute trash, I learned the game and played by the rules. My hope was to play the game, so one day I could be a key player with the power to push the envelope, little by little, to invite progress.

The society that raised me still punished little girls for being loud and rowdy, while praising the same behavior in boys. The double

standard existed quietly within boardrooms and courtrooms, in interview panels and academia, in basically anywhere women wanted to be. I was told if I worked hard enough, I could succeed but, there was always a whisper at the end of that message reminding me that, as a woman, I also needed to look nice, to know when to be sexy and when to be demure, to be smart but not to outshine my boomer male bosses.

"Be bold but do it quietly," I was warned.

Confidence in women is still seen as bitchiness, and I was reminded to keep my voice soft, to be calm. Emotion is a weakness, according to those who have created the messages that oppress us – unless, of course, the emotion is anger, and punches are being thrown. The manly emotion of anger was supposed to be admired. I learned the rules and did my best to play by as many as possible since I wanted a chance at *not* starving to death and *not* having to live in a dangerous neighborhood with constant gunfire. I planned to find a career where I would at least make enough money to survive and thrive. Maybe, just maybe, if luck and opportunity could align, I might find a way to run my own small company.

I got a bachelor's degree in psychology while working my way up from a minimum wage cashier job to a better-paying job as a group home counselor. While I was working on a master's degree in business, I got pregnant. A little earlier than I had expected, but no big deal. I could handle that. Then morning sickness descended and took over all hours of the day. All of my careful planning, sacrifice, following the rules that I hated, came crashing down.

After nine months of non-stop nausea so bad that I had to give up an internship that I'd created, my body stretched and bled and has never fully healed. Love and exhaustion occurred with a hellish, painful intensity. I did my best to find the time to shower and the brain power to finish my degree. My hair didn't look pretty, and I burnt a hell of a lot of meals while trying to keep a crying baby happy. Mothers do everything we possibly can to get everything done that needs doing. We borrow the necessary energy against our future,

against our health, against our well-being and happiness. Society doesn't much care if we're tired or in pain, as long as we're doing everything that has been asked of us. If we need help, the same society that praises the importance of motherhood is quick to tell women we're failures.

My daughter cried relentlessly. Months dragged on, and I slept with my eyes open on the sofa for a few minutes each night. Months of frustration turned to years of doctors ignoring my concerns, acting as if I were exaggerating. They implied that the crying and difficulty couldn't possibly be as bad as I had described. In lieu of a proper diagnosis, I devoted countless hours to helping my daughter. I did my best to teach her to work around her difficulties, to calm herself, to work on her ability to focus, to help her figure out what clothes she could wear without the material driving her mad all day. Hope for her future hung in the balance, dependent on my actions and patience. Hope for myself and my own future started to fade as I wondered if I would ever have some type of career again.

Despite the time constraints and my frazzled brain, I refused to give up and let go of the idea of some type of occupation that I enjoyed. I racked my brain, trying to figure out what kind of profession I could manage to create for myself in the few hours of the day that I had available. Being a personal trainer was flexible, and I enjoyed the work, but when everyone else was sleeping, I started writing – at first, just angry rantings and essays in a journal, then inspiration for a few stories struck, and I started writing whole chapters.

Slowly. Badly at first.

But the possibility of a life outside of being a parent became an anchor to withstand the difficulties of a child who couldn't be content, couldn't be quiet, couldn't concentrate. I kept writing, and the stories and characters began to take shape.

In all the chaos of raising a family and writing a few books, time passed without mercy. The youthful glow in my cheeks faded. So did my hair color. Grey streaks snaked out from my temples, and fine

lines decorated my cheeks. Lotion and hair dye commercials promised a solution. They could make me beautiful again, and, we have all been told, countless times in countless ways, that beauty is the originating value of women. We've been told that without beauty, nothing else is possible for us. I know the game, how it's played, and what I should do to succeed, but at this point in my life, I'm done playing by the misogynists' rule book.

Why does anybody get to decide what I'm worth and why? Not enough has changed since I was a kid in the 1990s. Revolution is often a slow-burning fire, but the people in need of change need the fire to burn higher. I won't apologize for my existence as I age. I want to age gracefully, but I don't need to stop time or turn the hands backwards. Knowledge is my power. If I had to gain a few wrinkles, gray hairs, and stretch marks to acquire that knowledge, so be it. I'm not here to be quiet, and I'm not here to follow behind.

Taming Fear

Shell Sherwood

I was a competitive gymnast for most of my childhood, 11 years of twirling tricks that could snap my neck with every crooked toe upon a beam. I broke my foot three times, and the base of my nose once. I strained my wrists, sprained my back, bruised every inch of skin. I bashed my knees, traumatized my thighs, infected my palms from chalking over seeping blisters. Those are just the injuries I can remember, the ones I admitted to.

The more complex the skills became, the longer each recovery dragged on. Tapping into muscle memory became a science for us; a calculation of how much shame you could bear before surrendering to the notion that working through pain was courageous. We'd navigate each grueling step to health with resentful eyes searing our backs, wondering when we'd just *suck it up* and tell the perfect lie to get medically cleared.

"You're still not healed? You're still not ready? Can't you just pull it all together?"

The push to be present and willing was unbearable. And all the while, knowing that when the bandages broke away, a piece of me would always remain behind. My knee would never be as strong. My hands were scarred and calloused. My foot would never lay as flat, or curve to a point as required – as expected.

That was the life of a gymnast in the '90s. I spent every spare moment convinced of nothing otherwise. Anxiety iced my veins and

crushed my chest at the thought of disappointing, failing, or hurting. The worry was considered proof of your commitment, the fuel that made you soar.

Those were also the days when toxic words were believed to warp young minds into greatness. Where shame was thrown about like coveted candies, our mouths wired open to receive. Jealousy encouraged competition, and success was measured by consistency. The girls with natural abilities were stacked upon the backs of those with lesser value, dangled high above our heads, despite their fear of heights.

The path to this type of greatness required twinkle toes and hushed mouths. Flipping up the blinders to anything – anyone – that could shatter your dream. You savored every rare glimpse of pride to trick your heart into believing you were supported. If a mate stepped out of line, she was ostracized, considered an enemy you should avoid at all costs... at least until she was deemed worthy enough to regain entrance to the group, though never quite forgiven in their eyes.

I would've done anything to stay under the fold. I would have believed anything: *They watch us eat because they care. They're aggressive to make us better. She gets more coaching because she deserves it. She failed, of course they sent her home. If I was prettier, he'd watch me too. If I was talented, they'd be prouder. If I was dedicated, she wouldn't yell. Crying shows your weakness. Don't ever cry. Stop crying.*

And yet, I was over-the-moon proud to be a gymnast. I had no knowledge of the vile morals that guided me, the ones that required me to be perfect and pleasing and viciously envious of those who rose above. I was a child – we were all just children – learning to be women in warped ways. We were acclaimed for being fierce and graceful, unlike the dancers or the cheerleaders we were taught to despise. Heaven forbid someone left to join a school gymnastic team. "I guess she wasn't a real gymnast, after all," they'd harp.

But something changed when I turned 15, and blood began to cycle. Hormones raged, my mind ran free, and fear infected my soul. Constant fear in the life of a gymnast is a death sentence for your career. It twists your brain and cripples your judgment, paralyzing your limbs in mid-air.

At the end of my final practice, I came inches away from damaging my spine: a double-back tumbling pass gone terribly wrong, the landing a mess of contorted sorts. I couldn't find my mark upon the faded warehouse walls. The air pushed back like steel, impenetrable, preventing me from flipping through to the finish. I landed on the top of my head with a crick in the neck — twice. It was the last day I called myself a gymnast. I walked out, my tears staining the jagged carpet as I fled.

There was nothing left to keep me there. My dearest friends were long gone, burnt out and broken. Shadows began to emerge in my mind, blocking reason and fogging focus required to master any skill. My tumbling passes were a disaster. My beam skills were sub-par. The vault and I had never been friends. Only the bars could still sing siren songs to coax me to stay, but it was too late.

I had been the fearless one, always the first to try any new skill. I'd thrown myself into risky flips, an extra release, a tuck, a spin. It never occurred to me that safe landings were not a guarantee. Fearlessness was my brand, the reason I competed. Now I was scared — now I was nothing.

I quit, with a simple, believable lie of needing to focus on my studies. I told my mother I just didn't love it anymore, though my heart ached every time I heard the phrase repeated back. I worked so hard to convince others I didn't need the sport, that I still second guess my motive today. *Did I give up too soon? Am I really that weak? I guess I wasn't a real gymnast after all.*

For years, I let fear drain the life from me. It bounced me around to all the wrong friends, the wrong men, the wrong careers. It controlled my thoughts, and filtered every word through a mesh so

thin I could only ever skim the surface with another human, sharing nothing more than the superficial facts that devoured my Scorpio soul.

If I ever made a mistake – and as an emotionally immature introvert, I made many – fear reminded me it was unforgivable. I had to be cautious and appropriate. If I wanted friends or a boyfriend, I had to tread lightly. For some people only give one chance, and even if you're lucky enough to get another, the stench of disappointment would always linger.

I didn't reveal to anyone why I really quit gymnastics, not for almost 20 years. Admitting fear was inconceivable, and so I pushed through life with upturned lips or fled to avoid being hurt first. On a random day at the age of 33, I blurted the truth unexpectedly to a fellow gym rat, one of my oldest friends. It wasn't my intention, and maybe it was the spirits in my glass, but I finally said *I stopped because I was scared of getting hurt.* Guess what? So was she.

As a woman in a world where we are constantly stepping up to prove our worth, fear has been deemed as a weakness. We hide it or mask it with other emotions. Pretend – to even our closest friend – that fear never crosses our door. Why is it that fear is seen as a weakness, when it has inspired some of the most courageous actions? Why do we see it as a step back when admitting you're scared to fail is how we grow?

I'm scared. I'm scared to fail as a writer, a mother, a friend, a spouse, a woman... a human. I'm afraid that I'm wasting my time and energy prioritizing the wrong things. I fear I will regret most of my decisions, or let my last chances pass me by. Even when we do admit fear, the decision of what to do with that emotion can be crippling. How do you get rid of it? How do you prevent it? The fact is, you don't.

Fear will always ebb and flow in our lives, no matter how hard you try to deny its entrance. It's not about abolishing it, but taming it, changing how you react to strengthen your next move. I wasn't ever

fearless, I just feared other things more. I used the fear that I was inadequate in other areas to push me through to taking risks. I'm a firm believer now that fear can be productive.

Fear can highlight what you truly value, what you can't live without. It can bond you with others of similar personalities on parallel paths. Fear of failure inspired me to write more. It turned me towards classes and groups with women relating to every impending doubt in my mind. I was terrified that I had missed my time to become a published author. That having children before I established a career was a mistake. That I was a quitter, and have been since the day I walked out of that gym.

Guess what? Thousands, millions of women feel the same way. Fear has led them to the same trenches of their true selves, forcing them to rise again with a passion and purpose strong enough to leave the emotion behind for another day. Our combined fear of missing out created a bond I never knew I was missing, and now can't live without. The fact that you are reading any of this is proof enough.

Thoughts at the Pump

K. Marie Bennett

At work, you feed a machine in a darkened room.
In public, you put your child under the cover of a cloth.

Get your body back, they say, as if you couldn't wait to be done with
the whole thing.
But the truth is, I could never get my body *back*.

It is now a sanctuary, a home.
And maybe you can't go back home, but you can visit and remember
what it did for you.

Rear View

J.N. Smith

Oh that girl.
How often she follows me down these haunted roads, early, when the
moon watches and shadows cradle the dawn.
Her light flickering at first, against the corner of my tired eyes as I
accelerate away from one heartache toward another,
when I can't remember where this road ends.
She blinds me with her perfect form, as she is wont to do.

Fearless
Careless
Window down
Bare foot propped on the seat.
She races recklessly through the fog
Bearing down, one hand on the wheel, the other pressing a cigarette
to her open lips
unperturbed by time or fear
And I cannot help but look back

How many times has she drawn my eye?
And I remember too late that I am here now, the driver of this
vehicle.
And I am shattered against the present
While she sits unblinking behind me and watches like a ghost.

The Aftermath

J.N. Smith

The sun lifts its tired head
over my tragedy.
In the rear view she is ice, a thin, fragile, masterpiece.
I watch from my aching fortress of flesh, as the rays pierce her
perfection.
I gasp at the dawn
While her cheeks drip from her chin,
Something in me comes alive with my breath
And I notice that she has none

I take the road once more.
Wrinkled but whole in my dented ride,
Blazing through the frosty dawn.
The sun grits her teeth against the haze, and the trees bear naked
witness to my revelation,
I glance back, just once
She does not follow.

And as the sun triumphs the sky, she disappears
My eyes settle on themselves and smile
My heart screams with gratitude because while she may be perfect,
I am actually here.
And there is love waiting for me at the end of this road.

Reclamation

Musings from My Spirit

Christine Weimer

I've been helping her see from outside. And by that, I mean from outside home. She trapped us for quite some time. White walls with very few windows and fluorescent lighting made her forget what the sun looked like. She stood in the shadows, shuffling from room to room, watching comfort fester through bare walls until septic. She became a Great Keeper of a dungeon where she tried to kill the pieces of herself that remained, lurking around the wounds of ruin as they rotted around us.

But now, I am taking her hand as we see from outside. I take her to sit with places where walls do not exist, and the light we take in is whatever nature provides us. And by that, I mean the nature of a city she once thought she despised, but feared so incessantly. She couldn't see past home. She couldn't see beyond cracked molding and stained-glass panels and all the things she wished would disintegrate.

That's all she wanted for her herself. Bones crushed, burned to ash, while I danced on top of the grave of all that she once was, but grateful that she never would be again. Except she can't bury herself and expect to keep feet above the dirt. That's why I sit with her where walls do not exist, and she does not feel confined to bouncing around everything she cannot change.

Death wouldn't work. She tried every means of destruction, but I would not let her separate me from this body. We are inevitably tied. She used to think that was the most impounding thing about this journey, because my human only communicates by way of shrieking, frantically pacing as she pounds on her chest with anger over what she's become. It's ongoing chaos. She is a reiteration of every first moment that befouled her ennobling purity, a haunting home video of every foreshadow that does not leave her guessing anymore. A replay of events that came and went, my human sticks to narratives that keep the hurt child close while denouncing accountability of inevitable growth.

She is a hurt child who latched to every means of defense she's ever had to learn. My human liked the walls she built because she felt safe within them. What else could she have known? She is a guard for the body we are housed in, and all she seeks is immunity from harm. My human acts as a shield, and I am here as the source. I am here to bring her back to the center, to wrap her in light when she lets me in, because I know she'll start to see not all her walls are needed, and home can be a hallowed harbor, and not a haggard heart.

When she is not confined to what she cannot change, she is more still. She sways instead of teeters, and together we listen to the noise that is not ours. As I sit where nature gives us light, my human sees they had missed the writing on the wall between the pandemonium of turmoil it allowed to gather in rooms that once were a haven.

When did our haven become my human's peril? The writing says it happened when she chose suffering over self-sufficiency. My human thought that'd be easier. My human knows suffering, but I know sufficiency, and the conflict remains in how we will work together now that we're outside. Without the shadows, who will we be?

I know my human's suffering is a misconstrued need for control. She does not know aversion from growth. She does not understand unpleasant feelings from the horizons broadening within her. My human does not know discomfort is expansion. She knows suffering

as an offense without seeing the savior in surrender. I know submission as a means of freedom, not an act of defeat.

I have nothing to win here. I am a mere observer of the creative experience one explores when choosing to live through their human. But not every spirit breaks through. I was once the cause of my human's dread, and it was not easy to open doors padlocked to keep me out. I kept whispering, knowing one day the sounds of my synergy would carry its way through to the other side.

She finally opened the door. Reluctancy is ever-present, but I am here on the outside with her as we seek to uncover how it feels to let the breeze hit us again. It's been years since she's opened up for me, even a little. But now we've made it to the city streets, and I can feel my human lifting weights from her shoulders. She's getting bolder in the way she walks, and I know this because we used to see the ground when we stumbled along, and now we are looking straight ahead, and there's a bit more stride in our step.

Deciphering which walls to take with her is the hard part. As a human, she is torn between what is dangerous and what is just fear, and she does not realize the two are different. She fears that which is not afflictive, because she expects distress over comfort. So, I help her exhale, to release some of the walls that blocked her from seeing the outside. She lost her sight in her safeguarding for some time, but I knew her feet on this pavement was enough to remind her she has ground to stand on.

She doesn't feel the need to withdraw as much. Tainted reels of reminiscence do not make her hide under the bed so easily these days. Slowly, my human is learning shattered fragments do not need to be swept under rugs. She's becoming more resourceful, finding ways to repurpose what she used to keep hoarded on the inside.

Sometimes, she retreats. But when she draws back she also keeps her eyes open now. She's letting fresh air in and I know she feels more compelled to waiting for the light to shine through her windows.

My human has a pen in her hand. I think we can expect new writing on the wall. She will heed the call this time, the more she sees from outside.

Refining Fire

Tristan Tuttle

The refining fire of motherhood feels more like Nebuchadnezzar's
fiery furnace than the warmth of home's hearth.
The fires of hell more than the fires of winter's past, where we would
gather together to hear old family tales.
The fire of battle, stories told of firefights and lost skirmishes, the
landscape riddled with casualties of the pressure of modern
motherhood.

But for now the refining fire of motherhood seems to be located
behind my eyelids, or at least that's how it feels after yet another
night of up at

Twelve
 One
 Two
 Three
 Four
 Five

Each time I wearily blink, I'm surprised my eyeballs haven't become
poached eggs.

So I rise again to rest in knowing that one day the fire will burn out,
and the memories will be the coals that keep me warm in the winter.

No.

Kathryn Averyheart

No lives in my closet, in a place I reserve for good Sunday coats and hats I buy but never wear. It is the cameo my grandmother wore on Easter Sunday and at christenings. No is for things that are absolute. Stealing and swearing in church. My mother looks at me and asks me to put my clothes in the hamper, and I say "Yes, ma'am," picking them up from the floor where I've dropped them before she can finish her statement. Feeling the red spread of shame on my neck. "Yes, Ma'am," for our neighbor lady, after she catches me skipping through her lawn, trodding over the daffodils she worked to plant in the spring season. I learn her knees are bent with arthritis, fingers crippled with it since she was 46. "Yes, ma'am" for my teachers, "Yes, sir" for the crossing guard.

No is a secret I hold in my chest, so it burns when I want to use it, a weapon I wield against myself. No is the word in my stomach, churning bile when the young man touches me – when I'm 15 going on 16, when his fingers edge my skirt higher and I don't want him to – but he does anyway. When I can barely say anything and I say "no" so softly he leans in, and his breath is hot on my neck. "No – I don't like it," lives in my chest, a heavy rock when my date kisses me too long. "No, I don't understand, can you help me," when the math and the science or the workload is too much. "No, I don't want to quit." But I am out of school and I am living with my boyfriend. And the no is piling in my body. And I get sick when I say it, so I think it – so

often that "no no no no no" rains against my brain like so many hammer fells. No more dessert, you'll gain 15 pounds before breakfast. No more laughing at that joke, you need to get up and clean the house. And I do. Stop the laughing and the dessert. I get up from the table as a young wife. I put the baby in the carrier, I do the shopping. I sweep and I sew. And I drink and there are so many drinks. "No more," I say. Just to be polite. Hoping they don't notice me appearing a little tipsy. A little less often. "No more or no more or no more." And the inside of me has turned rageful and angry and so loud, and the only way to quiet me is the drink. The bottles of wine I order online, pressing "delivery" with a kind of vengefulness. And the No still lives in my chest. In the angry, sullen place inside of me.

"Yes, ma'am. Yes, sir. Yes."

Yes is the outside voice. Is the way with the world. Is the food on the table. The way I commit and do everything. The car pool and dishes and make Christmas and Easter and our world so perfect. Yes is the skinny woman who lives in this house, who I see in the mirror, the one who everyone loves.

Who stands in the center of the living room on Christmas morning and screams, "Shut the Fuck Up!"

The doors clang shut.

They are always clanging shut. But in my head, in the stories, it doesn't sound like it does in real life. The metallic end-of-life sound of a rehab. The feel that I may never get my freedom or my sanity back. And I look around and I realize... there is nowhere to go from here.

And I open my mouth.

And I say "No."

No.

No.

And no is the anthem for this next part of my life.

No is the way I can say yes to being sober.

To being me.

To becoming who I remember I was. To the world.

No is my Yes.

I hold it with two hands and a broken heart. It is a fragile, timid thing.

I take No from the back shelf of the closet, from the place where I've saved it for Sundays and Easters, and Christmas and holidays, and I use it. On Mondays and Tuesdays, and Wednesdays — on all the days. And I remember what it is to be free.

I use it with everyone but mostly...

I use it on me.

Magically Wonderful Days Gone Bad

Jennifer Walker

Dressing Keeley was like netting a fish. Slippery and restless, she weaseled her way out of my arms and off my lap before I even got one leg shoved through a pair of polka-dotted leggings.

"I don't want to wear pants. I want to wear my rainbow dress!" she screamed, hands balled into tiny fists on her hips.

"I know you do, honey. But you've worn your rainbow dress all week, and Mommy has to give it a wash. Plus, it's chilly out today. It'll be too cold for it."

The aforementioned rainbow dress was a puffy rainbow tutu dotted with sparkly sequins and adorned with a bright pink sash at the waist. From the moment Keeley opened it on her 3rd birthday, we weren't able to peel it off of her. Despite streaks of raspberry jam smeared across the front and a wad of questionable-looking bubble gum smooshed into the back, Keeley thought it was the most beautiful thing in the world.

She stood unwavering in front of me, a freckled scowl on her face, strawberry-blonde curls wild after our scuffle, and I knew she had won. She always won. She was the most stubborn person I knew. She was, after all, my daughter.

"Okay, here's the deal," I said, as I sat back on my heels. "You get to

wear the rainbow tutu for the rest of the day, but then at bedtime tonight, we put you in regular pajamas and Mommy will wash it overnight. Sound okay?"

"Okay," she said flippantly as if I hadn't just worked up a sweat wrestling with her about it. Then, just as unexpectedly, she wrapped her chubby arms around my neck, planted a sloppy kiss on my cheek, and ran off down the stairs. It was a win in my books.

After doing a quick tidy of the kids' bedrooms, I made my way downstairs. Evan was sitting at the kitchen table, his head resting on his arms.

"What's up, bud?" I ruffled his hair as I passed.

"I don't know. Just feel kind of yucky," he mumbled.

"How about I make some pancakes for breakfast? Maybe you're just hungry?" Pancakes were Evan's favorite, especially when I took the time to make them into chocolate chip and whipped cream snowman creations.

"Okay, Mommy." Evan was my easy child, soft-spoken and good-natured, always eager to go with the flow.

But even after succeeding in creating a near-perfect replica of Frosty the Snowman on his plate, he barely ate a bite.

"Okay, I think we need some fresh air. Plus, Wally needs a walk. Go grab your coats, let's go." I glanced at my watch. 9:45 a.m. Another six hours before Daddy was home. This was going to be a long day.

Early on in my stint at motherhood, I found if I broke my day up into bite-sized pieces, the overwhelming vastness of it was a little easier to digest. Breakfast – half-hour. Story-time – half-hour. Play-time in the backyard – another half-hour. I stacked the building blocks of my day like appointments in a busy office job. And before I knew it, the last two building blocks – bath-time and nightly tuck-ins – were

underway, and the blissful freedom of bedtime was within my grasp. They always said, *the days were long, but the years were short.* All I found was that the mornings were long, and the afternoons were longer.

After clicking Wally's leash to his collar, I grabbed my jacket out of the front closet and called both kids to meet me at the door. 5-year-old Evan shuffled over, pale and bleary-eyed, despite a full night's sleep.

"You really don't feel very good today, do you, bud?" I rested the back of my hand on his forehead but couldn't tell if he was feverish or whether he was overheating under the thick sweater he'd pulled on. Keeley, on the other hand, clomped to the front door dressed in her rainbow tutu, a set of glittery fairy wings and a pair of oversized, hand-me-down, purple rubber boots. I opened my mouth to argue her attire for the second time today but decided some things were better left unsaid. After all, it had rained the night before, and slick puddles lined the street. Boots would be appropriate. She was surely going to be cold with only her T-shirt and fairy wings, but wouldn't that natural consequence be more authentic than another showdown with me this morning? I had to pick my battles.

"Okay, let's head out!" I said, with a bit of forced enthusiasm. "Maybe we can hunt for worms!" Usually, the prospect of hunting down anything creepy and crawly was enough to get Evan bolting out the door, but he loped behind me instead, solemn and quiet.

"No worms today, bud?"

"Nah, I don't feel like it."

"You want to ride in the wagon instead?" I asked. Usually, the wagon was reserved for his little sister, and there was no way he'd allow himself to be pulled along. But today was an anomaly. Instead of answering, he climbed in and took a seat. Maybe he really was coming down with something.

"You want to get in with your brother, Keeley?" I asked her.

"No way. I'm splashing in puddles!" she chirped. And off we went, scrawny little Wally leading the way.

We were twenty minutes out the door when strange coughing noises floated up from behind me in the wagon. Keeley was a few steps ahead, painting the world with her fairy wand, while Wally trotted beside her, marking every fence post and fire hydrant.

"Mommy!" The coughing transformed into gagging, and I turned around just in time to see Evan hurling chunks of Frosty the Snowman all over the front of his shirt.

"Oh, honey! You told me you weren't feeling well, and I didn't listen, did I? I'm sorry, bud." I raced to him, gently tilting his head to the side so the next round would hopefully land on the outside of the wagon.

"Hey, Mommy! Look!" Keeley called from up ahead.

"Not now, sweetheart. Poor Evan's feeling sick. Just give me a minute, okay?"

I stroked Evan's hair with one hand, Wally's leash wound tight around the other. Judging by the blank stare on Evan's pale face, another round of dry-heaving was about to begin. Wally was perturbed that his walk was being interrupted, and bounded back toward us. I put my foot out to prevent him from investigating Evan's recycled breakfast, but doing so caused the leash to get all tangled between my leg and the wagon's handle, so I dropped the leash entirely, figuring I'd sort it all out in a minute.

"Mommy, look, I'm in my own hot tub!"

The absurdity of her words was what finally caught my attention. I looked up, expecting her to be playing on the strip of grass between the sidewalk and the road. Instead, Keeley was sitting, hip-deep, in the muddy puddle of a giant pothole — smack-dab in the middle of the street.

"Keeley-Ann! Get out of there right now! It's dangerous to be on the street!"

"But, look Mommy, it's rainbow water. I have my own swimming pool!" To her credit, she was right. A thin film of oil was spread over the giant puddle, reflecting a swirl of rainbow colors in the dirty water. This only fueled my disgust and panic.

"Oh, Keeley. You're going to be such a mess. Come here, I'm going to have to clean you off." I raced over to grab her.

Back on the sidewalk, Evan gagged, then retched some more, this time blanketing the inside of the wagon, including my new Burberry purse. Having children and having nice things did not often go well together.

"Evan, honey, I'll be right there. Just try and throw up on the sidewalk instead of inside the wagon, okay? I just need to grab your sister." I turned toward Keeley with a pointed glare. "Okay, kiddo, time's up. Let's go." My tone was flat, absent of any of this morning's sing-songy optimism.

"No, I want to stay here. I like my secret swimming pool."

"Keeley, I'm not arguing anymore. We're lucky the street is quiet this morning. Now, up you go!"

"No." She punctuated the point further by scooting her bum forward and flopping herself back, transforming into a rainbow starfish in the middle of the street.

"Keeley, I'm counting to three. One... two..." But I didn't even bother counting all the way. It was evident by her behavior all morning that this wasn't a day where Keeley would give in. Counting was a futile effort. Instead, I dove down, scooped my arms under her armpits, and tucked her squirming body into a football-hold on my

hip. She screamed and battled me, soaking my face and my sweater with a muddy, oil-slicked mess.

And that's when I looked up to catch the quick movement of a rabbit darting across the road in front of us, its soft fur a patchwork of brown and white in the early spring.

A rabbit. If there's anything to get Wally going, it's a rabbit.

Sure enough, before the thought had even fully materialized in my mind, Wally was off like a bolt of lightning, his bright red leash trailing behind.

"Wally!" I cried, even though I knew my efforts at retrieving him were useless. When it came to rabbits, there wasn't much that could deter that dog.

"Mommy, let me go. I want to play in the puddles!"

"Keeley, enough with the arguing! You've had your play with puddles. We've got to track down Wally and get Evan home. So shush!" My grip around her waist tightened, and she quieted her body slightly. But there was no way I trusted her enough to actually put her down. We made it back to the wagon, where Evan's face rested listlessly on the edge. Out of the corner of my eye, I caught glimpses of Wally zig-zagging across the street after the rabbit.

"Evan, can you just stay here for a second? Wally got loose, and Mommy's got to go find him. Keeley and I will be right back, okay?" His eyes were closed, but he responded with a slight nod. I knew, at least, that one of my companions wasn't going anywhere.

"Wally!" I called, huffing Keeley further up my hip. "Come on, boy. Let's go home for a treat!" A blur of brown and white bolted past suddenly, followed by Wally lumbering behind. The rabbit paused, weighing its options, then squeezed through a gap in a neighbor's fence. Wally skittered in after it, so Keeley and I trudged across the road once more.

The gap in the fence was too narrow for a middle-aged mom and her feisty 3-year-old, but the gate was unlatched, and we were able to enter the yard that way. I called out to see if anyone was home, but it being 10 in the morning on a Tuesday, no one answered. We walked along a worn, gravel path onto a lawn that badly needed a mow. The rain from last night turned the blades of grass into a thousand sparkling diamonds in the morning sun, but it also soaked my feet up to my ankles. Keeley had the right idea with her rubber boots, after all. I scanned the lot for a sign of Wally or the rabbit, but it was empty. My impatience for the morning's events was at an absolute peak.

"Wally, come here right now. You're being a bad dog, a very bad dog. Come here!" The words surged out of my mouth, packed with more exasperation than authority. I was almost ready to call it a day and leave the dog to find his own way home when I heard a small whimper from under the back deck. I walked over to find that the skirting surrounding the patio hadn't been fully installed, with one side exposing a two-foot gap. I bent down to peer underneath. It was dim, but the sun filtered through small spaces between the boards, and I could just make out the silhouette of Wally's small, scruffy body on the other side.

"Come on, Wally, let's go. It's time to go home." I saw him move — or at least try to — but something was keeping him rooted to the spot. I continued to call him, with no luck. He was not coming out, which meant I was going to have to go in.

I lowered myself to all fours, a difficult endeavor in and of itself, even without Keeley strapped to my side. Reluctantly, I loosened my grip on her, and told her to stay put on the grass. The area under the porch was full of dirt, and last night's rain had turned it into a messy bog. The mud was thick and sticky, gobbling me with a loud slurp every time I nudged a hand or knee forward. I was halfway to Wally but couldn't get any closer without lowering myself further. Finally, I plunked down on my elbows to army crawl the rest of the way. Mud oozed up my top and down my pants, and I cringed to think of the

creepy-crawlers also living under the porch. Eventually, I was close enough to reach a hand to Wally. I pulled gently on his collar, enough that his front paw lifted from the mud. It was tangled in a bolt of wire mesh and a strip of fabric from someone's long-forgotten landscaping project. It took both hands to untangle him from the mess, which meant my face hovered just an inch from the mud. His paw finally came free and plunked down into the muck.

"Come on, you dirty dog. Now it's definitely time for home." I maneuvered my way from beneath the porch, which was more difficult in reverse. When I finally stepped back out into the sunshine, chunks of mud settled in my bra and plopped to the ground around my ankles.

"Mommy, you look like a swamp monster!" Keeley squealed with a tinkly laugh.

"Well, I feel like a monster right now too." I said, then walked toward the gate with an exhausted sigh. My body language must have signaled I was not up for another battle, as she dutifully trailed after me out of the yard without an ounce of nagging. I wasn't quite as confident about Wally's obedience and held tight onto his leash in case the rabbit made another appearance.

Evan was sitting where I had left him in the wagon just a few minutes before and perked up as we approached. "What happened, Mommy?"

"I had an epic battle with a mud monster, and well, the mud monster won. But I'll get him next time." I said with a wink. This coaxed a small smile out of Evan, and he sat up straighter. Keeley put her hand on the side of the wagon, intending to climb inside opposite her older brother when she caught sight of the vomit splattered all over. She thought better of it and instead fell in step beside me, her little legs moving twice as fast to keep up. It wasn't long before I felt the soft warmth of her little hand in mine, despite the mud and grit. She tilted her face up to the sun, closing her eyes and letting the warmth of it kiss her freckled nose.

"Isn't it beautiful today, Mommy?" She transformed her fast-paced walks into cheerful skips, completely unfazed by the squelchy sounds coming from her left boot every time it hit the pavement. Keeley had a way of discovering a little sunshine wherever she went.

We finally made it home, less than an hour after we'd left, although it felt like days. I grabbed the garden hose to spray down the worst of it all – Wally's matted fur, the rancid contents of the wagon, almost all of me. Then, we all stripped down to our underwear, right there at the side of the house. The last thing I wanted was to bring any of this filth inside. I figured if the neighbors caught sight of us, we would be offering them a little entertainment to top off their morning. We stood shivering and goose-pimpled in the front foyer as I used one of Wally's old, ratty towels to dry us off.

"Mommy, I think I want to lie down for a bit," Evan said.

"Yeah, I bet you do, bud. It's been a rough morning for you. Want Mommy to come in for a snuggle?" He answered by nodding his head. I scooped him up the way I used to when he was small, and we marched up the stairs. I figured Keeley would take the opportunity to go play on her own, but she followed us into Evan's room instead. I lifted his dinosaur bedspread, laid him down, then slid in beside him.

"Can I come for a snuggle too?" Keeley asked, her face pressed right up against mine. I'd succeeded in scrubbing the dirt from her little body, but I hadn't had the strength to tackle her hair. Mud clumped at her scalp, raising her tangled knots into a fiery crown upon her head. She resembled a woodland princess, which suited her just fine.

"Sure, come on in, Princess." I scootched over, and she climbed in, fitting like a perfectly matched puzzle piece into the crook of my arm. With our three bodies squeezed together, exhaustion blanketed us under the warm duvet. My eyelids started to flutter, my chest rising and falling in rhythm with my two children.

"You know what, Mommy?" Keeley yawned the words out, fighting herself out of sleep.

"What, Keeley?"

"I feel bad for Daddy," she said.

"You feel bad for Daddy? What made you think of that?"

"Well, poor Daddy had to go to work today, in his boring office, where nothing fun happens. And us? We had the funnest day ever! I bet he's jealous of us." She curled her legs tight against me. "It was a good day, wasn't it?"

I stroked her hair as tiny puffs of air blew against my neck where Evan's sleeping face pressed.

"Yeah, Keeley. You're right. It was one of the best."

Flip

Christin Rice

Electrodes strategically placed on my belly sing out a sound I've grown to love in my twice-weekly neonatal testing visits: a teeny, speedy heartbeat. Hers. Wildly irregular in thrum, but I'd been assured that was perfectly normal. If anything, fluctuation from fast to slow and back again is exactly what we'd been listening for this final trimester. It is one week before my scheduled induction, the prescribed timeline dictated by my advanced age, 43, and history of hypertension.

I'm not here for my usual appointment, though. I am in the largest of the flimsy seafoam rooms. My husband, Dan, stands at the foot of the bed, holding my besocked foot. A short, nervous nurse is hovering over the monitor. And the two OBs assigned to the task flank me. We are all here for an ECV, external cephalic version. We are gathered to try to "flip" the baby from breech position into a position that would grant me an attempt at a vaginal delivery during next week's induction.

Flub-blub, flub-blub-blub, flub, blub-flub. Her heartbeat will be our guide. If it dips too low, I will be rushed to an emergency C-section.

I had few informants on what to expect when expecting an ECV. My doctor told me there was only a 40% chance of success, and they'd allow no more than three attempts because more than that created too much stress on the baby. "Hurts worse than birth" was the only

consistent message I'd received, but each attempt would only last one to two minutes, so greater-than-birth level pain seemed worth trying for the option of an easier birth recovery.

The nurse at the monitor gives me something to relax my uterus so it won't fight back when the doctors apply the necessary pressure. Now, as we are about to begin, my kind doctors look genuinely reluctant to start. The more senior of the two says, "Just try your best to keep breathing."

"I plan to close my eyes and go to a very different place while you work," I say, and promise I will definitely try to breathe.

They place all four hands on me: two to shove her bottom, two to lead the shoulders and head. "Ready?" they ask.

I close my eyes and say yes. Dan squeezes my feet. The doctors lay into my stomach with the force of a thousand body builders bench-pressing their maximum weight. Breathing is not an option.

I try to relax into my go-to mental happy place, Ke'e beach on Kauai. A cliff on one side, the ocean on the other, sand beneath, and palm leaves above – a scene from my favorite vacation with Dan, and the setting for my self-hypnosis I use when trying to bring my blood pressure back to steady. I quickly realize I don't want to be steady. I want to shove something like the doctors are shoving. So I go to a tiny island off of Iceland. A nearly 10-foot tall, 8-ton concrete ball demarcates the line where the arctic circle crosses the tip of the island. The snow is two feet deep. Dan's squeezes of my feet become my boots crunching through snow as I heave my body against the ball.

The doctors take a break, attempt number one complete. We all watch the monitor. She immediately slips back into breech position. "Try the other direction?" they ask.

Attempt number two hurts worse because I now know how bad it can hurt. With the heels of their hands, they dig and push and will the

child to move. I feel my stomach turn a startling purple. I almost pass out. But the giant concrete orb must be moved, so I lean into it with my shoulder. I shove and shove, trying to take short breaths for strength. The doctors stop. This time she hasn't budged an inch.

"You can stop," says my OB. "At any time. You don't have to try all three times."

"Do you try something different the third time?" I ask.

He laughs. "Well, no. There are only two directions we can go, from the right or left."

When Dan and I met with our marriage counselor one year before for help deciding whether or not we wanted to try for a child, and if so, how hard to try, she helped us work through our options as well as our personal limits. In the end, we agreed that *if* we chose IVF, we would try two rounds. That was the limit of our willingness, our budget, and our spirits. Our first egg retrieval yielded only unviable possibilities. We went to Iceland in deep winter while recovering, unsure if a second attempt really was right for us. But we'd said two tries, so we tried.

"Let's try one last time," I say, and close my eyes shut ready to heave into the concrete ball once more.

The doctors lean in too, shoving, shoving. The arctic ball moves an inch. Then another. My belly is yanked, pressed, rolled, heaved, the doctors pressing into me with everything they have, arms quivering. The ball picks up speed, begins rolling on its own. With a last herculean effort, it falls off the side of the island, splashing into the icy water below.

She'd moved. We all focus on the monitor, her heart dipping into a slow unsteady pace. They turn me on my side to get a better reading. I stop breathing. Finally, "It's good. She's good. She has a lot of fight in her."

Joy, pride, relief thrill through me.

"It worked," Dan and I echo to each other. We can't believe our luck.

The vaginal birth I attempt one week later is long, horrific, and ends in an emergency C-section. But the reality of her transforms all of my previous definitions of luck.

Moving Picture

J. N. Smith

My new favorite thing is watching my 3-year-old son draw, his mop of brown hair hung over a piece of paper, his chubby little fingers gripping a marker as his creations take shape. Some parents wish their children would stay little forever, but I love watching mine grow. It fascinates me to no end.

He drew his first discernible truck about three weeks ago, and now he draws everything from volcanoes to whales. And they are just as adorable as one would imagine, with funny proportions, big swirly eyes, and toddler whimsy that cannot be duplicated by adults, no matter how hard we try. It's the best.

What's *not* the best is that he's been drawing these incredible little masterpieces and obliterating them with scribbles, unless I am able to snatch them away first. This has caused me endless frustration. Sweet drawing after sweet drawing destroyed, buried under jolting lines and thick patches of *nothing*. I actually cried one day over a picture of a mama whale and her baby that I couldn't get to before he scratched a hole straight through the paper, tearing it and laughing hysterically.

The result of my snatch-and-grab has frustrated him as well. I've tried to explain to him that once he's done with a picture, he should get a new piece of paper before he starts the next drawing. But he

just doesn't understand. He insists they are "not done yet," and gets so upset when I take them away and give him a new piece of paper to start again.

The other day, it all came to a head as I yanked a drawing out from under him, of a fire truck and declared he was done. He cried, big angry tears and boogers dripped down his face as he repeated, "I'm not done, Mommy! I'm not done!".

I stared at him, just not understanding. Drawing is simple. What part does he not understand? And then weird as it sounds, as I sat beside him, folded into the little blue chair at his 'project' table, waiting to grab his sweet little picture of him and daddy 'at the beach', a little voice in my head said *Shut the hell up and leave him alone*. Even weirder, I actually listened to it.

He was drawing as he does, his little tongue sticking out in concentration, and I realized how utterly ridiculous I was being. I wasn't stealing candy from my baby, what I was stealing was worse, his creativity. Shame on me.

I kept my mouth shut and my hands on my lap, and let him do what he wanted, however he wanted. And as I watched him babble and draw, I had an unheard of (for me) *second* moment of clarity. I actually saw what he was doing, and how wrong I'd been to try to stop him.

The thing is, drawing means something specific to me. And I'm guessing that most people – adults anyway – would share my view that it is a 'visual depiction of an object, or singular moment in time;' for example, a flower, a bowl of fruit, dad and son at the beach, a fire truck spraying water, a whale farting (whale farts have been the inspiration for many drawings of late).

The thing is, to my son, it's not. He missed that memo, or maybe he just hasn't gotten it yet. When he draws, it means something different to him, and I couldn't see it, because... to be honest, I don't

know why. Maybe because I thought I knew better. Whatever the reason, when I finally did take the time, I was blown away.

I pulled my chair around beside his. I was dumbfounded as I followed what he was *saying* while he drew, and I couldn't believe I had missed it.

It turns out, to my son, a picture is a story. An *entire* story. And his drawing is not done until the *story* is. I sat quietly, sipping my lukewarm coffee as he "drew" me a story of him and dad at the beach throwing rocks. By the end, the white page was a mass of scribbles. "All done," he said as he pushed the paper aside.

Then he got a clean sheet of paper and did the exact same thing again, and I caught on to his process.

First, he sets the scene and gets his characters in order. Those are the adorable drawings I've been snatching away. Then he begins his story. He draws the 'sounds,' which he makes simultaneously with his mouth. Trucks 'vrooming,' things 'whooshing,' and yes, whales "pffffbt-ing.' They quickly clutter the page, just as sounds would in the real world if they could be seen. Then he adds movement. Lines and scribbles showing where things are going, the path his characters are taking in their journey from here to there. Fish swimming, rocks being flung. Intensity and speed are measured in how hard he presses with his crayon or marker. The thicker the line or the more saturated the scribble, the more energy was being exerted by the fire truck or exploding volcano. If he digs a hole straight through the paper, that means whatever is happening is *intense.* According to him, whale farts fall into this category and explains why he erupts into maniacal laughter every time he draws one. Lines accumulate on top of each other as he narrates in his limited vocabulary. "Mommy, then the fire truck..." his voice trails off as he draws sweeping lines across the page faster and faster, harder and harder. "Vroom!" He stops and scribbles over the "flames" he drew which look like an orange X. "Then he put out the fire!"

Yep. That's right. *What I thought was destruction is really my son, in lieu of the words he cannot say or spell, telling me a story.* Through drawing, he is not only conveying the events that take place, but sounds *and* emotions too. It is absolutely incredible.

Unfortunately (for me), he does it all on a single page. And I've been stealing his scenes, before he can even begin. No wonder he's been upset.

His joy is not the final product, but in the *creation* of it. The beauty in his work is found in his voice, when I sit quietly beside him, and listen to him explain what he's drawing, *while* he's drawing it.

To him, a picture has sound and movement. And why not? To my son, a drawing doesn't capture a moment in a story, it tells the whole thing. Who am I to say that's wrong?

I learned something about myself that day. I learned something about my incredibly creative child. I am fascinated. I am so proud. I'm a little ashamed of myself, if I'm being honest, and wonder what other things I am doing, assumptions I am making, that I am blind to. But I am grateful too. I am so glad that little voice, wherever it came from, told me to shut my trap for a minute. Otherwise, I might have missed one of the most fascinating things I've ever witnessed, a new form of artistic expression invented by a toddler – not on purpose of course, but just because it happens.

I wish I could capture all the stories and sounds and pen strokes and hang them all up on the wall together because the physical papers are a mess. The next day, even he can't remember what the scribbles mean, and the magic is lost. But for those few minutes, while he's drawing, while I'm watching and listening, I now see the real pictures, as he sees them, as he intended them to be, and they are breathtaking.

Memories

Crystal Rowe

Notice the quilt hanging on the wall,
its perfect seams and fine design,
permanently displayed for all to see,
pinned smooth and straight.

I'd rather be an old worn quilt
shoved into the storage chest,
with all its rips and tears;
signs of love and a life well lived.

To have been stuffed in bags with sunscreen and beach toys,
mounds of sand collecting in all its undone seams;
imprinted in memories for years to come.

To be washed so many times I now am soft,
battered and tattered with love,
providing warmth, comfort, and safety
for the ones who love me.

I'd rather be hidden in the back of the car
waiting for unexpected adventures in the forest or at the sea,
than to be a pristine quilt that looks brand new,
never to be moved,
cherished from afar.

I'd rather smell of picnics and sweat,
falling apart and needing repair.
If it means a life of memories
I'd rather be an old worn quilt.

We Need Each Other

Jill Robinson

Just when I think we've called out and settled the mommy wars conversation, it pops up again. I've seen passive-aggressive responses on my social media from family members. I've overheard snide remarks on the playground. I've felt judgment in a family member's backhanded comment. In the rough ocean of parenting and the lonely sea of womanhood, I've been left to weather the storm on my own. The people I thought I could depend on to support my family choices have let me down. What I thought was settled is alive and well, continuing to breed discontent and deepen the divide.

Many will judge us for doing what is best for each of our unique situations. Our choices are invalidated by those who don't live in our shoes or our home. No matter what we do, someone, somewhere, will express displeasure with what doesn't concern them.

Do you stay home with your kids? You are now lazy and entitled. It doesn't matter if you use your time to volunteer, to spend time with an aging family member, to coach your child, or to pursue a dream. Others don't see the value in taking stress off your spouse by taking on tasks to give them a break on the weekends.

Do you work? How *dare* you leave your children with someone else! It doesn't matter if you worked hard for your degree and your work fulfills you. It doesn't matter if your income provides your family with what it needs. Others don't see that working keeps your household running at its best.

Are you a woman who doesn't want children? You are now labeled as heartless and uncaring. How *dare* you exercise your right to bodily

autonomy! Strangers should comment on your breeding status. It doesn't matter that you are making the best choice for your own self.

What are we supposed to do? We're damned if we do and damned if we don't. We run ourselves into the ground fulfilling expectations the world lays at our feet and are then judged by our families, our friends, our neighbors, the news, and the faceless public.

What purpose does this self-made divide serve? Do these thoughts come from a place of jealousy, anger, or exhaustion? They certainly don't come from a place of love or caring. What if we supported our sisters, our friends, and our neighbors instead?

We should thank the mothers working outside the home for showing our children they are valued members of the work community. We should be thankful to them for providing a model to our daughters of what they can achieve. We should be thankful they show our sons that women belong in the boardroom, the operating room, and the classroom.

We should thank the mothers working at home for showing up to volunteer. We should be thankful they are showing our children that they can choose the path that best fits them. We should be grateful for the time they can spend caring for the people we love.

We should thank the mothers who do both for showing our children we can do hard things. We should thank them for proving we are not limited by our gender.

We should thank the women who show our sons and daughters there is more to womanhood than being a mother. We should be grateful to live in a time when women have the freedom to choose their own path.

The next time you find yourself judging another woman's choices about motherhood or career, I challenge you to ask yourself what need is being served. What insecurity are you feeding? If they are

happy and thriving in their position, why would anyone else's opinion matter?

We all have a unique path to forge on this earth. That path shouldn't be guided by those who are not on the trail with us. When we find someone trying to force us from our chosen road, we should be free to turn away and continue on our journey in peace.

So forge your own path, judgment be damned. For you can't please everyone, and the judgment will come anyway. You might as well be criticized for taking the path that makes you happy with a light heart and a smile on your lips.

While you're at it, seek out those who shine a light on your success and shield yourself from the passive-aggressive busybodies shooting flares from their sinking ship.

Apricity

Madilyn J. Whitley

I never thought of burning alive as being so cold.

My blood had turned to ice, ice sharper than new kitchen knives, shredding my veins and leaving them, tattered, to infection. My chest was a black hole, an endless maw devouring who I was and who I could have been.

Outside the bathroom door, my 4-month-old son screamed for his mother. My husband tried vainly to calm him, and I heard my toddler come in to ask what was wrong. He didn't understand – none of them did. They didn't understand why Momma was so tired. They didn't understand why Momma had gone from silence to a raging monster, yelling through sobs until she slammed them out of the bathroom. They didn't understand why this person who looked like Momma didn't sound like Momma. Didn't love like Momma.

I stared at the stranger in the mirror, fingers coiled around the cool counter. I didn't understand either. The weight of my failure threatened to push me through the floor, my legs crumpling in worthless heaps. The echoes of the screams and questions outside battered the inside of my head.

Failure. Failure. Failure.

For almost the first half of my second son's first year of life, this was our reality. Pandemic had struck mere months before he was born; I

had a COVID-19 test while in labor, and was checked in wearing a mask. There were no visitors allowed. Afterwards, we stayed in our new home in a new state. The pandemic raged outside, but my own blizzard whorled within me. Though I clawed and screamed until my heart and mind and soul were raw, I suffocated in my own incompetency.

I failed because I birthed not one, but two premature babies. It did not matter that they were healthy. Every problem, every common sniffle and allergy, existed because I was incapable of carrying them in my womb for 40 weeks.

I failed because I could not nurse this one, either. At least with my first, I exclusively pumped. With my second son, the letdown was extremely painful, but if I relaxed, the milk gushed out of me and down his throat until he coughed and gagged; when I sat him up, milk pouring down my shirt into the chair, he expelled everything he'd managed to swallow all over me. And then he would begin to cry, hungry. Meanwhile, my breasts became swollen and hard with the milk he could not drink.

I failed because I became so desperate to escape the babe clinging to my shirt that when I found the freedom of his sleep, I did not burp him for fear of waking him. And when he woke in a torrent of screams and spit up, I cowered in the shadows of my guilt.

Most of all, I failed because I looked upon the miracle I had birthed and felt only resentment that he kept me from "my family."

He did not feel like part of my family. And though part of me knew that, logically, he was, still he was an outsider—the *enemy*.

When I went to my OB/GYN for a pap smear at six months postpartum, my doctor sat down on her stool, rocking back and forth on the wheels while she tapped the 10-question questionnaire I had filled out.

"Seems like you're having a hard time," she said. "Would you like therapy or medication?"

That was it. Six months of hell boiled down to a simple question. She didn't even mention a name, though I had seen it on the top of the questionnaire: *postpartum depression.*

I left that day without treatment. Everyone had always said adjusting to two kids was hard. Maybe I was being overdramatic on the questionnaire. After all, every other mother of multiples had figured it out; surely I could, too.

The most lethal weapon in the arsenal of postpartum depression is its ability to make its victims feel alone. It is a parasite, coiling around our lungs, spouting poison into our brains, until we are unrecognizable from the women we were before. My mind was always my sanctuary. There, I could escape from reality. Depression was the ultimate betrayal. It was a church burnt to ash, abandoning me to pick up piece after charred piece. No one, *no one*, understood what I was going through. How could they? I couldn't figure it out myself.

Influencers on social media tried. Black and white photographs of staged messiness, vulnerability shown at just the right angle to be relatable without being entirely true. It was just enough to make others feel so "not alone" as to hit like – rarely enough to pull someone out of the darkness.

Because that's not the point. Those aren't people wanting to get out of the darkness. They just want to know the darkness isn't lonely.

I am not one for a crowded darkness. The night holds no joy simply because others dwell there with me. I crave the sun. And I knew it, even as I walked through the valley.

But how do you climb out? How do you find the strength to claw your way up, fingernails breaking in the clay and the dirt, as others' vices and your own failures pull you down? The exhaustion sets in.

The sweat trickles into your eyes. Suddenly you can't see the sun anymore; you start to question whether it even exists. What then?

We cannot sit still. If motherhood has taught me anything, it's that. We are caught in whitewater – no matter how hard we try to sit still, to breathe, to slow our heart and rest our legs, still River Time drags us by the hand: *I am moving. We must go.*

Children grow up before our eyes. You put on clothes that fit them yesterday, only to be greeted by a peeping belly button or ankle. They open their mouths, and instead of jibber-jabber, words and sentences spill out. You adjust car seats. Toddler forks are suddenly too small in their hands.

I am moving. We must go.

That was supposed to make me *feel* something! My children were growing up. And yet, where my heart was supposed to swell, there was only a desert, a vacant lot of overgrown weeds and buzzing gnats.

I suppose not all social media posts are the same. In a flipbook of monochrome, one or two technicolor images stand out. And maybe that's why influencers believe themselves gods – because every once in a while, their screams into the meta mean something.

I still remember scrolling through Facebook and seeing those words jump out at me. I had just started following that blog, *From Blacktop to Dirt Road*, a few days before. Her picture, nothing but her face, smiled at me from below words that changed my life:

"I take antidepressants, and it makes me a better mother."

Never, not once, had I considered that taking medication would make me a better mother for my kids. It had always been my fight, and medication was another failure, something else I was incapable of doing on my own. If I admitted to medication, I admitted to failing my kids and my family.

And yet, here was someone whose simple words turned my world on its head. *It makes me a better mother.* The words bounced around my mind.

In all my struggles, in all my screams and frustration and failures, that was all I had ever wanted to be: a better mother.

I am moving. We must go.

My children, my family were leaving me behind. No – I was holding them back, drafting them into a war that wasn't theirs.

I am moving. We must go.

The next day, I called my primary physician and started treatment.

Almost a year later, I have climbed out of the trench but still fight on the battlefield. Depression is a constant fight; after weeks of good days, suddenly I wake up back in the bathroom, clinging to the cold counter. I practice the dance every day, the monster inside of me prowling, waiting until I am weak.

And yet, the scene has changed. Now when I look in the mirror, I see remnants of who I used to be. I see the woman I learned to respect when she moved out on her own. When she learned to make her own choices. When she vowed to love herself. When she became a mother.

Motherhood is never an easy road. Postpartum depression makes it harder. I tell my children I can give "magic mommy kisses," which erase all boo-boos, but I cannot magic away the wounds I dealt when bound by the chains of PPD. Even as I strive to heal my mind, I must rebuild the relationships that crumbled under the weight of my sickness. I am not the only one left with scars.

And yet, I am thawing. The maelstrom calms, and the world warms. Time scoops me up, carrying me like a prince who swept his lost

damsel off her feet, and we ride onwards, towards the edge of winter and brighter sun.

I am moving.

We must go.

Eden Renee:
An Open Adoption Birth Story

Kim Patton

Saturday, February 1st, 2020
My phone blinks in the dark of evening
A notification on Facebook says:
New Birthmother Situation

I click like I have done so many times before
Wondering,
Is this the one?

Kevin and I have been praying about fostering and adopting since
early 2018
After years of an empty womb
After tears of confusion, dripping off my face
After research and conversations with respected friends and pastors
Nudging us toward welcoming home children not of our blood

But still, my heart ached
I begged God to give me the strength to release my infertility to Him
So that He could bring us

Our family

I open the file to see a short blurb posted by a case worker at an attorney's office

Baby girl due any day. Biracial. Please call Sue if interested.

I glance at the clock and walk toward Kevin lounging on the couch, head tucked on a small pillow

The phone glows and his eyes match mine as he reads

"Can you call her?" He asks

He is all in
He has thrust forth his chips, his finances, his future.
He eagerly waits for God to bring us our family

The bedroom light is wild, shining a spotlight on my shaking hands
as I dial her number
Leave a message
Send an email
And then go to bed,
heart pounding

Sunday, February 2nd
Sue is in Colorado, flying back to Florida
"Call me at 2pm" She says

I watch the clock, text my family, bounce my leg up and down during church
And
Pray
Pray
Pray

We are at Sonny's Barbecue for lunch and the food is slow as snails, not reaching our plates
Kevin and I stare at my phone
Then each other

Back and forth, our thoughts spinning around in our heads like
hamster wheels

Is this the one?
Are we going to remember this moment forever?
Or is this another child dangled in front of us before being snatched
away?

I had gotten used to letting go of plans
Of dreams
Of wishes
And even sometimes...
Hope

My heart, once soft and open, was now steeled
Caged
Protected

To avoid rejection, I turned my back
Against the possibility of another dripping wave of disappointment
Of hurt
Of bone-breaking pain

But when Sue's voice came on the phone before 2pm
My eyes were wide with expectancy
Possibility ballooned in my chest once again

Kevin saw me scrambling for a pen and unwrapped the silverware,
thrusting the restaurant's paper napkin in front of me
He held the edges down securely while I took notes

Ashley's due date is February 27th, but she has shown signs of early
labor
All six ultrasounds show a very healthy child
Baby is expected to stay in the hospital for five days after birth for
monitoring
I only have one other adoptive family profile to show to her on
Wednesday.

I write to Kevin,
BETWEEN TWO
And circled it twice.
We have applied for so many birth situations, but
We have never
Ever
Ever
Ever
Been this close to being matched with a birth mother

We choke down half our food and box up the other half to let sit on
the car floor while we run into Staples to print documents.
I mail the documents overnight to Sue
and then...

more waiting

Wednesday, February 5th
Kevin verifies the procedure before he leaves for work

"So you'll call me if you hear anything?"
He is holding his lunchbox and water bottle, ready to go

"Yes." I nod, still wondering if all this would be for nothing
Still thinking I might be left empty
Still expecting to be told, "no" once more

I am tired of holding my breath

"What time are they meeting?" He asks

"Uhhh afternoon. That's all I know." I say, and he puts his phone in
his pocket

"K." He says.

"K." I say.

We have no other words

At 2:25pm
I have done my work for the day.
I have felt the jitters run through my veins like the sugar in a gallon
bag of Skittles
I have used up every ounce of patience I can muster
And I am treading on thin ice, praying not to break through

Sue texts me.
.
.
.
.

.

"Do you have a name for this baby?"

The thumping is my chest is the only sound I hear
I type the few names Kevin and I had been talking about,
hoping Ashley won't be detracted by our choices

I wait a minute and then couldn't help but ask,
"Does this mean she chose us?"
The late afternoon sun split through my window, warming me as I
read the answer

"Yes."

Friday, February 7th
Kevin and I hop in our little red car for the hour long drive to meet
Ashley for the first time

She is tall and strong in a black dress, her 37-week pregnant belly
jutting low
Her eyes are deep and dark and her smile is wide
her skin is deeply tanned with Italian flavor

She is beautiful

At Outback Steakhouse, we scarf down bread with lots of butter
And talk about animals,
Baby names,
Her parents and siblings
We are all nervous but okay

She teases us and we tease her
She is blunt and sarcastic and makes me laugh

I instantly like her

She asks about our youth group and church,
And quotes her favorite Bible verse

When we leave, she waddles and comments about how big she feels,
How uncomfortable she is,
And how this baby is perfect, healthy, a miracle

We look into her eyes in wonder
At the possibility of this adoption actually going through,
My eyes can't help but see through that belly to a curled up child
that doesn't belong to me...

Yet

Monday, February 10th
Ashley wants an ultrasound
And we offer to take her

She climbs on the table,
Stretches her arm over her head
And looks up to one of the many screens in the room

The gel is rubbed gently on her belly
The transducer kisses her skin
And suddenly,

Baby girl is everywhere

The technician clicks photos and types measurements,
Her keyboard taps filling up the dark room
She points out baby's fuzzy hair on top of her little head
And quietly mentions that baby is over 6 pounds

We are mesmerized, frozen in the juxtaposition of
Life
Adoption
Humanity
And Ashley's unspeakable pain as she breathes in sadness and
breathes out a cough of heartbreak,
Gulping air and spilling tears

They roll down her face
And I am there,
Rubbing her arm,
Patting her in reassurance
And whispering,

"I know, honey. I know. It's okay."
She chokes out the words,
"I'm happy but I'm sad
She's so perfect."

I see baby girl,
Hand tucked under chin

My heart isn't open wide enough for both of them
I hold Ashley first

I want to believe baby is ready for us,
But so many things could happen and my doubt gets in the way
It's too hard to open up and accept a beautiful gift that isn't here yet

So I hold back
And focus on Ashley

Baby has to stay warm and cozy for a little while longer
Before I have the freedom to call her
Mine
Mine
Mine

Friday, February 14th
My friend texts me, begging to help with preparation for baby

I am busy working on the registry,
Collecting diapers and wipes,
Researching pregnancy, labor, adoption and local hospitals

My phone is constantly plugged in to retain power

She is desperate to help
But doesn't know what to do

I am overwhelmed and worried about one big thing:

How do I feed the baby?

The milk banks do not have extra supply for adoptive mothers,
only preemie babies in the NICU

But then through online Facebook groups
Mamas are stretching out their arms, offering me frozen breastmilk
from their bodies
from their freezers

A wealth of generosity that measures far deeper and wider than I
could have imagined

So my friend flies into action, driving all over town,
communicating with the donor mothers
picking up bags of frozen milk

Her freezer fills up
But she is willing to get more, and finds someone else to help store it

I am humbled by her kindness
and relieved to know I am not alone
Before I am a mama,
I am seen as a mama

Friday, February 21st 1:30am
The darkness peels from my eyes as a melody floats into our room
My phone is ringing
It is Ashley

"We're going to the hospital" she says,
Her voice faltering, like a ball slowly falling down the stairs

My legs slide to the floor and I nod along, cutting through brain fog
to focus on her words

"I can't stand the pain anymore" she croaks
and I can hear the strain in her voice
I soothe her as much as I can before she hangs up to finish out in
strength
the final moments of her pregnancy

Kevin is moving toward his hospital bag that he packed days before
And I am zombie-ing around the house to make sure I have
everything I need
Then we are gone,
Into the chilly night air
Under a twilight sky

We walk arm in arm to Labor and Delivery
and knock on the large wooden door
On the right lay a small wrapped bundle in a bassinet,
On the left, a bundle of blankets stretched out and exhausted on the
hospital bed

I walk gingerly up to Ashley,
Set my bag down,
And give her the joy bursting from the waterfall within me

"You did it, honey! I am so proud of you!"
Her hair is wild and free, her face filled with relief and then tears.
She has brought life into the world, and as I clasped her hand
I tell her it is no small thing.

She knows

She smiles because we are here
and her great physical pain is over

Her eyes float to the baby, and she tells me to go see her

Kevin is standing over the bassinet, gazing at the tiny package of
6lbs, 14 ounces.
I watch the nurse put a thermometer in her armpit
And marvel at the tiny squeal that baby girl makes,
Her virgin skin turning even more pink.

Ashley says she labored without pain medication,
Giving birth nearly in the hallway
But making it to a bed at the last minute

"Stop and drop"
The nurse says as she checks Ashley's blood pressure

Ashley is wagging her head back and forth,
rubbing her tired eyes,
Bragging about how perfect the baby is

How healthy
How strong
How absolutely beautiful

Kevin and I slide the little tiny pink and blue hat off baby's head

And stare at the thick, black hair that sprouts mere inches above her
eyebrows

Before Ashley asks me to dim the lights so she can rest,
We take a picture all together,
Birth mother, baby, adoptive parents

Ashley beams with pride,
then looks toward us and hands us sleeping baby

"What is her name?"

I let Kevin answer
It is a first and middle name rich with meaning,
a thousand stories living behind the letters and cadence

"Eden Renee"

And suddenly,
She feels like ours

Legacy

Casandra Chesser

I love being a mother. It's everything I ever wanted. My entire life, my plan was to be a stay-at-home wife and mom. I wanted to be the mom who wrestled around with her kids, who would go with them on field trips, make them dinner at night, and just be *present* in their lives.

Writing seemed like the answer. I started writing pretty much as soon as I could form the words on paper, and turning that hobby into a career would be perfect (or so I thought). I could do something I liked, do it from home, still contribute to the household finances, and be with my kids. It would be so easy!

If only I could talk to myself then.

I am fortunate, so fortunate, to be able to do what I do, and to have six kids. I know so many people would love to be in my shoes, which is exactly why it's so hard to talk about how hard it all is because moms aren't ever allowed to be unhappy. Then you get labeled ungrateful. Selfish. A bad mom.

Most days, I feel like I'm killing it. I write like a boss, take care of my kids without losing my shit *most* of the time, make awesome food for everyone, and I'm even learning to play piano just for funsies. On the surface, it would probably look like I have everything together – or maybe everyone can see what a hot mess I am. Who knows? But what I *do* know is how lost I feel, so much of the time.

Who am I, now that I'm a mom? Sometimes, it's hard to remember who I was before my entire being was taken over by children. Who was I then? Who am I now?

I used to be a singer. I went through vocal training and had dreams of singing professionally once. I would sing karaoke every week with the same group of friends, and we never missed a week, ever. Those were some of the best times of my life. I would go to museums, read whenever I wanted, watch whatever I wanted. I was outgoing, ambitious, opinionated, and I had a body to kill for – which, of course, I didn't appreciate *at all* before I had kids.

Now, I rarely sing for myself or anyone else. The only museums I go to are the ones geared towards kids, and I'm too tired to be outgoing. Life has smacked me around one too many times for me to still believe I know everything. And every day, I struggle with not hating my body – the pudginess of my stomach, the stretch marks everywhere, the boobs that now point towards the ground rather than straight ahead. Every day, I'm overwhelmed, exhausted, and touched out. If someone asked me who I am today, I wouldn't be able to tell them. I don't know who I am, except for one thing.

I am a writer.

I am a mom, but I'm still a writer. Motherhood has changed virtually everything about my life, but my creativity can't be stolen away, no matter how tired I am or how much I have going on. I still lie in bed at night, with characters visiting me as my mind fades to black. Inspiration still erupts in the craziest moments, when I wouldn't have ever expected it. That itch to write, to create, still blooms. And it's for more than just my own satisfaction.

One day, I won't be here anymore, but the things I've created will live on long after I've died. I will leave behind a legacy, one that I pray will make them proud. I hope that they will be inspired to take on whatever goals they want, and through my example, know that it's possible. I hope they look at what I've accomplished, and know that *I*

can do that, too. I hope they read my books after I'm gone and see glimpses of me in the stories I've written. Art is so much more than the ability to make a living. It's to create something that, even if only in a small way, allows us to live forever in the hands of those we love.

So it's true, I may not know who I am anymore. But I know who I'm doing this for, each and every day.

Wings
Discovering ADHD Magic

Adva Shaviv

Her image filled me; little me at age 8, clinging tightly to the railing from the outer side of the footbridge, high above the road.

My eyes focused on the screen again, blinding in its whiteness.

My little self moved her right leg, and nearly missed her next step by the width of a book spine. Up until that moment the thrill of adrenaline killed any trace of fear within her, but this hint of falling generated a few drops of cold sweat on her childish palms. She never wished for safety, of course. That was for the others, the regular ones. The whole point of putting herself in unnecessary danger was to get out of it unscathed. It wasn't fun otherwise, just plain silly. Little me sneaked a glance below, then lifted her face to the sun.

"I can do anything I want," she whispered to herself or to the world.

I stared at the blank screen. Can I do this?

The little girl's whole body came to life with precious sensations, ones that safety and comfort simply could not provide. Up there, everything was up to her; there was no one around to point out her

inadequacies and tell her she should stop acting like crazy, or how come a bright girl like herself, or why can't she be like everyone else just for once. What's the point of being her, if she's to be just like everyone else?

The image lingered, little me clutching the vertical shafts of the railing from the wrong side. What a free little spirit. A free little spirit clinging with all her might to the outer wall of the cage. What would have happened had she slipped back then? Would she have fallen? Or would she, I, rather have grown wings?

It wasn't entirely empty, my screen. It did have a title I saw as I stared at the otherwise blank, white screen, stared so hard and long until I didn't see the whiteness anymore, but rather all kinds of colors dancing in unshaped movements around the center of my gaze. *ADventures Heading up and Down*, it said; my new take on the ADHD acronym and the title of my novel-to-be. My ADHD fantasy novel.

Back then, little me knew she was different, but there was no name for her difference, the letters ADHD having hardly met each other yet, and so she thought she was simply damaged. There was something very wrong with her, something nameless, and she was terrified of anyone ever finding out.

But I found out. Decades later, still refusing the cage of social demands, my difference was given a name. I wasn't damaged; my brain was differently wired. It didn't, still doesn't, deal well with the mundane, the banal, the necessary; but it thrives on the unique, the extraordinary, the fantastic. It gets stuck on the consistent, the boring, and the steady, but shines in the novel, the challenging, and the unexpected.

The words flowed under my typing fingers, and a new world was born: an ADHD wonderland, where little me could safely climb around cages. A world built to accommodate her, me, and the likes of us, allowing us to reenter ourselves, this time through ADHD magic.

I did not doubt it anymore. I can do this, I told myself as time went by, filling pages after pages of my novel, exploring the fantasy of my brain. Sure, I thought I would have finished this novel three times by now, but time-blindness was always a crucial part of my ADHD reality, just as it is of my ADHD fantasy.

I'm off to find my wings.

Worst Mother in the World

Kimberly Parsons

When my son was 6 weeks old, he fell from an improperly tied soft wrap onto a hard concrete floor. One trip to the ER, two CT scans, and an overnight stay in the children's hospital later, we were cleared to go home. He was fine, but the person who tied that wrap? She was not.

I couldn't talk about it for three years. The shame and inadequacy were overwhelming. I didn't want anyone to know what had happened, and I agonized over my son's safety much more than was healthy for either one of us. My husband and parents all assured me it could have happened to anyone, and I shouldn't keep beating myself up over it. I wish they had told me that self-recrimination was part of parenthood, too.

As a tween and teen, I was a popular babysitter. Families engaged in bidding wars for my services and pooled their resources for couples' nights out. I ran our church children's programs. I was a part-time nanny during college. Then I waited much longer than my peer group to have children. When they were marrying and starting families, I was in graduate school. When they were vying for places in premium preschools, I was building my career as a music educator. By the time I managed to marry and procreate, my friends' children were almost old enough to babysit. With the arrogant wisdom that I imagined came with age, I pictured myself coming

fairly close to being The Ideal Mom™. I would be something like
Mary Poppins — unflappable, capable, magical, and practically
perfect in every way. In reality, the only things I have in common
with Mary are my vocal range and a black umbrella.

A list of my unmagical mothering moments includes not brushing
my toddler's teeth thoroughly enough, so that he had 3 cavities
before he was 3 years old; not installing safety straps on the dresser
in the master bedroom so that when my child scaled it like Everest, it
fell over on top of him; dozing off while my 9- and 6-year-olds played
and knocked out a permanent tooth; failing to tell my dad how to put
parental controls on his television; getting behind on the laundry
and teaching the kids what going commando means; using swears
(the big ones); and eating their candy after bedtime and lying about
it.

Forgive me, Mothers, for I have sinned.

Are you shaking your head, thinking, "There aren't enough Our
Fathers for that, lady!" Maybe, just maybe, you're thinking, "Me,
too, sister. Me, too."

Not only am I not the mother I imagined, but these *kids* I have are
not the ones I imagined, either. Maybe like me, you expected blissful
days at the park. Blue skies, cool breezes, friendly squirrels, right?
Nope. Not in my cards. We watched a squirrel *die* one day at the
park, and on another blue-sky, cool-breeze day, I looked into the
towering green of a blossoming pear tree to see an arc of golden
urine tumbling 15 feet to the ground. "I wanted to see if I could pee
from a tree, Mommy!" Avoiding the city park for a few weeks in case
anyone recognized us as the tree pee'ers was not what I had
envisioned for us. No, ma'am.

I dreamed of cuddles and lullabies, but my baby wanted to see the
world, rolling over on his own at just 8 weeks of age, crawling at 10
months, and full-on running soon after. We skipped the adorable
babbling stage, went straight to talking, and he hasn't stopped since.
Carefully chosen gender-neutral toys? Psh. Please. Trains and

trucks, thanks. Other people's kids slept until 8 or 9 each morning. Nope. I was up regularly at 4 a.m. to make sure he didn't play with knives, electrocute himself, or skip town after hot-wiring the car.

My second baby loved to cuddle, but he *never* wanted to be put down. He spent every waking hour in a wrap (properly tied), in a carrier, in my arms, or *on my body*. This baby enjoyed the trains and trucks his brother chose but also wanted to wear pink glittery shoes. In one of my favorite photos, he is wearing a red polyester turban, a camo pajama top, a diaper, burnt-orange baseball socks, and those sparkling shoes. The best part? He's giving me major stink-eye because I insisted he put on pants before we went to the store. Oh, the *horror*.

So much of motherhood is not as advertised. *I love them and their quirks fiercely and unconditionally.* Every age and stage, each child has been full of surprises — many of them good, many of them hilarious. But motherhood has left me perpetually off-kilter, feeling that at any moment, just when I think, "I might have this gig figured out," something is going to shift. The kid who loved pizza pockets last week when I bought a case hates pizza pockets now, and the kid who wanted a kitten more than anything in the world is allergic to the kitten. Surprise! There is a worldwide pandemic, and we have to stay home for a few weeks, then a few months, and now it seems a few years. That proverbial carpet is forever about to be pulled out from underneath my feet, and there is absolutely nothing magical about it.

One of my children said, "You are the worst mother in the world! You try so hard, but you are really bad at it!" I joke about putting that on a mug, but inside, I'm not laughing. It's not that I'm surprised he said it. It's a sign he's growing and individuating. The surprise is that *it is true*. I am not the mother I had hoped to be. I don't know what I'm doing, and when I finally think I might, the game changes, and I have to figure it all out again.

But I suspect most of us, if we are honest, feel the same way. We all have confessions to make. We all have moments we wish we could revisit and redo. We feel that we cannot figure things out, not fast

enough, and that no matter what we do, we are lucky to be right even half the time. *Deep down, most of us suspect we are the worst mother in the world.*

How do we keep going, all of us who are vying for that title? "You try so hard..." he said. And we do. So damn hard. Every day we show up, do the best we can, and then do it again the next day. That is what all of us worst mothers in the world are doing day after day after dead-squirrel-in-the-park day.

The thing that keeps me going is that I think they *know*. My son, even in that moment of pure disgust, admitted he sees my effort. He sees me trying – trying and failing, but trying just the same. And I wonder: is that the best I can give? If I cannot give him a great mom, can I give him a mom who tries? A mom who shows up? I cannot give him Mary Poppins, but I can give him a mom who tries *so hard*.

The next change is right around the corner. Surely the hands of fate are already tugging at the carpet's edge, and there's no telling whether I'll teeter or tumble. I do know that I will keep showing up, the Worst Mother in the World. Maybe I can be the best at trying. Maybe, just maybe, that is more perfect and more magical than I can comprehend.

In Sickness, In Health

Sarah Fedchak

In the emergency room, they assumed I was his wife. I glanced sideways at this boy I had only known for a few weeks and thought about how he'd asked to kiss me the night before, how we hadn't talked about that awkward kiss hours later as we wound down the switchbacks of the Alabama mountains to the nearest hospital, his fever spiking. While we waited in triage, he shivered and tried to flash me a flirty smile, but the whites of his eyes were shockingly bright for the middle of the night. I looked away, knowing he was trying to reassure me even though he was the one who was sick, feeling like I should be the one offering comfort. "This is good," he mumbled, his fingers brushing against my hand. I didn't know if he meant that it was good that we were at the hospital or that we were there together, but before I could ask, he turned his black baseball hat around to face forwards, gave a flick to the lucky paperclip attached to the brim, and dozed off as more feverish chills coursed through his body. When he was admitted to a room, the nurses rolled in a stiff recliner for me to sleep in, insisting it was too late for me to drive back to camp. He and I spent our first night together, separated by IV lines that poured life back into his depleted veins.

In our wedding pictures, he's ghostly pale. His eyes are too white again, the internal bleeding draining even them. By then, I was almost used to the hospitals, the rigid cots at the bedside, the overpriced cafeteria food, the times he'd be rolled away for routine tests, and the alarm for a code blue would echo through the hallway moments later. These visits had folded into our life every six, four, three months.

We vowed to love each other in sickness and health, and when I spoke those words, I thought I knew what I was promising.

Less than a month after the wedding, I sat alone in our new apartment, surrounded by gifts from family and friends. He was in a hospital in another state, recovering from the first surgery. A week-long recovery became a month, as another emergency surgery was needed, as his body refused to heal, as everything that we had hoped to go right went horribly wrong. And then I had to leave him and go back to work. During the sleepless nights, when the plans we'd had for our new life together haunted me, I unpacked our wedding gifts and stacked them in the corner of the living room. When I opened the shiny stand mixer from his aunt, I first put it in the pile with the rest. But as the long lonely nighttime hours stretched before me, I pulled it back out of the pile and set it up on the tiny kitchen counter, the bold red mixer clashing with the ghastly yellow walls.

It started with cupcakes. Mint chocolate chip. Pink champagne. Mexican hot chocolate. A flurry of flour as I poured all my stress into the bowl of that KitchenAid mixer. I tried to take all the different pieces of a recipe and make something whole as I watched someone whole fall to pieces.

Loving someone whose body is broken is a special kind of torture. We were young and in love, yet so much of our lives were determined by sickness. Still, we had hope. We made lists of the trips we'd take and the food we'd cook and the names we'd give our children. When he was released from the hospital and finally came home, we made plans with friends. We decorated the apartment. We tried to start our life together, the one we dreamed would be full of adventure and good health.

Six surgeries in three years shattered every plan we had made. I was never able to trust that he would still be around, not knowing what betrayal his body would launch next. After the last surgery, I walked with him through the hospital hallways, a supporting arm around his waist and IV lines trailing behind us. Every shuffled step broke away

another piece of my heart, watching his once-strong body struggle with the simplest movements. When we made it to the end of the hall, he turned and gave me a hazy smile, the painkillers numbing the agony inside him. "That was good." Even though it would be several more days before he would get the energy to walk that far again.

And still, there were the cupcakes. Pink peaks of frosting on chocolate cake. Spun sugar and toasted meringue, putting all the things I couldn't say into that mixing bowl. Anger for the pain he had to endure. Frustration because I couldn't advocate for his needs. Guilt for the times I didn't want to. Disappointment over cancelled plans. Resentment because so much was out of my control. I baked through my loneliness and fear and heartache, and turned them into something beautiful and delicious, sharing them with friends, neighbors, and coworkers instead of admitting how much I was struggling.

Fourteen years. Sometimes, it all blurs together, as if no time has passed at all, and I am overwhelmed by the ache of hope and happiness that we've made it this far. Thankful for the three children who've joined our family. Relieved that the hospital trips have been replaced with regular check-ups. Excited about all that is to come. But there are days when the details come into sharp relief, where I relive the moments that seemed to last a lifetime, and I wonder how we have survived this long. These are the days when he comes alongside me, wraps an arm around my waist, and helps me take the next step. Helps me see the beauty through the pain.

It's been fourteen years since that first night in the emergency room.

Fourteen years of loving someone completely and not being able to help when the pain consumes him.

Fourteen years of the life we envisioned together never coming to fruition, always limited by this physical body.

Fourteen years of discovering that vows to love are harder to hold when you're pushed to breaking.

Fourteen years of *not* breaking. Of not giving up.

Salted caramel cupcakes are his favorite. I make the caramel sauce by hand, carefully stirring the melting sugar so it doesn't splash on the sides of the pot. Every movement is measured so the sugar doesn't go astray and crystalize. One errant crystal can ruin the entire pot, spreading its spiked edges throughout the smooth syrup. The sauce is easy to burn.

When it's ready, I pour the caramel into the batter, swirl it in with a spatula before filling the cupcake tins. They come out of the oven, the sweet scent filling the kitchen, and I start on the salted caramel buttercream, swirl it on top of the little domes of cake. As I drizzle the golden caramel over the peaks of buttercream, he sneaks one off the rack. He unwraps it and gives me that mischievous smile, the one I first saw all those nights ago in an Alabama hospital.

The one that tells me he knows what's coming, and it's going to be good.

My Sea World

R. D. Gabriel

"그냥 먹어, 다 먹어" (Just eat, eat it all). This was what my mother-in-law said at dinner that night, commanding me to eat a plateful of sashimi. It was our wedding anniversary, and my husband decided to surprise us with that very special dish that night. I did not like raw food. It was not something I grew up eating in my home country. But my mother-in-law quickly took a huge serving and placed it right in front of my rice bowl, just for me to eat.

When I first came to Korea and received this kind of treatment every day, it felt like mealtimes were a test of my obedience as a daughter-in-law. I certainly thought my mother-in-law was using each meal as an opportunity to exercise her power over me. The classic mother-in-law vs. daughter-in-law conflict was a prominent theme in every K-drama, and in every story that migrant wives spoke about on Korean TV. And there I was, living it all. It was no fun. This whole experience mirrored exactly what I heard about the "시월드" (sea world) in Korea.

When a young woman decides to get married and live with her husband and his parents, this is technically called "si-jib." But recently, "si-jib" has also been referred to as "si-world," with Korean-plus-English coined words becoming catchier and trendier by the minute. "Si-world" could be directly associated with "sea world" in English, and the actual experience is far from trendy. All it

took was a second for me to realize that this sea world represented all the strange things in the sea. When people say "sea world" in Korea, we imagine a world of arguments, tears, brokenness, and division. Young couples these days try to avoid living in the sea world if they can help it. It doesn't matter whether the daughter-in-law is Korean or foreign – the sea world is known to overwhelm the new female member because there can only be one queen, a know-it-all who commands and makes the rules.

A human being who is so used to living on land, wide and free, going into the sea for the first time will be forced to swim, to learn the names of the creatures there, and to breathe in a totally different way. In her own sea world, a daughter-in-law might first feel like she's going to drown. There's this huge generation gap between her and her husbands' parents. Their personalities, beliefs, and attitudes will obviously clash. In my own sea world, it felt frightening. I decided I had to work hard to survive, for better, not for worse.

Nobody really likes to be told what to do, what to wear, or what to eat. But each day I lived with my in-laws, the list of things that I was required to do and not to do as a newcomer at the household was getting longer: you should always wear socks, you should call them to let them know you got to your destination safely, you should not stay out too late, you should ask and make sure they're hungry before you even start preparing dinner, etc. These were some of the rules that had to be observed in my sea world. I spent my first year in Korea as a housewife, something I had never imagined myself to be. I spent those long days at home learning how to make local side dishes and family favorites.

In the winter, each of us was expected to be present for "kimjang," an elaborate kimchi-making period where our conversations and actions were all about the task at hand. And since my mother-in-law was the director, I had to learn the true meaning of "손맛" (roughly translated as 'the unique flavor of handmade food') from her. She wanted the radish to be sliced into long, thin strips with a regular old-fashioned knife, not by some automatic vegetable slicer. So one whole day would be easily spent coming up with these thin slices to

make enough stuffing for about 80 pieces of cabbage. And of course, we also had to make "nabak" (clear, watery) kimchi for the Lunar New Year. She instructed me to manually peel, slice, and squeeze the juice out of pears and apples to achieve that unique, handmade taste that she was aiming for. She had her own established ways of doing things in the kitchen, and she expected the rest of the family to follow the exact same steps.

My time in the kitchen seemed like forever. Keeping food on the table for four adults and cleaning up after meals were my most important tasks as a daughter-in-law. It felt like I was working hard to survive, yet I was quickly drowning in this sea world. Self-pity and homesickness ate me up inside every single day. *Was I raised to become a strong, independent woman just so I could be stuck in the kitchen all day long? Was my purpose in life really about making food for the family?*

But, without a word of warning, my mother-in-law took that role away from me immediately after I gave birth. Every waking day, she went straight to the kitchen to make her special seaweed soup with only the choicest Korean beef. From Day 1, she vowed she would do it for me, but I did not believe it at that time, since she had been suffering from severe scoliosis, with her upper body bent down to the shape of an inverted "L" as she walks. Still, every time I woke up, I'd find her in the kitchen first, perfectly executing her plan just as she had sworn to do.

My husband had asked her to stop and just take care of her own health. But as usual, she listened to no one except herself and spent early mornings in the kitchen. It seemed like she had this mission to make sure I had seaweed soup to eat every single day for one month, so that my body would completely recover from pregnancy and birth. So, as usual, she put the bowl right in front of me and watched me until I finished eating the whole bowl. She did that three times a day. "Just eat, eat it all," she'd keep saying. Strangely, it no longer felt feel like she was being pushy anymore.

"You won't win if you try to do otherwise; my mother is the most stubborn person you'll ever meet." My husband warned me when I first came to Korea to live with them. It has now been eleven years since then. I have learned enough Korean and watched and listened to my mother-in-law closely enough to better understand her motives. These days, I am feeling less forced and more than happy to accept and obey. I still remember the words my husband said about my mother-in-law, but I have chosen to interpret the word stubborn in a positive way with the famous English saying, "Mother knows best."

If you are wondering whether I ate the sashimi she offered me for dinner, well, yes, I did. Later, I found out that sashimi was her most favorite food and she had not eaten that in years, but she chose to give me the biggest share because she was certain I would like it, and she believed it was an amazing source of protein, especially for young women and expectant mothers. She was not really being stubborn after all; she just really knows best.

Being in a sea world is not easy. When can we ever say that a world with family is easy? A sea world is particularly full of challenges and strange things. But it is also full of so many colorful things to discover – there are species that seem stubborn, and then there are creatures that know best.

Kiss Your Writing Life Goodbye
A Mother's Journey Past These Cutting Words

Ynes Malakova

I didn't expect it to happen. At first, I was open to the idea that it might – after all, when my husband and I got married, I let a realtor talk us into buying a four-bedroom, three-bathroom house out in the suburbs (in an excellent school district, our realtor added). But for me, having children wasn't an aspiration. I'd chalked it up to one of those things that would happen "someday," but I didn't put much stock into it beyond that. My husband and I broached the topic from time to time, but three years going on four into our marriage, it still hadn't happened.

At that point, we made a decision: we were going to stop worrying about it, move on, and shape our lives around each other, just the two of us. That year, we traveled the country: New York City at Christmastime (we watched The Nutcracker ballet), New Orleans for my birthday (a five-course meal at Commander's Palace). We took a two-week road trip across the state of Texas, stopping by beaches and amusement parks. At the end of it, we put our big, spacious house up for sale and started looking into renting a townhouse in the heart of the city. The game plan? Live there for a year or two, move to Seattle for a few years, and after that, go where life took us.

We'd received our first offer on the house... and that's when it happened.

We were having a baby.

Oh, hell.

I was deeply committed to my career, part of a world where I ran with powerful women, almost none of whom had children. We worked hard, and I loved the adrenaline rush. I also began to try my hand at fiction writing: earlier that year, a dark, beautiful gothic fantasy flashed through my mind and begged me to write it. It did cartwheels in my head all day unless I sat down and put it on paper. I'd filled two entire notebooks with plot points, character arcs, and scenes at the time I found out I was pregnant.

I was terrified. The thought of keeping up with my career filled me with dread. I railed against the idea of giving up my writing, but did I even have a choice? What kind of mother would I be to my child? After all, I'd never even held a baby, I had no experience whatsoever with kids, and exactly zero mom friends. I made it my mission to change that, but no matter how many women I spoke to, every conversation somehow skewed in the direction of my greatest fear: balancing a demanding career and creative writing with parenting. They always asked: how in the world did I think I was ever going to balance those things?

Texting a friend about a movie? Mom/life balance. Wishing a relative a happy birthday? Mom/life balance. Checking out at the grocery store? Mom/life balance.

My stomach churned with morning sickness as well as agony. My creative writing always seemed to be at the forefront of women's minds, and not in a good way. It was a concern, a problem. Something needed to give, and it was the obvious choice. Silly girl, get your priorities straight.

"You're a writer? Oh, that's so wonderful," these conversations would start, "But wait 'til you have that baby. You'll be too busy changing diapers and doing feedings to write."

I remember vividly the first time I heard this. I was at a potluck, and a well-meaning friend made this quip. My heart sank into my stomach. *Is it true?* I wondered. *Is this the end of my writing journey? The end of life as I know it?*

In some ways, it was. The weeks after I had my son were a whirlwind; with little sleep, days and nights blurred into one. Of course, we ended up keeping our big house in the suburbs. I spent most of my time on the couch with my son's crib pulled up next to me. I'd doze off and wake up every five minutes just to make sure he was still OK. After my C-section, I couldn't climb the stairs, let alone hop in the car to go anywhere. The magical, romantic outings to the ballet stopped, and my husband and I wouldn't dare take our son to a restaurant. I was away from my career for eight weeks, and nearly lost my mind. Never had I been so happy to return to an overburdened inbox with astronomically high numbers.

Eventually, things began to stabilize. I learned how to type my stories on my phone with one hand while feeding my son with the other. Over time, my husband took on the lion's share of the caregiving so I could continue to meet the demands of my career. We found a great nanny to help around the house. We evolved, and we figured out how to make it all work.

One part of my life, though, never went through the evolution: the notion that motherhood, career, and creative writing could coexist.

The advice I received never seemed to change, no matter how much time had passed, or how successful I was at maintaining that balance.

"You're still writing? And working? Wow, really?" the conversations went, when my son was two months old. "Wait 'til your son starts crawling. You can kiss your writing life goodbye."

At five months: "Oh, sweetie! He's crawling already? They grow up so fast. Wait until he starts walking. You can hang it up on your writing."

Wait until he starts...

- Teething
- Climbing
- Going to daycare
- Potty training
- Getting sick
- Preschool
- Kindergarten

Then you're in for it, Mama. Your writing days are O-V-E-R.

My son is six years old now. He's walking, running, climbing, spilling juice on the floor, and causing all kinds of little-boy mayhem. At each stage of his growth, my life has continued to change, but I'm still a career woman, a mother, and a creative writer. If anything, I've had to become even more creative over the years to think up new ways to make it all work together.

What I discovered is that children aren't life limiters. They are life enhancers. The secret is we have to choose to grow with them in what we do. Having my son prompted me to evaluate my life, over and over again. Like cleaning out my closet, I had to periodically stop to evaluate what was still working for me and what I needed to put into the giveaway pile.

I chose to leave behind judgment, stereotypes, and limitations. Those had no place in my life. I now run a small independent press dedicated to empowering women and the LGBTQIA+ community: both of whom face scrutiny and severe judgement every day simply for existing. I started working with an immensely powerful concept artist who has developed breathtaking illustrations – and I've developed a whole network of illustrators since. I've published several of my short stories and poems, and am now an award-winning author. And, as for the beautiful dark fantasy I started working on around the time I found out I was pregnant? The release is set for 2023, and it's going to be amazing.

At six years old, my son has a firm understanding of writing and the community that is its lifeblood. He knows that books are not a solo endeavor; they take teams of people to create. He has met editors, proofreaders, formatters, illustrators, authors, fans, readers, and friends.

The other night, we sat in bed with a book to do story time. Before we started reading, he pointed to a name on the front cover and said, "Mama, look. This one's the illustrator. It means he drew the pictures." He flipped the book over and pointed at several spots, "This is the blurb, this is the ISBN, and this is the publisher."

I felt like I might burst with joy at that moment. In this single crystallized moment, I realized that my son and I are on this journey together, where being a mom and a writer are inextricably linked, woven together in a colorful, whimsical tapestry. As he continues to gain a mastery of letters and words, there are many more things for him to discover beyond the parts and pieces that make up a book. Soon, he will have the skills to write his own stories.

Because I am a career-oriented woman, a writer, and a mother, my son is growing up in a world where he sees, firsthand:

- Mothers can have both passions and careers
- Husbands can be caregivers who support their wives' endeavors
- Men can be illustrators who dream up dragons for a living
- Editors can be transgender, genderfluid, nonbinary, and more, and they bring a unique and valuable perspective to storytelling .

Above all, he is learning that creativity truly has no bounds: whether he grows up to be a creative like his mom, a technician like his dad, a lawyer like his grandfather, or an educator like his other grandfather, his words will always guide his path. He will have so many of them at his disposal to express his thoughts and feelings, to protect himself and others, and to make a difference in the world.

It is not my goal to put down any woman who has ever, in a moment of concern, desperation, or maybe even frustration, chastised me about how career, motherhood, and writing do not mix. We live in a

world where centuries upon centuries have passed, and still women are tremendously overworked, underpaid, taken for granted, underrecognized, and dismissed.

We aren't going to change this if we point fingers, criticize, and tear each other down. So instead, I offer up this advice to those who told me to give up my writing:

YOU MUST NOT GIVE UP ON YOUR OWN DREAM!

I know you have a creative dream buried deep within your heart. Maybe it's got a few layers of cloth draped over it – fear, expectations, feelings of unworthiness – but underneath, it still shines bright. Maybe someone has cautioned you that chasing it would be frivolous, irresponsible, silly.

Or perhaps you feel like you're not ready? Like you don't have any experience, you don't know what you're doing, and you're going to fail miserably if you even try?

I can understand that. I felt when I found out I was going to be a mother. I'd centered my life around different priorities, and all of them had to be unraveled and reworked, one by one.

But here's some good news.

My son crawled, walked, ran, climbed, teethed, potty trained, got sick, started school, and did so many other things I didn't anticipate. I braced myself, waiting for the day that he would do something so far beyond my ability to handle that I'd no longer have time to write.

That day hasn't come.

So it's time for you to stop waiting, too. Time to uncover your own dreams and get started.

The Ties That Bind

Katie Carrick

"Today is really important. Can you smile big for Mommy?" I desperately plead with my two-year-old son. We're at a photography studio, and I'm helping him into the trappings of a family tradition 90 years in the making. I want to relish this moment, helping him into the small, old suit, but there simply isn't time.

"Watch me, Mommy!" my four-year-old daughter demands as the photographer tests lighting levels. Today's sole focus should have been my son and the suit. In an attempt to also squeeze in family photos, I had unintentionally been the creator of chaos.

"No! No snacks until we're done with pictures," I bark at my husband as I attempt to dress my fidgeting son. Toddlers don't have patience for anything, much less sentimentality.

Nanny, my great-grandmother, acquired this suit in the early-1930s for her first son to attend a wedding. A genuine luxury at the time, it has been passed on throughout the family, each little boy having a formal portrait taken wearing it. Arguably the best investment ever, it's been worn by sons, grandsons, great-grandsons, and now, great-great-grandsons.

"Ouch!" The buttons of the vest have been lost to time, and I inadvertently stab myself with a safety pin. The last legacy I need to leave is a bloodstain.

A series of photographs are prominently displayed in my grandparents' living room. Each image features the subject standing, smiling at the camera, looking curiously regal for a two-year-old. The collection spans three generations of boys, including my grandfather. Even now, I have a hard time reconciling the black and white image of a small, fully cheeked child of the 1930s with the convivial, six-foot-tall man who played a pivotal role in my childhood.

Contrary to many men of the Silent Generation, my grandfather was gregarious, good-humored, and openly loving of his family. He worked as an economist by day, but was an artist, a woodworker, during his spare moments. He created prolifically - drawing plans, then working the wood into banks, train cars, figurines, and Christmas ornaments, painting each one with tiny details. His creations were another manifestation of his love, and he expected nothing in return.

My mother once asked him what he wanted his future grandchildren to call him. "Mr. Westmoreland, of course," he teased. We called him Poppa.

For most of my life, he and my grandmother lived a 10-minute drive down the road. A team of unconditional support, they came to every music recital, sporting event, church performance, and academic ceremony, brimming with pride and praise. In his typical lighthearted and patient way, Poppa taught me how to hook a worm, tell a joke, and "catch" a burp in a bottle. When my son was born, it felt all too fitting to give him Poppa's middle name: Winslow.

Poppa did not live to see Winslow in the suit.

In the summer of 2019, I booked a red-eye flight from Oregon to North Carolina, knowing it would be our final goodbye. After months of hospital stays, fluid retention, and an ambiguous diagnosis that would have required a kidney transplant, Poppa came home to die. The doctor gave him two weeks to live, and I naively

hoped that would be enough time to sufficiently communicate a lifetime of love and appreciation.

Winslow, 14 months old at the time, accompanied me on the trip. While the adults were sad, having a baby around, oblivious of the circumstance, created much-needed moments of levity. Unfortunately, it also required a lot of work – managing sleep schedules (or lack thereof), preparing food, and keeping him occupied – leaving little room for me to navigate my own emotions. My husband and three-year-old daughter joined us a week later, but due to work logistics, I ended up solo parenting during most of the vigil. Mothering two small children is exhausting on a good day. This was next level.

After Poppa's death, physical remnants of him surrounded me. Though his art was everywhere, I remained disconnected. My sadness was present, but the floodgates of grief remained closed. I wanted to reminisce on every memory I owned and cry until it hurt. I needed the world to slow down, pay attention, and understand who they just lost.

Most of all, I wanted a sign: a tiny, coincidental signal that I could cling to later and say, "See, that was Poppa!" Surely, if I was going to feel some direct connection to his departed spirit, it would be here, in his home. But I laid on the floor where Poppa slipped out of this world and felt nothing.

The family suit came into my possession at Poppa's memorial service, and we flew home several weeks later. With everyone back in a routine, I figured I could find the time and space needed to process my grief, working through it in a healthy way. Instead, I set it on a shelf in my closet, encapsulated in the small, tan box. There it remained for the next year, as my son grew to fill the suit's dimensions.

Life marched on. Yet, there were flashes of my unresolved heartache, packaged so neatly out of sight. It manifested as impatience, a mix of rage, sadness, and irritation, boiling over at

random — crying a stream of silent tears during a remote conference call, resenting my husband, feeling robbed of an appropriate experience of grief, as though one even existed.

"Hold still! Let me fix your hair." Winslow looks quite handsome in full costume.

The relics are black slacks, no tag to identify their maker, with buttons and elegant fabric suspenders to keep them securely fastened to a squirming toddler. There's also a delicate cream vest, without the buttons lost to time. The featured piece of the ensemble is a sturdy, warm jacket, complete with coattails.

But the photoshoot is too hectic. Winslow becomes suddenly shy, and won't stand on his own. The snack bribes come out and the kids start fighting.

"Winslow, can you please put the cracker down for a minute?" I beg.

"No! No! No!" he screams and throws his body on the floor. I'm not sure if I'm more concerned with getting a good shot for his portrait, or preventing damage to the treasured family heirloom.

Eventually, I give up, and we head home.

The photos I receive a week later are beautiful, but they aren't right. They're lifestyle photos, the kind I love to share on Instagram, looking polished yet casual. But, for this commemoration, I need a formal portrait that mimics those from 20, 50, 80 years ago. I make another appointment.

This time, it's quieter, just me, my son, and the suit. I start thinking of all the mothers before me, each in their own present while holding on to a fragile past. Did their photos feel important, too? Did they know they were part of such an extensive family connection? Those dapper toddlers grew into young boys, and then into men, raising their own families. Several of them are dead. Will this suit go on to outlive us all?

The mood of this shoot is easygoing and enjoyable. Appropriately, the new images are perfect. I realize that I needed this more than anyone – the ritual and the release. I required a slowed-down space, an intentional contemplation, and a physical connection between Poppa and Winslow.

As I pack up the suit to be shipped to the next boy in line, holding the physical material that allows me one final goodbye, I begin to cry. My tears are mournful, but tinged with something like hope, and I feel the journey of grief move forward.

Here I am

Niamh Donnellan

Here I am. Three soothing words.
Brain fogged and sleep deprived
Stumbling through long days and nights
Soft shoe shuffle to more than Mammy.

Motherhood's collateral damage
a contrary metamorphosis to caterpillar.
Silk dresses and slick eyeshadow
Gave way to hoodies and dark circles.

One day I unfurl mothballed finery
And emerge blinking and unsteady
In the neon light of a Saturday night
Back into the world beyond you.

When I Grow Up

Rose Jay Rigby

You know how on tv they always make it out that little girls have their whole lives planned out by the time they can walk? They know who they're going to marry, who their bridesmaids will be, what their dress will look like, how many kids they're going to have, and what their future job will be. I never did that. When I was young, planning for the future gave me anxiety, like I was drowning underwater with indecision, or the weight of all life's choices was hundreds of pounds on my shoulders.

It never faded as I got older. Even something that is supposed to be fun, like New Year's Eve, sent me on a wave of emotion. The unknown that came with the new year brought on tears, and thoughts of insecurities of what may happen. What I did not know was bad to me.

In high school, I had no clue what I wanted to do. How was I supposed to make such a huge decision at such a young age? How does one choose? There are billions of different possibilities. At one point, I wanted to be a chef, a photographer, crime scene investigator, a graphic designer, a veterinarian, and a hairstylist.

So I didn't choose. After graduation, I settled into a work routine at the same job I had in high school, and just lived. I loved animals, so it seemed natural to work at the pet store. I got to play with animals for a living. That transformed into working as a veterinary technician,

which, too, was playing with animals for a living. I internally knew that these jobs were not what I wanted to do with my life. But even at a young age, going back to school seemed like a tremendous feat. It brought on anxieties. Could I work and go to school? Would I be able to afford my bills? I was drowning again. But, as life goes, change happened. A man came into my life. And with him, he brought adulthood and the promise of forever.

Forever with this man wasn't so bad; actually, it was great. But the thought still lingered. What do I want to do when I grow up? I thought a few times I had found the answer. Month after month for eight years, we mourned what could have been, what we had been praying for. I cried on the phone to my mom many times, whenever we had yet another negative test. The weight and the want were heavy on my shoulders. Until one year, as if a present for our anniversary, our prayers were answered.

And, nine months later, when I held the answer to my prayers in my arms, I knew what I wanted to be when I grew up.

Emotion Is Art

Sarah Reilley

As a young child, I was always drawn to art in a variety of forms. I loved to paint, draw, write, and act, and I loved music. I took piano lessons for several years, practicing at my grandparents' house because we didn't have our own piano.

Music has always been incredibly important to me as a way to process my emotions. If I'm having a good day, I want to be surrounded by upbeat and fun music. Sadness requires pensive music. Anger needs something loud and pejorative. I love to sing, radio cranked as loud as it goes in the car or as I'm cleaning the house. It feels like I'm talking to the universe.

Piano, though. Oh, piano is something else entirely.

I had a music teacher in elementary school who was brilliant. I've rarely come across teachers who have the same passion for what they teach, as well as a deep love for the children they're working with. She's unmatched in so many ways.

I remember Waltzing Matilda or square dancing in her class. I remember playing recorders and xylophones. We had drums and bells and every sort of way to make noise together — let's face it, elementary-aged kids mostly make noise. It's the foundation for music but often isn't music yet. Her classroom was long and rectangular, with old carpeting on the floors and cabinets filled with

instruments and music. My favorite, though, was the year she played "Mister Beethoven Lives Upstairs" for us. It's a narration of a young boy who writes letters back and forth with his uncle about their new upstairs tenant – Ludwig Van Beethoven – and his eccentricities. Scattered throughout the story is the music of Beethoven, timed perfectly to the emotions of the story. A madman has moved into the house? Beethoven's 5th Symphony plays. Uncle replies with sympathy and compassion – Pathetique Sonata, Op13. It's brilliant. Epic. I love everything about it.

Beethoven became a fascination for me. My uncle lived in Germany for a while, and when he returned, he'd brought for me an early 1900s biography of Beethoven that still sits on my shelf today. Perhaps it is just that the music is so incredibly moving – it really is powerful, and it touches my soul. But I think that part of what drew me to Beethoven was that I see a lot of myself in him. No, I'm not deaf, nor am I German. But he is a cranky man, misunderstood by those around him, driven by his desire to create music, faced with a series of challenges that would cause the best of us to just give up entirely. Instead, he cut the legs off his piano when his hearing became so bad that he couldn't hear anymore – and used the vibrations of the notes combined with what he already knew to create more music. What should have stopped him in his tracks only made him stronger.

As a child, I had no idea what was coming in my future. I had no idea that challenges would rise that would often leave me wondering if it would be best to just give up. But I knew that there was a solid resilience in Beethoven that I admired. I wanted to be just like him.

So, I took piano lessons. I felt silly most of the time. My piano teacher was this adorable, tiny, older lady who had fingers so short I wondered how she was able to play as well as she did! She was kind and patient, and helped me to build on my ability to read music that had begun in that elementary classroom. Eventually, I was able to play Fur Elise by Beethoven. I loved the song so much, it was one of the first pieces I memorized. It wasn't the full piece – if you've seen

that, the mid-section gets technically complex and I wasn't playing at that level yet, but the two pages I did learn were beautiful.

Thinking back now, though, it really is a wonder that I learned the piano at all – not for lack of skill or musicality. My barrier wasn't deafness or disability. No, my challenge came with the fact that my grandmother, who had never learned to play, was an eternal critic. We had a fraught relationship. There was always something I'd done that wasn't good enough – I was too loud, too fat, made too many mistakes… I wasn't my brothers, who were perfect in her eyes. I was nothing like what she wanted me to be, and she didn't understand me. I'd sit at the piano to practice a new song and with every missed note, my grandmother would announce "oops!"

It became even more important that I get the notes right, so that the mistakes I made wouldn't be pointed out. For someone who never played piano, she sure had a good ear for when the notes were wrong.

I struggled as well with dynamics. *Piano* and *pianissimo* were just fine – they were quiet. But if a piece called for a crescendo with *forte*, I was banging on the piano. I was too loud. It was yet another thing I couldn't do right.

Eventually, I grew tired of the criticisms. When I went to junior high, there were more musical options, and I joined band and choir and dropped piano lessons. Clarinet and singing would hold the place for me that piano had in my heart, though it often fell short. In high school, I'd grown bored with clarinet, so I learned flute, trumpet, and saxophone. I desperately wanted to learn the baritone saxophone, but my band teacher told me it wasn't an instrument for a girl, so I never learned. String instruments were cost-prohibitive, though if I ever win the lottery, I'm buying a grand piano, a cello, and an upright string bass, in that order. I joined every choir I could – there was the basic choir class that anyone could join, and then there was a choir you had to audition for. It was still large, though, and most people were accepted. I was also chosen for the girls select choir, a much smaller choir, and more elite. Somehow, I still

managed to take AP classes, as well as extra English electives, auto fundamentals, Spanish, and more throughout my high school years. I wish I'd taken art classes – painting, sculpting – because the technique would have been beneficial, but I was so focused on an outlet for my emotions that I was familiar with and good at. Music it was.

In college, I took a one-semester piano class, hoping that I could rediscover my love of classical music and build my skill even further, but I realized that I'd spent so many years being told what I was doing wrong that I couldn't even play if someone could hear me. I'd use the practice rooms at the college when there was nobody else around, but the second another musician was in a room, I was done. I couldn't handle anyone hearing me play. I was terrified.

For the next 18 years, I barely touched a piano. When I did, it was for something silly, like playing chopsticks for the kids. We even rented a home that had a well-tuned piano, but I couldn't bring myself to play. And then my oldest child wanted to learn "panenno." When she was old enough, we found her a teacher. The basic skills came easily to her, but the teacher wasn't quite the right fit. We found another who was excellent with her but stopped teaching lessons only a few months later. We took a break – we didn't have a piano anyway – and I still had a deep fear of playing piano at my grandparents' house. My grandmother passed away before my oldest began taking lessons, but the fear and memory of her criticism were deeply ingrained in me.

A couple of years ago, we decided that my daughter wanted to play the piano again. This time, I called my elementary school music teacher with the hopes that she had room for her. I'd never taken piano from this teacher because her time was so highly coveted, there were never lessons available when I wanted them. I crossed my fingers and dialed the phone.

"Hello?"

"Mrs. C?" I asked.

"Yes." The voice, now much older, replied.

"This is Sarah... I don't know if you remember me, but... "

"Oh! Sarah! Yes, dear, of course, I remember you!"

I'd never been greeted with such excitement by anyone other than my children at daycare pickup or my dog. My heart swelled with joy, and as we discussed the logistics of piano for my daughter, I knew that in many ways, I'd come home.

Music isn't just about the sounds, apparently. Music, for me, is about a deep connection to this woman who shaped my entire experience in school. She'd supported me, encouraged me, and cheered me on when it had felt like nobody else wanted me around. I was a nuisance to many teachers – I asked too many questions and was always bored – and to my grandmother, there hadn't been much of anything I did right. But this teacher, this absolute angel of a human, had given me the gift of music. I remember Christmas concerts, where she allowed a few students who had taken lessons from other teachers outside of school to play. Two brothers played Jesu Joy of Man's Desiring on the violin and cello. She held a performance of *The Nutcracker* with the upper elementary students every few years, spaced out just perfectly so that every child had the opportunity to be involved. She directed the musicals at the high school, which introduced me to *The Phantom of the Opera,* and led me into the world of music as a way to tell a story. Here we were, 25 years later, and we picked up our conversation as though we'd never had any time apart. This time, though, we spoke as friends.

She took in my daughter for piano and helped her grow even more than any other teacher had. She saw beauty and kindness in my child who was struggling in school because she is her mother's daughter – she has ADHD, and is so intellectually capable that she's often bored at school, and her social skills are only slightly more awkward than my own. This wonderful woman, now in her eighties, sees my

child for the pure potential she is, alongside the best of her qualities. It's exactly what she did for me all those years ago.

Yesterday, after nearly 20 years away from the piano, I took my first lesson again. We sat at the baby grand in her living room, and I dreamed of the day that I could have my own baby grand instead of the hand-me-down out-of-tune piano currently in my basement. I opened the one piano book I felt comfortable bringing along to show her where my lessons ended. She found three more, and loaded me up with Bach, Burgmüller, Beethoven, and the confidence booster I needed to remember that I can play the piano well.

When I got home, I sat at my out-of-tune piano and played through the selections from my lesson. I played for over an hour, feeling the music swell and fall with each crescendo and decrescendo, the *pianos* and *fortes* emboldening me like they never had before. When I'd explained to my teacher, my friend, why I was struggling with the dynamics of the music, she quickly told me "Well, in my house, the piano makes a lot of sound!"

In my house, too, the piano will make all the sound it needs. I've already said this – I am filled with emotions – big ones – that don't know how to sit back quietly. I've spent two decades ignoring the fact that music always brings me relief, so long as there isn't anyone besides me to call out "oops" with every missed note.

Yesterday I realized that I'd been inauthentic in this way. I haven't let myself really sit and feel the music in so long. The world had been hinting at this to me for a while, with the release of *The Greatest Showman* and *Hamilton*, both of which have soundtracks that will make me forget to turn back to my house while I'm out driving. When there is power and emotion in me, I need to find it matched in music. Happy or sad, there is a song for everything I feel, and now I don't have to sing in my car alone anymore. Bless my children, they have always loved to sing along loudly in the car with me, and I hope that they always feel that they're allowed to use music however they need.

The next step for me, after allowing myself to become more engrossed in the piano and embracing that emotional outlet, is to become more in touch with painting. I come from a family of artists: my great aunt was an award-winning watercolor painter, my uncle is well-known in Japanese Sumie painting on the East coast, and my youngest brother is a brilliant hyperrealism painter. My art is like stick figures compared to theirs.

But the comparison between myself and others is antithetical to authenticity. Will I ever play Beethoven as well as Beethoven? Will I ever paint something to hang in a gallery? Will I write a bestselling novel, or will my screenplay be turned into a movie? Does it matter? Sometimes I think it does. Sometimes I want to leave a mark on the world that is so much bigger than this small space of Earth I currently occupy.

Ultimately, though, authenticity isn't about fame and fortune. It's about being true to myself. If there's a song in my heart, I need to sing or play it. Maybe someday, I'll feel confident enough to write a song. I've written lyrics before, but never with music to accompany. I've always felt like an impostor in all these areas. I'm not good enough, I'm not better than anyone else, I'm not award-winning or groundbreaking.

I can't let it be about that, though. Any artistic expression, no matter the medium, is an extension of myself, and that is exactly enough. I am enough. Perhaps without the constant "oops" beside me, I'll be able to fully realize that.

I Do Not Regret To Inform You

Candice Stanfield-Wiswell

I do not regret to inform you
that I will not be joining you
in the formality of conventional ways.

I would rather lie in the grass
Dream in the dust of moth wings
Sculpt ocean currents into rainclouds
Shout into hurricane winds
Walk off a pier into sparkling oddity
Swim nude toward the silver moon
Kiss constellations to blushing
Harvest vapors from a comet
Dive into a collapsing star
Spin eternal
Never fold
 another piece
 of laundry.

Yes, She's My First.

Amber Payton

Babies should come with a return receipt. Surely God would take this child back. He made a mistake sending her to me after all. Biology said it wasn't possible, but we defied those rules. And here she is, and it's terrible.

Not the baby, of course. The baby is a miracle, a bundle of innocence in my arms, with eyes too wide and tiny breaths too sweet. No, *I* am terrible. Too many nights without sleep. Too many demands on my sore and healing body. Too many thoughts in the dead of night that I wish my imagination never conjured.

I hold her on my knees. She's screaming. She's always screaming. Tears spring from her recently opened ducts and trail down her red face.

"You'll figure it out, don't worry." My mother's words float in my ears, from our conversation yesterday. We spoke on the phone, instead of side by side, the way we were supposed to be. The way I'd planned to be as a new mother. Pandemic babies, they're called now. Mine was among the first, born the last week of March 2020. She was due in late April, but these pandemic kids have minds of their own.

I raise the baby to my breast again, and she latches. But she just ate.

There's nothing left. Her face pinches and her chest heaves with another scream.

You wanted this.

My husband is still asleep. He'd come out and hold the baby and let me sleep, but the guilt would keep me awake anyway. It's my daughter. If she's suffering, I deserve to suffer with her.

We paid a lot of money for this. We worked hard for this. Not *this*, though. I didn't put my body through the fertility treatments, the months of testing, a hundred needles in my stomach, the surgery, a picture of seven frozen embryos and the one we put inside, for *this*.

I never thought I'd want to give the baby back.

Please, God. She's only eight weeks old. She's better with you. I've failed her already.

No answer.

Maybe she needs a diaper change. The rash might be back. It's taken weeks to heal, but I finally smothered on enough cream and aired out her tiny buttocks for the rash to go away. Maybe it's back.

I unzip the legs of her onesie, all the way to her neck, and fumble her tiny limbs free. The cold air makes her more mad. I hook a finger in the white diaper and peek inside. No poop, no rash. I zip the outfit back. There, she's warm again.

Her screams are nails in my ears.

My own tears escape down my face. I can't hold them back anymore. I draw a sobbing gasp. It's ugly and loud, but I can't stop. More tears fall, changing the color of her outfit one round dot at a time.

"Please." I bend my head over my baby. "Please, I can't do this. I don't know what's wrong. I can't help her. Please."

The screaming has stopped. My pleas are the only noise echoing through the dark, quiet room.

The baby is staring at me. Her big blue eyes are wide open and tear-free. Her little brows crease as though she's confused about this turn of events. I'm not supposed to be the one crying. That's her job.

I'm sorry, I want to tell her, *that you're stuck with me*, but there's a whole universe inside her eyes, and my words are gone. Her lips pucker and gape like a little fish, like she's trying to comfort me, but she can't speak yet. Her pink tongue darts in and out, and she lifts a hand towards my face.

It's an involuntary gesture, my mind spins. Eight-week-olds can't control their jerky, inconsistent motions. But I don't believe it. I know she's reaching for me.

I press her tiny knuckles to my lips.

She is my universe now. There is no return receipt, and if there was, I could never exchange her. Thank you, God, she's mine now.

"Babe?" My husband's steps are soft, cushioned on the plush rug. "Are you okay?"

"Yeah." I try to wipe the tears, but his sharp gaze sees all.

"Are you crying?" He hurries to me and kneels down. He helps wipe the tears from my face.

"Yeah." I said. "She was crying, and I didn't know what to do." I try to laugh, but it's fake and we both know it. "Hormones, probably."

"Here." He gathers our daughter in his arms. "I'll feed her."

He takes a bottle from the fridge, another evidence of my failures as a mother. Can't even make enough milk for my baby. Her greedy face searches for the bottle, even though it's cold and tastes like old pennies.

"Babe." He says, and this time there's a richness in his tone, and I know whatever he's about to say, he thinks it's true. "You're doing a great job. You really are. I never worry about her because I know you're taking care of her."

There are no more tears inside me. The baby's fish eyes search the room, and lock on my face, even though I'm much too far away for her underdeveloped retinas to see.

And I think, maybe for the first time, he might be right.

August 8, 2017

Abby Harding

The sun settles low in the sky behind me as I turn off the country highway onto one of the grid-like roads that bisect the fields of corn and beans into tidy squares. The August heat still hangs heavy in the air, and I'm thankful the air conditioning in the van works. I chew my lip, thinking about the two toddler girls I've left behind with their father, relief and guilt warring. He's a great parent, more than capable, but still, the internalized need to be mom 24/7 is hard to leave at home. Not that I am forgoing that entirely, I muse, glancing in the rearview mirror at the infant car seat in the back of the minivan. At just six weeks old, my son is a sweet, easy baby, portable and comforting on such a difficult outing.

Rolling up to the final stop sign before my destination, my heart gives an odd little lurch in my chest. Across the road, dozens of barn swallows dance through the air, the jewel-toned sunlight flashing on their darting wings. Such an unusual display of my favorite bird feels like both a benediction and an omen, and I am suddenly convinced that tonight will be the night.

I don't really believe in such things, though, not really, so I shake off the notion and resume driving, heading to the farm.

A mile later, gravel crunches under my tires as I pull onto the driveway and park under the tulip tree. The engine ticks as it cools,

and I gaze out at the flower fields behind the ancient collapsed barn. When I started working here after high school, the barn had still been standing, barely, but a storm knocked it over at some point. By the time my husband and I moved out here, it was no longer recognizable as a barn, just a pile of worn wooden planks interspersed with volunteer mulberry trees and ragweed.

I inhale deeply as I step from the van. For as long as I can remember, the farm has had a distinct fragrance. It's sweet and floral, pungent and herbal: the smell of Sweet Annie, a tenacious, unruly herb in the artemisia family. Growing up, I had no idea that smell had a name; I just assumed it was a blend of all the herbs my grandparents grew. All my life, they have been specialty farmers here in Illinois. The farm was a passion project that grew from my Grandma's fascination with the natural world, conservation, and her love of teaching. I don't remember a version of her from before she was a farmer – all of my lived memories are from this phase of her life, where she grows things and shares them with other people.

My heart throbs with a cocktail of complicated emotions. Even though we don't live here anymore – and haven't for a couple years now – this place still feels like home. The farm has always been one of the places that calls to me, a place that creates a yearning tug deep in me, in my soul. It's situated on land that has been in our family for over a century, with a giant white farmhouse that has been Frankensteined into life over the years. The oldest parts were built in the late 1800s; the newest were added by my grandparents in the 1970s. Surrounding the house, there's a patchwork of farm buildings and greenhouses and big, settled-in trees, and if you look out across the fields, you can see for miles. There are no real hills, but the ground has a gentle undulation, and when the wind dances through the beans, it reminds me of the ocean.

Collecting myself, I walk around the van to gather my son, and brace myself to walk into the house, remembering what it felt like when we moved here. We'd all been so hopeful: me, my husband, my grandfather, and my grandmother. This was exactly what we all wanted, all needed. The dream of the farm would live on, the land

would stay in the family with someone living in and loving on the old house. I don't know exactly what my grandma pictured when she thought about the coming years, but I know I saw the two of us sitting on the deep porch, sipping iced tea, scheming up ways to get more foot traffic to the farm shop while we watched my yet-to-be-born children playing under the maples in the front yard. We'd be together, living in tandem, taking care of each other.

The day we moved, there was a storm — not just a little storm, either, but a torrential downpour that moved at the exact pace of the moving van the whole ninety-mile trip. Despite the rain (another would-be omen), I brandished hope in my hand, a flashlight to dispel my doubts, and I celebrated the secret cluster of cells in my belly: our first baby, who we'd discovered was on her way only two days before we'd packed our last box for the move.

I remember pulling into the driveway, quelling the unsettled alarm bells ringing in my head: *This is a mistake. Turn back now!*

No, it would be fine. Living together, a jumble of generations, would work out wonderfully. The baby would be doted on and adored, bringing a bright ray of joy to my grandparents' final years. It would be fine.

Sure, Grandma was a complicated, difficult person to be around. Yes, the house was quietly losing a battle against my grandparents' hoarding tendencies. And of course, the farm business was hemorrhaging money at an alarming rate, without a real business plan. But I was utterly sure I could handle it. I would *will* this to work out, come hell or high water.

Now, over four years later, I stand in the barnyard, staring at the big white house that is no longer my home. Obviously, things didn't go to plan.

I sigh, giving the door inside the entryway the particular jostle it needs to open. Grandpa and my aunt look up as I walk in, threading my way through the boxes and furniture that fill the large family

room, moving my way toward the hospital bed on the far end. Grandma hasn't been awake for over a day. No water, no food, very little output in her catheter bag, her breathing shallow. We know it's close, but it could be days yet.

"Any change?" I ask, just to break the silence. Double shakes of the head: no, she's the same. I nod, and settle into the rocker at the end of the bed, leaning over to unbuckle my baby from his seat. He's ready for a snack. Once I get him situated, nursing happily, I turn back to the hospice bed, which sits awkwardly in the room: sterile, medical, out of place in this cluttered, cozy home. I study Grandma's face, looking for change. She looks so familiar, and yet so foreign. The lively spark is gone, her skin pale and cool as the toxins her kidneys can no longer process slowly build up in her blood. This person in the bed is so far from the woman I knew, the girl who she used to be.

In March of 1938, a baby girl was born. Although she was intended to be named Elizabeth James (a generations-old family name), my great-grandmother fell into a (temporary) diabetic coma after labor, and my great-grandfather took the opportunity to name his infant daughter Florence Caroline, after his mother and his grandmother instead. Perhaps the name change started her off in a state of disequilibrium, because this girl was a spitfire from the word go. Taking matters into her own hands – a pattern in her life, as it turned out – she chose to go by her middle name, Caroline, or sometimes Carol.

Caroline was whip smart, but those smarts came at a cost: she was keenly aware that being born a woman in the era she lived in was going to hold her back in some circles. She never really got over that, truth be told. It was one of those burning embers that you carry your whole life, one that gives you warmth and illuminates the world around you, but will also blister your hands and make you uncomfortable in your own skin. Some truths can't be unseen, and this one made her keenly aware of the injustices all around her, the

way the men in control can neglect and disregard anyone who isn't like them.

That fire in her belly – her desire for the world to do better – followed her always. If she saw something she thought was wrong, she'd speak out, tact optional. She told my aunt, "Some people are put on earth to comfort the afflicted. Some, like me, are here to afflict the comfortable!" That attitude ruffled a lot of feathers, and sometimes damaged relationships, but she was stubborn and principled, and wasn't interested in compromise.

There are so many stories I could tell about my grandma. She was fascinated by the supernatural, and was 100% convinced both that her house was haunted, and that she'd once been visited by aliens. She lobbied for the conservation of a local forest park and won. She broke most bones in her body at one point or another, survived cancer, a heart surgery, and a simply staggering number of other chronic and occasional illnesses. She was a scientist, a reader of romance novels, an entrepreneur, a collector of anything that interested her. She was a wife for more than 50 years, a mother, a church-goer, a teacher. She was many things to many people, but to me, she was just my Grandma: the woman who taught me to cross-stitch, instilled in me a passion for plants and sustainable farming, and gave me one of the most complicated relationships I've ever had.

In so many ways, she was ahead of her time, but no one can escape the influence of the world around them completely. Although she fought with all her might to be taken seriously as a woman, she struggled to accept her own battle with mental illness. In a world where the stigma around mental health was still very strong, she was diagnosed with depression as a teen, and would remain medicated for that diagnosis the rest of her life. To her, the problem was purely chemical, just an imbalance of her brain juices, and not a challenge she could overcome in therapy.

I often wonder what life could have been for her if she had been able to overcome her inner demons with the same passion and vigor that she battled with the outside world. I wonder what the emotional

heritage of my family would look like now, who we would each be if she could have taken the first steps toward health.

Certainly, my relationship with her would have been easier. Perhaps we would have even been able to keep living together. Perhaps my life would be entirely different.

"I think her breathing is changing."

I startle from my reverie, looking to my aunt, whose face is pinched with concern. She looks at Grandpa, who looks at Grandma, studying the rise and fall of her chest. He nods. I hear it, too: her slow, labored breaths have become even shallower. Now, there's a hiss beneath them, too, and the space between has lengthened alarmingly.

I glance at my phone, checking for texts from my mother. She is on her way back up from her home in Memphis, a whirlwind reprieve from the exhausting string of days that have made up the last few weeks. Could it have only been just three weeks since she called with the news?

Grandma has decided to stop dialysis.

In other words, Grandma has decided it's time to die. The doctors said she had anywhere from two days to two weeks to live after her last treatment. Well, it's been three weeks and a day, so she's carrying on her tradition of stubbornly ignoring the experts and doing things her way.

The days have passed in a blur. So much beauty, but so much pain. I've sat by her bed, watched my eldest – that sweet baby who was born while we lived here, now pushing four years old – as she fed her Grammy ice chips like a tiny mother bird. I've talked to the hospice nurse, made myself available in the midst of my chaos-world of young motherhood, my breasts leaking and belly still swollen from pregnancy. I've stood quietly to the side as she saw all four of her children face to face, watched her reconcile with her estranged

brother (will wonders never cease?). I've comforted, fed, fussed, brushed her silver hair, held her hand. I've been as present as I can be.

But every time I leave, every moment I'm home with my family, shame still floods me, that I can't be here all the time. I should have been. I was supposed to be here. That was the plan.

And every moment we find ourselves alone, we gaze at each other, wordless, and I wonder, is she waiting for an apology, too?

By the time we realized things were not working, when our relationships were frayed and failing, it was too late. We couldn't recover our equilibrium before teetering over a ledge.

We were expecting our second baby when we made the decision to move away. I still remember the gut punch I felt when we told my grandparents the new baby was on her way, a few months after our first turned one.

"Oh, I wish you'd waited," she said. No congratulations, no excitement. I knew she was remembering her own two under two, the hardship of that season, but I still felt stung, slapped raw.

Even now, two years later as I sit by her bed, the memory drops a stone in my middle, angry and hurt. I push the thoughts away.

There's no news from my mother on my phone, but I text her: *What's your status?*

She won't text while she's driving, but I'm anxious. I'm worried now that she won't make it in time. I was confused by her decision to go home for a few days. Would she really be ok knowing she missed her chance of being here when it happened? I'd been so relieved when she started heading back. What are the chances she'll make it in time now?

I glance between my aunt and my grandpa, studying their faces

studying her. I realize there are four generations around her bed: her husband, her child, her grandchild, and her great-grandchild – beautiful symmetry.

I watch her chest, holding my breath as I wait for her next. Will this really be the night? Finally, after all the nights I thought were the last? There were so many times that first summer we lived here that I watched her get bundled into an ambulance and I thought for certain I would never see her alive again, that this was goodbye.

I don't really believe she's mortal at this point. She'll probably live to see my children graduate college.

But no, her breathing is even more drawn out now. I count in between. One, two, three, four, five... soon I can't bridge the gap, can't hold my own breath long enough to keep pace.

My son is nursing again when she takes her last breath. I didn't realize how anticlimactic it would be.

"Is she gone?"

"I don't know."

Finally, I retrieve a stethoscope from the bathroom, horrified to find myself letting out a nervous giggle.

Yes. She is gone.

My aunt is crying.

I feel... nothing.

My grandfather holds her hand, bends low, touching their foreheads together. "I love you, I love you, I love you," he whispers to his wife of more than half a century, the woman who drove him mad and loved him fiercely. "Go in peace."

Fifteen minutes later, my mother arrives. I meet her at the door, tell her what's happened. I'm apprehensive, expecting self-recrimination and shock. Instead, she sags a little, but says quietly, "I took the wrong exit. I've made the drive so many times, and I missed the exit, tonight of all nights. Maybe I wasn't supposed to be here."

Soon, my other aunt and my closest cousin arrive. We convene in the kitchen while Grandpa makes some calls, but we women find ourselves drawn back to the bed in the family room. A nagging at my soul turns into a song, and I begin to sing the Doxology over her, my mother and aunts joining hands and joining in.

Praise God from whom all blessings flow,
Praise God all creatures here below,
Praise Him above ye heavenly host,
Praise Father, Son, and Holy Ghost.

A couple hours later, after hospice has come and called a time of death, after the funeral home has come and collected her body, I'm back in the van, headed home to my little family. As I drive further and further away from the place we both loved, I try to make sense of what I've just witnessed, taken part in. I'm grateful for her beautiful death, that she died in her home, on her own terms, just as she lived.

I know the tears will come, but tonight all I feel is… lightness. A lifting of weight. Relief.

What does that mean?

I'm sorry I tried to change you, that I couldn't love you perfectly, just as you are.

With sudden clarity, I realize I'm not angry anymore. Somewhere between those last breaths and this moment whatever kept us from apologizing, from saying those words to each other, became irrelevant.

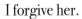

I forgive her.

She was flawed and beautiful, damaged and perfect, and I hope I can be half as strong.

The Crossword

Sheelah McCaughan

A baby at my breast and a toddler dancing across the table. Three zoom-schooling elementary girls peering over my shoulder, ignoring the side-eye I continually throw their way.

"Are there any questions about sports?" my oldest always asks.

"Any questions about Gwen Stefani?" the middle chimes in.

"How do you know you're not wrong?" my precise and perfect first-grader repeatedly grills. "Do you check? You know the answers are in the paper the next day, right? Do you make sure you're right?"

At the height of the pandemic, the New York Times daily crossword puzzle was my break from it all, right in the middle of it. Quarantining with five kids ten and under and a husband suddenly working from home was loud, busy, and rambunctious — not an image of the term "hunkering down" I had ever imagined. And every day at lunchtime, I sat at the kitchen table, blocked it all out, and soaked it all in with a red pen cocked between my fingers.

"You do crossword puzzles in pen?" someone once asked. "You do the New York Times crossword puzzles in pen?"

It's not a matter of confidence, I had to admit, but a matter of quirk.

"I can't stand the sound of pencil on newspaper," I told them.

It's been that way for as long as I can remember, but the red color is new. It happened one day when a blue pen couldn't be found: a common occurrence with a husband and five kids who lose pens as often as I lose my patience. I discovered over the course of that day that the red ink was bright enough to see from across the room. Where there was once time to sit and solve, pandemics and pandemonium have left snippets of time to sneak in a clue or two. That bright red ink makes the holes I need to fill visible from anywhere, a quick-glance reminder to slip a brain break into any tiny, square-shaped moment.

The bright color of the ink and the frenzied state of play may be novel, but crosswords have charmed me for decades. I can't remember falling in love with them, but falling in love through them is something I'll never forget.

Fifteen years ago, in a giant pink house on Seattle's Capital Hill, I met the man I was going to marry. He had a crossword up on his computer, and I was spellbound. It turned out to be a random fluke – or maybe fate – because he never was a big crossword guy.

"You do the New York Times crossword puzzle?" he asked me, surprised. "My grandmother always did them."

I knew I had him hooked.

I thought I had him hooked, I should say, since after spending the entire evening together and getting my phone number, he smirked at me and said, "Well, I should get back to the girl I'm kind of seeing. She's probably pissed right now."

We moved in together shortly thereafter, and only ever got the paper here and there until the pandemic hit. Just as he was never really a crossword guy, he was never really a computer guy either. So, he wanted a connection to the outside world that didn't include a screen.

From time to time, he'd shout out headlines to me across the room (and over the kids).

"I know," I'd always smile. "I saw that on my phone yesterday."

Subscribing to a print newspaper when I was glued to my phone, doom-scrolling through the news of an emerging pandemic seemed so backward... and so us.

He is one way, and I am very much another. He's always been the down to my across.

"Why don't you try picking up the crossword again," he suggested one day, and I laughed him off.

"When would I have time to do that?" I scoffed.

But he kept asking every couple weeks until one day, he purposely distracted the kids, and I agreed. I rested the paper on my then pregnant belly and grabbed the closest bright red pen.

It took just that one time for me fall back in that same puzzling love, and every day since I've reached for the otherwise ignored Arts section – even the day I went to the hospital to give birth.

"Are you normally a crossword person?" the on-call OB asked.

"Yeah," I smiled. "I guess I am."

Of course, not every day presents a chance to solve. Often the paper sits untouched by anyone on that same kitchen table as the wild world of pandemic family life spins around it.

Sometimes the solver just isn't in the mood.

Sometimes pandemic parenting is just too much.

Sometimes pandemic coupling is just too much.

But on those days, I can't help but see the crossword and smile. Because on those days, that gray, folded paper isn't just a crossword; it's a peace offering. When words are left unspoken and an embrace is too far to reach, I'll often find the crossword carefully left in sight — that same red pen resting on top at the ready.

Spaghetti-gate

Colleen Markley

On a beautiful spring day, my thirteen-year-old was taking advantage of the gorgeous weather by hiding in his cave of a room, where the curtains and windows had not been open for several years. This lair of doom and stench caused humans who entered to have momentary loss of clarity, and to lose their grip on reality. This is normal when you enter the life of a teenager – or so I am told. I walked over his threshold and became confused as a green mist wafted through my nostrils. Why was I there? What was I supposed to be doing?

"Hello?" I sputtered, confused. I couldn't see him. I barely remembered his name.

Out of the darkness rose a sound.

"Mom," said the disembodied voice, deep and gravely, a man's voice.

"Yes?" I squeaked, trying not to breathe.

"You know the game I downloaded a week ago where it's a prison simulator and you have to escape?"

I made a confused sound of agreement, even though I had little understanding of the words he was speaking.

"Well, I just beat all six prisons, including the one modeled after Alcatraz. Just in case you were wondering, this is the warning flag that you'll look back on later - where it all started going wrong."

I laughed, inhaled teenaged toxins, and passed out.

A week later, it did all go wrong. Slowly, just one strand of sanity unraveling at a time.

I can't remember now where I was when the chaos began. Maybe doing six loads of laundry. Maybe taking a nap. Maybe out saving the world. The way I remember it, I was out all day saving the world, came home to throw in a load of laundry, and laid down thinking how lovely a nap would be. Saving the world can sometimes be exhausting. But wherever I was on this particular day, I was not in charge. My hubby was in charge.

It was a Saturday night, and Brian was making dinner with the kids — pasta dinner, spaghetti, to be precise. And with Brian in charge came the sharing of important lessons, like how to tell if spaghetti is done cooking. When I was a kid, my mom also shared this tidbit with me. You scoop out a strand of pasta, give it a second to cool and throw it against the wall. If it bounces off, it's not done yet. If it sticks, it's done. In the 1980s, having a parent tell you something you could replicate yourself became gospel. Now, if you actually research this, the internet will tell you that this method doesn't work. If you throw spaghetti at the wall and it sticks, it simply means your spaghetti is sticky, not al dente. My childhood was much more fun without all the fact-checking.

My 11-year-old, who still spent a good amount of time outside their room and enjoyed the company of a parent, loved cooking with dad, especially since it involved throwing lessons. For some reason, the throwing took place outside the actual kitchen, in our hallway near the powder room. I am not entirely sure why this occurred, as our kitchen does actually have walls. Hallway pasta doesn't make any sense for a myriad of reasons. What struck me as the strangest was

that they threw the spaghetti strand at the wall, not at the end of the hallway (optimizing throwing distance and follow-through potential), but sideways, in the middle of the hallway, where they had very little room to wind up or execute a proper throwing maneuver. Part of me wonders if that is why the spaghetti didn't initially stick on the wall. Was it a lack of distance? Was the spaghetti not fully cooked? Or is gluten-free spaghetti, missing the gluten protein, also missing any sticking agent? Whatever the science was, the spaghetti didn't initially adhere. So the child, under direct supervision and approval from dad, gave it a good mush into the wall, and there it stuck for days.

On Day One, I saw the spaghetti. I did a double take as I passed it on my way to the powder room. I shook my head... and I left it there. It took great restraint on my part not to pluck it off the wall and return my home to "normal." But I resisted and waited for the person who put the spaghetti on the wall to clean it. They made a mess. They should clean up after themselves. No further action needed on my part. This was important parenting.

On Day Two, I heard my family laughing behind my back. They thought I hadn't seen the spaghetti. They thought I had walked by the spaghetti, on the wall, for 24 hours and not noticed. It was eye level. It was not small. It was making me twitchy, but still, I persisted-resisted. I did not remove the spaghetti.

On Day Three, the electrician came to the house to repair an outlet in the living room. He asked to use the bathroom, and I directed him past the spaghetti. He gave me an odd look, unsure what to say to the crazy lady with pasta on her walls. I offered no explanation.

On Day Four, I decided public shaming was in order and took to Facebook to vent publicly about the disgusting humans who live with me. "It is day FOUR of Spaghetti-gate in my house. 'Someone' tested if the spaghetti was done cooking. 'Someone' thought it would be funny to see if mom noticed that they left the spaghetti on

the wall. For. Days. Yes. I noticed – on Day One – and so have all the

other people who have come to our house wondering what kind of barbarians live here. It is now a battle of wills to see who is going to clean the spaghetti off the wall. #notcaving. #yourmessyoucleanit."

I tagged my husband to make him aware that my mental state was precarious. And yes, I was aware that hashtags were meant for Twitter users to see what is trending. But I believe we should use technology to its fullest potential, including passive-aggressive hashtags to share wife/mom angst.

Day Five of Spaghetti-gate dawned. The windows were open, and the gentle spring breeze wafted through, carrying the promise of the change of seasons, pollen, and dog fur. I passed the spaghetti, sneezing and rubbing my eyes from allergies and disbelief. I stood resolute and dreamt of a padded (spaghetti-free) room. The dog fur was now attached to the spaghetti. On my wall. In my house.

Day Six. The Spaghetti Queen made her appearance on the Earth. She was drawn in chalk on my wall. The spaghetti was her backbone, an irony that did not escape me. The Spaghetti Queen stick figure smiled at me, showing off her cute chalk bob flip hairstyle. The Spaghetti Queen's arms spread wide to the world, balancing her curved spaghetti spine. She wore a triangle skirt and heels. She reigned over my house.

Day Seven. I lost all control, and we entered a whole new level of chaos. The Spaghetti Queen was accompanied by an entire wall of chalk drawings. She herself now sported full regalia and an entire court of ladies in waiting. Drawn in full detail were a dais, worshippers, multiple levels of terraces and fellow stick figures in various positions of genuflecting. The chalk mural now spread throughout the entire hallway. The spaghetti was still attached. I avoided the bathroom.

On Day Ten, I threw the gauntlet. I wrote a letter, signed it, and

posted it on the spaghetti wall, right over the Spaghetti Queen's crown.

Dear Family,

You have been very funny about the Spaghetti Queen. Spaghetti-gate has been very entertaining. Thank you for your humor and creativity.

But what I am thinking about today (DAY TEN) is this: the spaghetti has not gotten moldy. It has not decomposed. It has not changed in any way. You are teaching me an important lesson in science – processed food is bad. How hard must it be for our bodies to digest pasta if it has turned into a glue-like rock substance that defies even gravity?

I think this is an excellent springboard for a new diet for all of us. No more processed foods – no more spaghetti, pasta, mac and cheese, pizza dough, chicken nuggets, taco shells, bread, rolls, crackers, granola bars, muffins, donuts, tater tots, or fries. All of that enriched flour (gluten-free or otherwise) must be BAD if it can create mold-resistant art. From now on, we will only eat leafy green vegetables and things that I know would wilt and decompose and die before our very eyes. This diet will continue for the entire time the spaghetti is on the wall, reminding me of this important information. Should the spaghetti be taken away, the wall cleaned, the evidence removed, I may become forgetful and serve something unhealthy, processed, or full of taste in general.

Until then, we shall eat lettuce, spinach, broccoli, string beans, cauliflower, and my favorite – Brussels sprouts.

Thank you for this health incentive. You are my favorite humans.

With much love,
Mom

Shockingly, within an hour of the letter being posted, the spaghetti disappeared, along with the Spaghetti Queen and all her followers. Apparently, vegetables are extremely incentivizing. An anonymous note appeared, printed in ransom-like font, taped to the mostly clean, chalk-smudged wall:

"I am writing to acknowledge that I am the perpetrator of Spaghetti-gate and its aftermath. I take responsibility for my actions, though in fairness, I was instigated and assisted by at least one other co-conspirator whose identity, like mine, shall remain anonymous. Please know that no disrespect was intended by my actions, which were driven solely out of curiosity and good fun. I have cleaned the wall to the best of my ability. All Hail the Spaghetti Queen."

On Mother's Day, a week later, I receive a framed photo of the Spaghetti Queen... not her followers or her dais, but just her and her spaghetti backbone. We are both steadfast and strong with spines of steel spaghetti.

It Is Always Worth It

Jessie Renee

I didn't tell them I had a husband and child at home.

I wasn't trying to get away with anything. I just wondered what would happen.

Wife. Mother. They were always the things that led the conversation, the things I said about myself first, so often that I wasn't even sure anymore if I'd have anything to say if I didn't talk about who I was to other people.

So I did it out of curiosity. Who would I be without those things? Was there a 'me' still inside there anymore? I just wanted to know, to prove to myself I still had something interesting to say, to be. Just me.

But is that true?

Maybe I did wonder about something more.

I was in a tiny little oasis town in the middle of the sand dunes of Peru, a strange place for a wife and mother to find herself.

It was nearly the end of my trip, traveling alone in Peru.

I traveled light – just a small carry-on bag for the entire time. Maybe I chose to travel so lightly because the baggage I was lugging inside of me was already filling my arms and weighing on my heart, so I had no room for more than that.

And maybe, nearing the end of my trip, I was realizing I hadn't yet put down all that baggage or decided what to do with it.

And I knew I was not going to return home the same person I came as two months before.

Not telling my temporary friends – the kind of instant friends you only make when you are traveling, with the kind of bonds you only make on bumpy bus rides, in the long hours through moonscape deserts in a foreign country. They are not like normal friendships. You barely know each other, and yet you are willing to bare your deepest soul, perhaps helped by the peculiar magic of half a giant fishbowl margarita in some sandy little nightclub in the middle of nowhere.

I felt more myself in those two days in the desert than I had in years.

What was I meant to make of that?

I was purposely lying about details of my life. Details I would have previously said were the most significant things about me - the things that, at home, took up almost all of my time, made up almost all of my identity.

Wife. Mother.

What did it mean that without those things, I suddenly felt so free? That for the first time since acquiring those labels, I actually felt like me?

When I had been planning this trip to Peru, my husband's friend had said to him, "What if she doesn't come back?"

We scoffed at that, my husband and I. How dare that man say something like that, even think it? That I was going on this trip to run away.

But something uncomfortable squirmed within me. I didn't acknowledge it then. I couldn't.

Perhaps this all makes me seem deceitful, like I was messing everyone around. Perhaps you think me a selfish, terrible mother, for traveling alone for two months with a husband and two-year-old daughter at home, all the while having doubts about my marriage, and lying about their existence while sand-boarding and dancing with strangers in the middle of Peru.

But it is only in hindsight that I see all of this so clearly.

It is only in hindsight that I can now tell you the story of what was going on. That my husband was co-dependent and emotionally abusive. That I was hurting and carrying unresolved trauma and years of learning that girls don't say no.

While I was in it, I was just swirling through a confusing mix of long unexpressed feelings, things that had begun in me years before, long before I got married.

But life has a way of marching us through the milestones, without really stopping to think, because stopping to think is dangerous. You might realize uncomfortable things. It might make you stand up and rock the boat.

I think it was looking for the space to stop and think that called me to Peru in the first place. Seeking an uninterrupted moment to stop and breathe, to inhabit my body again. To be with myself for longer than tiny stolen moments in a life that kept hurrying me along a pathway I couldn't really remember choosing.

Lying in bed in the middle of the night while everyone else was asleep. Locking the door to the toilet and sitting there longer than

actually needed – but not long enough to make anyone think you have an embarrassing problem!

Are these the only moments mothers get to themselves?

There are bigger things inside of us that need to be given space; more space than can be found in stolen moments of a life dedicated to making sure everyone else is happy.

We are very rarely encouraged to take the time to make sure that we, too, are happy.

It was my husband's idea that I go to Peru.

People, to this day, many years on, still think it was my masterminded idea, my escape plan somehow. But it was his idea.

He knew I had given up my travel plans for him, back before we had even got engaged, with plans to rebook my trip at another time. And then marriage, jobs, life, motherhood had come along, and it had never happened.

But it was all living inside of me still, these unrealised dreams, like so much dry kindling. Perhaps he could tell there was something in me that threatened to burst into flames and consume us both if we didn't do something about it.

He knew I had always wanted to travel to Peru. He told me to go. He would organize work and childcare at home. I should go.

I think I already knew it then. This was his peace offering. He didn't want me to blame him for my unrealised dreams anymore. But this was also his bargaining chip. *I'll give you this trip. And then you come home and finally settle down as a good wife and mother, okay?*

I traveled light to Peru because this was the weight I was carrying with me. The expectation that I was going to take whatever dissatisfaction had been plaguing me and leave it behind in Peru like

a good girl.

My husband's friend, the one who voiced the question that I suppose everyone else was also thinking, was uncomfortably close to the truth.

But I didn't know it at the time. I was just fulfilling a lifelong dream. I was indignant at people's questions and assumptions.

Why are you going to Peru?

I think I said something about wanting to learn Spanish, and then changed the subject.

What could I say? Just because I want to? Because my husband guilted me out of travel years ago, and is trying to make up for it? Because I'm a human being and a woman, not just a mother? Because being a mother doesn't mean my life is over?

Because I'm selfish, messed up, and trying to escape? I not-so-secretly feared that this was the real answer.

But I went anyway. I felt called there. I couldn't have turned back, even if I wanted to.

And it changed my entire life.

I remember standing at the kitchen window of a homestay in the Sacred Valley; looking through it, there was a garden with a pumpkin vine taking over. But I didn't see that – it was like I was momentarily transported somewhere else, looking out at the path of my life extending before me from that point. And I suddenly felt it, deep in my soul, that I had to walk that path - whether *he* came with me or not.

It was a thought that just surprised me with its intensity, and seemed to spring up out of nowhere. But it was truth. I knew it as soon as I felt it.

And I wasn't sure how I hadn't seen it before.

Was it the kindred spirits and other travelers I'd met in that home — friends that were mine, not his, who finally listened to me and my thoughts like no one had in years?

Was it the wachuma plant medicine I took in the garden of that home that left me vibrating and seeing things in the fire that seemed like visions from something outside the natural world?

Was it the tarot reading I got from a bold, tiny woman, the first person I had seen read cards so intuitively, who saw things that cut right to the heart of things I didn't even realize I was feeling?

Perhaps it was all of it—the peculiar magic of Peru to rearrange your perspective.

And simply that I finally had the space. The space I'd not given myself since I met him, the man I married, to really hear the truth of my own soul.

I had a path. Did he have a place beside me on it?

I was on my way home, in the last days of my trip, carrying the grief of leaving beautiful friends, and the confusion I hadn't yet begun to unravel after my realizations and transformations, when I lied about being a wife and mother.

No one asked me directly, of course. I almost thought they might, like wife and mother, were such consuming parts of me that it would somehow be written on my body. But of course, it wasn't. And without even really consciously deciding, I just didn't offer it. For the first time, I didn't lead with it.

Wife. Mother.

I left them aside. Left the space open to see what else would come

out, to see if there was actually anything else of me left in there.

And you know what? I didn't disappear. I was still there, even without those two huge labels defining me.

Somehow, I felt more real than ever.

But I didn't give those temporary travel friends my phone number as I left. I didn't give them enough to look me up on Facebook. I didn't want them to find me and discover the things I hadn't told them.

I wanted to leave them with the me that existed outside of all that. Because then, somehow, I might be able to hold onto that as I went back, back into a life that I was starting to realize didn't fit me anymore, and maybe never had.

I'd feared it had been true, what people said before I went to Peru, that I was running away. But really, all this time, I had been running *towards myself.*

And I'd finally reached her.

Two months in Peru opened up a space inside me to start to see things I had been hiding from for years.

Two days in the desert, out from behind the labels I'd been wearing like masks, and I got a glimpse of a me I hadn't seen in a long, long time.

I went home and tried to make it work. For more than a year, I tried to bring us back together. Him and me.

I didn't want to admit that people might have been right. I didn't want it to be true that for the past nine years, I had been making decision after decision that had taken me further and further from myself, for the sake of everyone else. I didn't want to decipher how what I'd thought had been love had caused so much pain.

It's inevitable that people take sides in a divorce, look for who is to blame. But it is almost never that black and white. I tried to find where to lay the blame too. There were so many things we could, and did, sling at each other as the reason for all of it.

But it started long before that moment in the window where I saw my path laid out.

I was simply seeing the truth of something that had begun the moment I was born. Maybe before, absorbed through the things laid on my mother to bear, the violence she endured even while I was in her womb.

It was not even the moment I said yes to him, when somewhere inside of me I knew I meant no, that was the first decision to betray myself.

It was before that.

I often wonder what the first moment was. The first moment I realized I was a girl. And as a girl, it was my job to say yes. To allow. To submit and surrender. That I was a girl, and to stay safe in this world, it was my job to betray myself, so that everyone else could stay comfortable.

People may blame me - and they did, and probably still do. They say I was the one who made those decisions, to get married, and all the cascading decisions that followed afterwards.

But is it a real decision, when you long ago figured out that you don't really have any other choice?

Peru did not cause my divorce. It simply opened my eyes to the things I had been accepting as normal, that should never be normal, things I forgave, and absorbed, and swallowed, and bit my tongue over, and sat on my hands, and cut away parts of me that didn't fit. Again and again.

Over and over, I stayed silent, and held back all the things I knew would not be acceptable in their version of who I should be, until I didn't even know I was doing it anymore. I just thought I had always had no voice.

Ironic, then, that it was something I didn't say, in the desert in Peru: Wife. Mother. It was my silence that finally opened my eyes to everything that was waiting to be spoken out, that reminded me I had a voice to use. And I had to. I had to use it, no matter the cost.

It took me another year after returning home to finally speak it, to finally realize that though it might cost me my marriage, financial stability, my home, my friends, my reputation, my identity, maybe even my daughter, as I feared how he might punish me for daring to say it all...

That though it would cost me everything, it would cost me even more to stay.

It would have cost me, me.

And when I look at my daughter, though it might be a long, long time before she understands - if she ever does - I know I had to do it for her, too. We all too often think we are staying for them, but my daughter did not need another example of a woman betraying herself, shrinking herself away, silencing her voice, handing her power into the hands of man.

I hope she can one day see the courage. I hope, when the time comes, what I have dared to do in the face of a world that would keep us small, will make it a little easier for her to do the same. That maybe she will never have to go so far to find herself, never have to break everything apart to find her voice again, because she will never give it away like that in the first place.

But if not, I trust she will have her own journey, her own Peru, to guide her on the path back to herself.

And if she ever asks me about it, if I even get the chance to tell her this story, if she ever asks me if I regret going to Peru, was it worth it?

I will tell her: Peru cost me everything. But it gave me back myself.

And the life I have rebuilt on the foundation of my truth has been worth every bit of pain in between.

And I will tell her, if she ever doubts if she is too much, if the things she has to say are worth the difficulty that comes from saying them, I will tell her:

The world needs your voice more than it needs a good girl.

It is always worth it.

About the Authors
(In Order of Appearance)

ALLIE GRAVITT is a poet, musician, and author who spends her days mostly in her head trying to keep a lot of little humans, animals, and plants alive. She is a published poet and non-fiction writer, who loves connecting people with each other and themselves, and hangs out on social media as @whenalliewrites. When she has time to breathe, she likes to travel and play music. *(foreword, pg. 78-81)*

LA ROQUEMORE is a writer, a conversationalist, a professional photographer, a friend, a mother, an asker of ALL the questions, a collector of moments, and an encourager of souls. She is currently writing her first novel, and recording her podcast, Gospel of Courage. She hosts writing workshops for growing writers in Lakeland, Florida, where she lives with her three kids, and a cat named Leaf. *(pg. 8-9)*

K. L. MIELKE spends her days as a paraprofessional and her nights as an indie, fantasy romance author. She is also a mom of two boys, whose imaginations and humor provide her with endless inspiration and laughter. Joining the Moms Who Write Facebook page was the push she needed to pursue her dream of publication, and she is eternally grateful to those who provided support on her journey toward publication. And besides, who better than Mom could teach her boys that they can do anything they put their minds to? *(pg. 10-12)*

ALLISON PRINE is a mother, storyteller, lover, daughter, sister, and healer. She is Mama to a spitfire 4-year-old daughter and lives in the Bay Area in California with her family. She spends her days bouncing between being immersed in the magic of her daughter's world and connecting with other parents as a therapist specializing in parenting and perinatal mental health. Holding space for others to share their stories and supporting growth through the most vulnerable moments of life has become her passion and life's work. Writing for her is about processing, connecting to others, making meaning, and contributing to the rich tapestry of motherhood. *(pg. 14-17)*.

LAURA BABYN is a Canadian-born author, who writes adult adventure/ fantasy novels and children's books. As a Biology graduate from the University of Guelph, when she's not writing, she loves exploring the great outdoors. You can often find her hanging from cliffs, swimming in the ocean, or running through the mountains. She currently resides on the West Coast of BC with her husband, daughter, two dogs and millions of trees. *(pg. 18-24)*

LIZ TIETHOFF has wanted to be an author since she was 6. She is now a mom of two and mostly writes poetry about motherhood, adulthood, and healing. She is also exploring literary fiction short stories. *(pg. 25)*

AMELIA ORR is now in her mid-30s, and mother to a human child. The pregnancy was planned. She tries her best to trust evolution. *(pg. 26-27)*

EVE CROSKERY lives in Auckland, New Zealand, with her partner and two young children, who are the inspiration for much of her poetry. She is a primary school teacher who loves sharing the powerful nature of the written word with her students. She loves to be out exploring the great outdoors; hiking, camping, trail running, and puddle jumping. *(pg. 28)*

LISA MASÉ is a parent, poet, nutritionist, herbalist, and social justice activist. She emigrated from Italy to the U.S. as a teen and writes about food, family, geography, and cultural revivalism. *(pg. 29)*

CRYSTAL ROWE is a former attorney born and raised in Georgia, who now lives in small coastal town north of Boston. She adores the beach and would spend every waking moment there if she could. Crystal home-educates her two daughters and spends whatever free time she can find writing, cooking, or reading. You can find more of her writing at SoulMunchies.com. *(pg. 30-31, 172)*

JENNA WILSON is a mother, English teacher, and chai tea enthusiast from a town surrounded by cornfields in Central Illinois. She received her Master's in English with a focus on writing from Illinois State University in 2017. Jenna's favorite subjects to teach are Contemporary Fiction, Creative Writing, and Theater. When she's not teaching or writing, she's likely to be found searching for the secret to raising a strong, self-reliant, confident young woman while somehow surviving the experience of raising a strong, self-reliant, confident toddler. *(pg. 32-35)*

YUY REN has three main passions: writing, music, and art. Within those spaces, she never runs out of creative endeavors. When not working on one of her projects, she can be found reading, gardening, or spending time with her family. *(pg.36-45)*

MEGAN HANLON is a work-at-home mom and former journalist who grew up in Texas. She now resides in Ohio with her husband, two children, and a disobedient Boston terrier. Follow her on Facebook and Twitter at @sugarpigblog. *(pg. 46-48)*

LANE PATTEN is a writer, wife, mama, cook, and Emergency Physician. Previously, Lane wrote and dabbled in recipe development at WithTwoSpoons.com. Together with her husband, two kids, and lazy labrador, Pippi, she is making her way through this thing called life. Currently located in Minneapolis, MN, she is trying to figure out who she wants to be when she grows up. *(pg. 50-53)*

TRISTAN TUTTLE is a writer and poet from north Georgia. Her poems are often found at the intersection of motherhood, nature, and spirituality. For another layer of vulnerability, she often makes videos and voiceovers of her poetry. Her debut poetry collection is called *A Kudzu Vine of Blood and Bone*, and she can be found on Instagram @tristantuttle. *(pg. 54, 59, 149)*

SHELL SHERWOOD is a poet, fiction writer, freelancer, and creator of silly children's stories, who could live on coffee, pastries, and romantic tragedies. She lives in Hudson Valley, NY, with her three boys, and aspires to own a small writing getaway in every climate. Shell is currently working on her debut poetry collection. *(pg. 60-61, 134-138)*

KRISTIN YATES is a writer living in Evanston, Illinois. She is currently working on her first novel. *(pg. 62-64)*

CARA HOWARD lives in central Indiana with her husband, two kids, and dog. She was raised by a wonderful mom and is so grateful that she gets to be one herself. Over the past 15 years, motherhood has often stretched and sometimes broken her, but it has ultimately taught her more about the person she wants to be. *(pg. 66-75)*

R.H.G. is a 33-year-old stay-at-home mom who usually writes about the darker side of life. *(pg. 76)*

EMMY SEAL has adored all things romance from the time she was a girl and first read *Little Women*. Growing up she always dreamed of her happily ever after, which she has found with her husband and two children. She spends her days daydreaming about books and writing in her down time. *(pg. 77)*

HANNAH GODFREY is a writing mama living in Greensboro, NC, with her husband, son, cat, and dog. She's been writing since floppy disks were a thing, but these days saves her sci-fi and fantasy works up in the cloud. For more of Hannah's work check out *Venus Rising: Musings & Lore from Women Writers* and follow her on Instagram @hannahgodfreywrites for more updates. *(pg. 82-84, 94-97)*

FRANCES LU-PAI IPPOLITO is a Chinese-American writer in Portland, Oregon. When she's not spending time with her family outdoors, she's crafting short stories in horror, sci-fi, fantasy, or whatever genre-bending she can get away with. Her stories have appeared in Nailed Magazine, Red Penguin's Collections, and Buckman Journal's Issue 006. Her work was also featured in the Ooligan Press Writers of Color Showcase 2020 in Portland, Oregon. *(pg. 86-91)*

KATE LOVEDAY is a mother of three, teacher, traveller, lover of words and nature. She is originally from the U.K. and currently living in Taiwan, writing and discovering the country whilst on maternity leave. She writes poetry and prose inspired by the messy imperfect beauty of life. *(pg. 92)*

HEATHER CARTER lives in St. Louis, Missouri, and is the author of *Of Songs and Saltwater*. The first book of her upcoming series, *The Mountain King*, will be released in spring 2023. When she's not writing fantasy novels, she enjoys creating music and drinking lots of coffee. *(pg. 93)*

ABBY HARDING is a writer of fiction and poetry. Her work focuses on relationships, grief, and the difficulty of Being Human. She lives in a rural town in Central Illinois with a husband, three children, two cats, and six chickens. *(pg. 98, 240-249)*

ROSE JAY RIGBY is a fantasy-romance/young adult author who resides in a small suburb of Atlanta with her husband of 17 years, two children, and a crazy miniature pinscher rescue. When she is not writing, she is homeschooling her kids, wrangling the dog, or working at her church. *(pg. 99, 226-227)*

EMILEE MOORE is the proud mother of two beautiful girls. She has her BA from Brigham Young University, and lives in Virginia. *A Friend for Princess Ada*, her first book, will be published in Fall 2022. When she is not writing or parenting her little ones, you will find her reading, baking, or going on family adventures within her community. *(pg. 100-102)*

JENI CONRAD is a wife, mother, teacher, writer, reader, and a human (honest, she can pass those robot tests almost every time!). She usually writes YA paranormal stories and has two books published with four more coming out next year. Since 15 years old, she worked in the restaurant business while getting through high school, a BA in English, and then an MA in sociology. Now she works from home while wrangling two small girls, a dog, and two crazy cats. *(pg. 104-114)*

LISA HOLCOMB writes fantasy, non-fiction, and poetry about families, both ones born into and those that are found. She fell in love with books on her mother's lap, under the Nebraska stars. When not writing, she does fiber arts, helps train PTAs, runs meetings of the East Texas Writers Guild, and cheers for her three kids' band programs alongside her fantastic husband. She has spent twenty years blogging about adoption and reunion, and parenting while chronically ill. Her most recent publications are an essay about parenting in *Boy Moms: Collective Tales about Mothers & Sons* and a time travel story in *Next Chapters Unleashed: A Beachy Anthology*. *(pg. 116-117)*

MONICA L. CULWELL is a single working mom of an amazing boy, two dogs, and 11 chickens. She loves using her imagination to craft unique stories, but also appreciates how personal stories can help others in this world. *(pg. 118-121)*

S. ESCOBAR is a writer of fantasy and Gothic fiction. She has written several novels and short stories, including the romantic ghost story A Song Beyond Walls. She lives with her husband and daughter in a misty lake town in Northern Idaho, where she bakes far too often and pretends she's far more foreboding and mysterious than the yoga-pant wearing mother that she is. *(pg. 122-124)*

CHRISTINA LYNN LAMBERT currently writes steamy paranormal romance and poetry. She tries to create a picture of hope with her words that a reader can hold onto for a while. When she's not writing, she enjoys spending time outside and finding ways to avoid cooking. She lives in beautiful Virginia with her husband, two daughters, and a sweet, hairy monster of a dog. *(pg. 126-133)*

K. MARIE BENNETT works as a technical writer during the day. She lives with her husband, son, and two spoiled rescue dogs. Her debut children's book, *Better Together: A Cherry and Friends Tale* is available and she's been featured in podcasts such as the NoNap Podcast for children. Learn more at ThatKatieLady.com. *(pg. 139)*

J. N. SMITH is a geologist turned stay-at-home mom. She is a writer at heart and lover of (in order) family, coffee, happy hour, and chickens. *(pg. 140, 141, 168-171)*

CHRISTINE WEIMER is an entrepreneur, creative copywriter, two-time published poet, and writing mentor from Queens, New York, who sought an innovative way to amplify women's voices and advocate for their stories. In 2019, she co-founded Our Galaxy Publishing, a one-stop-shop press collaborating with aspiring authors and entrepreneurs to instantly improve their storytelling and accomplish their creative desires. Christine is currently studying for her MFA in Creative Writing & English. Her first poetry collection, *Tainted Lionheart*, was Readers' Favorite 2021 Gold Medal Winner. *(pg. 145-148)*

KATHRYN AVERYHEART is a Chicago writer currently based in Tampa, FL. She has two amazing kids, Jayne and Aaron, who are her favorite early readers, (thanks guys!) and a beagle named Gryff. She is working on a short story collection themed around loneliness and addiction and a novella about time travel. She's excited to be a part of MWW and the anthology and to share "No" with all of you. Find her on TikTok under her name or @writingeveryday. *(pg. 150-152)*

JENNIFER WALKER is a writer, fourth-grade teacher, wife and mother of two from Edmonton, Alberta, Canada. She writes contemporary middle-grade and young adult novels that feature kids finding the strength in themselves to break the mold and do something incredible. She published a contemporary YA romance with Finch Books entitled *Within the Folds of a Swan's Wings*, which spent more than eight weeks as the #1 bestseller in multicultural romance for young adults on Amazon Canada. She has

another contemporary YA romance entitled *Finding Aloha,* and a forthcoming middle-grade adventure novel called *Karate Chop Kate: Secret Operative. (pg. 154-163)*

CHRISTIN RICE's work has appeared in Litbreak, Fictional Café, Pif Magazine, SoMa Literary Review and more. Her short story, Bring Your Soul to Work Day, was nominated for a Pushcart Prize. She has an MFA in Creative Writing from Queens University of Charlotte and an M.Div from Princeton Theological Seminary. She lives in San Francisco with a cat, a toddler, a mate, and is currently pursuing a certification in professional coaching. *(pg. 164-167)*

JILL ROBINSON is an author, wife, mother of two, athlete, speech-language pathologist, and lover of all animals. She is a contributor to Chicken Soup for the Soul, Her View From Home, and Heartland Society of Women Writers. Jill loves the outdoors, singing off-key, and creating writing memes. Writing brings her peace. *(pg. 173-175)*

MADILYN J. WHITLEY grew up under the watchful eyes of the Appalachian Mountains of East Tennessee. Her rural home inspired her to imagine worlds of magic and dragons – and by age 5, she knew she wanted to practice the very real magic of writing books. She later obtained a BA in English from Tusculum University. Currently, Madilyn lives in South Carolina with her loving husband and two boys. *(pg. 176-181)*

KIM PATTON lives in Georgia with her husband Kevin and two adopted daughters, Eden and Shiloh. She spends her days walking to the park, teaching her toddler the ABCs and juggling nap time and feedings with the baby. She writes at kimpatton.com and is an active micro-blogger and book reviewer on Instagram and Facebook. *(pg. 182-192)*

CASANDRA CHESSER is a freelance writer and novelist. She recently moved to Pennsylvania with her husband and six kids, and when she's not wrangling work and kids, her other loves are music, reading, and history.

ADVA SHAVIV writes ADHD fantasy while living ADHD reality. A philosophy PhD, homeschooling mom of three, pet mom of four and jack-of-all-creative, she spent most of her life feeling weird, until the late ADHD diagnosis changed her view of life. Her gradual move to an ADHD-compatible life culminated in becoming an ADHD fantasy indie author. To be. Don't mention deadlines, please. *(pg. 198-200)*

KIMBERLY PARSONS is a mother, musician, and writer. She homeschools her two children, manages her menagerie of five dogs and a cat, and writes mysteries in her spare time. She is a native of the PNW, but makes her home in deep East Texas. *(pg. 202-205)*

SARAH FEDCHAK is an outdoor educator, writing teacher, and home-schooling mama of three based outside Atlanta, GA. She studied creative writing at Hollins University and toggles between writing poetry and a cacophony of novels that she will likely never finish. She loves pirate lore, cool knives, themed Reese's, and Jesus, though not necessarily in that order. *(pg. 206-209)*

R. D. GABRIEL was born in 1984 in the Philippines. Growing up with five siblings, she was exposed to complex family dynamics and felt drawn to each individual's ups and downs, what crushed them and what lifted their souls, particularly by observing their unique ways of speaking and relating with each other. She migrated to Korea in 2010, obtained her PhD in Linguistics, and now works as Assistant Professor at a private university. She currently lives with her husband, son, and in-laws and remains curious about family, friends, and self. This is her first public attempt at sharing her own life by submitting an entry to an anthology. *(pg. 210-213)*

YNES MALAKOVA (she/her) is the black sheep in a family of wolves. Beauty in darkness and lyrical prose is her magic, her love, her moon. A fan of the pastel goth aesthetic, she collects adorably sinister plushies and pleasantly disturbing scented candles. She has authored several award-winning and bestselling short stories in anthologies, which can be found on her bookshelf above her mini Zen graveyard, and her debut novel (*A Viper in the Court*) releases in 2023. A protectress of the arts dedicated to supporting underrepresented voices, Ynes is CEO/Publisher of Balance of Seven press, an instructor at Writespace Houston, producer of the album *Restless Days*, and associate producer of the independent film *Gary Screams for You*. *(pg. 214-219)*

KATIE CARRICK is a scientist, mother, and writer, with the order changing on any given day. She's a transplant from North Carolina, now living her best life in the Pacific Northwest. A self-described lover of all things DNA, she has spent the better part of the last decade working in cytogenetics and molecular diagnostics. *(pg. 220-224)*

NIAMH DONNELLAN is a mother, writer and poet from Ireland. Her debut thriller novel *Mind Yourself* is available on Amazon. She is currently finishing her first collection of poetry. *(pg. 225)*

SARAH REILLEY is a teacher, author, and editor raising two girls in a crazy world. She has a BSEd English Education, which currently serves to help her as she corrects her husband's gamer lingo. She's a believer in all things good and beautiful — especially fairies. *(pg. 228-234)*

CANDICE STANFIELD-WISWELL (she/her) is a poet, writer, and psychologist. Her work has appeared in The Minison Project, Volition, and elsewhere. She grew up across the U.S. and Europe, but currently lives in Virginia with her husband, daughter, and lazy cat. *(pg. 235)*

AMBER PAYTON is a military spouse and mother to a young daughter. Instead of having any free time, she decided to start writing and hasn't looked back. Her debut fantasy romance will be published by City Owl Press in 2022 under the name A.N. Payton. *(pg. 236-239)*

SHEELAH MCCAUGHAN is a Pacific Northwest mom and children's book author. She spent years writing for grown-ups, but as a mom of five, her heart is with her kids, and now her pen is, too. *(pg. 250-253)*

COLLEEN MARKLEY is an award-winning writer, and Erma Bombeck Writers' Workshop Humor Writer of the Month (June 2021). Colleen's path traveled through the hallowed studios of Jim Henson Pictures and Thirteen/WNET, NYC's public television station. Colleen has enjoyed turning life's mishaps into memories worth writing about, and finds her friends and family are excellent material. Her award-winning essay ("Unflappably Calm, Occasionally Furious, Ready and Willing to Hide the Bodies,") was published in an anthology entitled *Sisters! Bonded by Love and Laughter*. Colleen's latest project, *Lilith Land*, is a story about a pandemic virus and the end of the world where only the women survive. (It's a novel, not an action plan.) *(pg. 254-259)*

JESSIE RENEE is a tea drinking, tarot reading, unschooling mother of three. She is the author of YA fantasy fiction, and transformative non-fiction books and apps that help you live and speak your truth with confidence. At any given time, you will find her with a dozen creative projects on the go, and coaching multi-passionate entrepreneurs and writers to get their ideas out of their heads and into the world. She lives a simple yet daring little life with her family in Adelaide, South Australia. *(pg. 260-269)*

About Moms Who Write

Moms are creators. We create life. We create love. We create homes. And some of us create things with our words.

The catalyst for this project was my cry for friends who would get it. For other women who were trying to create and get the words and stories out of their heads. Who were struggling to fit everything in. Who were doing it all and still struggling to do anything.

So I reached out. And those people came.

It turns out there are so many of us. So many of us that scribble things on random pieces of paper or tap them into our phone notes or stay up way later than we should to get these words out of our heads. So many of us are fumbling through our creative process, trying to grow social media presences or hire an editor or figure out how the heck you even begin the query process. And when we come together, we are encouraged. We grow. We create.

It's really easy to believe that your words don't matter. That you're too busy and there just isn't time. That it's just too hard right now. And maybe it is. Or maybe we just need to know that we aren't alone and that there are hands on our backs.

I'm so proud to know these women. And we are so excited to invite you to join us as we tell our stories to the world.

You can find us at momswhowrite.org. Join our Facebook group. Follow us on social media, and sign up for our mailing list to be a part of any upcoming anthology opportunities.

Lightning Source UK Ltd.
Milton Keynes UK
UKHW020637220422
401905UK00009B/625